The House on Q Street

ALSO BY ANN L. MCLAUGHLIN

Lightning in July

The Balancing Pole

Sunset at Rosalie

Maiden Voyage

The
House on
Q Street

A NOVEL

Ann L. McLaughlin

For Kitty.
with thanks for all your wise criticism
& good luck with East Hope
April '06 Love,
Ann

2002
JOHN DANIEL & COMPANY
SANTA BARBARA, CALIFORNIA

Cover photo by Ellen L. McKee

Published by John Daniel & Company
A division of Daniel and Daniel, Publishers, Inc.
Post Office Box 21922
Santa Barbara, CA 93121
www.danielpublishing.com

LIBRARY OF CONGRESS CATALOGING-IN-PUBLICATION DATA
McLaughlin, Ann L., (date)
 The house on Q Street : a novel / by Ann L. McLaughlin.
 p. cm.
 ISBN 1-880284-59-6 (alk. paper)
 1. Washington (D.C.)—Fiction. 2. World War, 1939–1945—Washington
(D.C.)—Fiction. 3. Nuclear physicists—Fiction. 4. Girls—Fiction. I. Title.
 PS3563.C3836 H68 2002
 813'.54—dc21
 2002001329

For Charlie again

I wish to thank the Virginia Center for the Creative Arts once again for a fellowship to work in that beautiful setting. My thanks, too, to John Silard, for insights about his uncle, Leo Szilard, and to Morton Brussel for helpful information on the Manhattan Project. My thanks to Tina Hummel for research help and computer aid and to Ellen McLaughlin for advice about *Antigone*.

I want especially to thank my writing group: Kate Blackwell, Kathleen Currie, C. M. Mayo, Leslie Pietrzyk and Mary Kay Zuravleff for their thoughtful discussions of this novel as it developed and their encouragement throughout.

1942

Chapter 1

JOEY tipped her head back to look up at the cluster of red, white, and blue balloons that she had tied to the dusty overhead lamp in the front hall. They would surprise Poppy and people should be patriotic now with the war on. Her damp pigtails swung forward as she backed down the ladder and turned to the living room. "Mum, Mad! Look," she shouted. "Come here. Doesn't that make it look like a celebration?"

Her mother was pinning a blue madras spread over an old plush couch that hulked beneath the bay window, as Madeline, Joey's older sister, slouched in an overstuffed chair watching. "It's not really a celebration." Madeline pulled herself out of the chair and stood looking up at the balloons, her hands jammed into the pockets of her shorts. "It's just the first time Pop's had a real dinner with us since we got here. That's all."

"That's why it's a celebration," Joey insisted and bent to scratch the side of one thin leg. "We haven't had a real dinner with him since Pearl Harbor almost." She frowned, deepening a slight crease between her eyebrows.

"He brought Chinese food the night we got here," Madeline corrected.

"That doesn't count, Mad. It was late and we'd been driving all day. Anyway," she said and looked up at balloons again, "they'll be good for my birthday next week, when I turn ten."

Joey's mother stepped to the doorway and looked up. "They're pretty, dearie," she said. "They cheer up that dark hall." She glanced back at the couch. "That looks better, don't you think, Mad? It gives the room a little color at least."

"Yeah, it's better." Madeline put her hands on her hips and sighed. "But there's not much you can do to improve this place." She stared at the black threads hanging down from the worn arms of the over-stuffed chair she had been sitting in. "This house is so old and dreary, it's depressing." She lifted her blonde pony tail from her neck and sighed again. "And what's more, I'm dying of the heat."

"It's a lot hotter in North Africa in the desert where the Allies are," Joey said.

"Oh, Joey. Stop it." Madeline flung herself down in the chair again and rolled her eyes upward. "You sound like Edward R. Murrow." Joey gazed at her sister. Her bare legs were splayed out and her damp hair was pushed back. She shouldn't be so smarty pants; she wouldn't be thirteen for months. Besides, the desert *was* hot in Africa and the soldiers *were* fighting hard.

Their father had called long distance from Washington, D.C. to Cambridge, Massachusetts a month ago to announce that he had found a house for them. "What's it like, Poppy?" Joey had asked, when it was her turn to talk.

"Well, it's kind of old and dark, honey," he'd admitted. "But houses are almost impossible to find in Washington right now, what with all the war workers and the military people pouring into the city."

"We'll fix it up," Joey's mother had told Joey and Madeline later. "It'll be our contribution to the war effort. Your father's been working so hard, living without us in that Washington hotel almost six months now, ever since we got into the war."

The war. Everybody talked about the war. On the news they reported Hitler's advances and where the Allied Armies were and they

kept repeating the same names: *Luftwaffe,* Solomons, RAF, and London. Two English girls, Janet and Antonia, had entered her fourth grade class in the middle of the year, sent over to escape the bombings. Joey felt weak when she imagined their homesickness.

She folded the stepladder and looked back at her mother. "Miss Abbott told our class that we might beat Hitler and the Japs, too, before Christmas," she reported. "Then we can go home to Cambridge."

"Dearie, you mustn't plan on that or...." Joey's mother pressed her fingers to her lips and left the sentence hanging. "Maybe I could put another madras spread over that," she said, looking back at the chair Madeline was sitting in.

Mum had been acting sort of uncertain for weeks, Joey thought, lonely without Poppy, of course, and worried about the war. But now things would be better; they would all be together again. "Poppy's going to be so surprised," she said with a sudden heartiness. "That couch looks almost new now and there's much more space, since we moved the big chest thing down to the basement."

"I think I'll take that picture down." Her mother pointed to a framed reproduction over the fireplace of a shepherdess standing in a bright pea-green field holding a lamb. "It's dreadful."

"You could put up the big picture of Newbury, Mum," Joey suggested. "The one with the birches and the view of the sea. It could go there, right over the mantelpiece. That would remind Poppy of home, of where we always are in summer anyway, and remind us, too."

"Maybe," her mother said. "Maybe." She turned. "I've got to get dinner started. Go fix your pigtails, Joey. They're coming loose, and Mad, why don't you put on a skirt? You, too, Joey. Let's all look nice when Poppy gets here." She pushed a strand of light hair back into her bun as she started into the dining room, then stopped to stare at a long gray stain on the dark mahogany table. "I wish I'd brought those place mats with the sea scenes," she murmured. "They would have been a little touch of home."

* * *

Joey's father arrived late. He draped his seersucker jacket over the banister post, admired the couch before he sat down on it, and took a gulp of his Old Fashioned. When they had settled at the dining room table and he had served the bean salad from the wooden bowl, he looked around at them and asked, "Now tell me about the trip down. What happened with the car?"

"The engine overheated," her mother began. "There was a lot of traffic and it was very hot and I thought—"

"This nice man helped us, Poppy," Joey interrupted. "He brought us a big can of water, but he said we had to wait until the radiator cooled before it was safe to pour the water in, so we sat in the weeds by the side of the road and had our picnic right there. Queenie snuffled down some animal holes and I picked a big bunch of Queen Anne's lace. See?" She pointed to the vase of shaggy, white flowers on the buffet behind them, its dark surface cluttered with fuzzy little blossoms.

Joey felt her father's smile touch her forehead and its warmth seemed to spill down over her shoulders. "Thank God it wasn't anything worse," he said, looking at Joey's mother. "If only you'd gotten here Saturday, the way we'd planned, then I could have helped you unpack and settle in." He leaned forward and his eyebrows pulled together. "But that trip up to the lab in New York was urgent."

"I know," her mother said. "But we've been all right. We've gotten a lot done." She cocked her head a moment. "It's funny you never got my telegram."

"Western Union's overloaded right now like everything else in wartime." Joey's father shook his head. "I should have told you to forget the expense and just call long distance."

"Well, the important thing is we're here," their mother said. "And now you're here with us." She smiled.

He picked up the serving spoon and scooped the last of the salad from the round bowl. "Any more of this? It's great."

Joey's mother took the bowl to the kitchen and when she settled

the refilled bowl in front of Joey's father, a smell of fresh mint and pepper rose. He scooped salad onto the plate Madeline held out and then onto his own. "Oh boy," he said. "Home cooking again at long last." He encompassed them all in his vigorous smile.

Joey turned to glance at her mother. This was what they wanted, wasn't it? This was why they had left Newbury and driven all those hot miles. When Poppy had come into the front hall an hour ago, he had seemed tired. He was wearing a gray-and-white striped seersucker jacket that Joey had never seen before and she had stared, feeling that he was a stranger almost. But now it was all right, she thought, smiling back at him; he was Poppy again.

She studied him as he sat at the head of the table in his white shirt sleeves. He was really a physics professor at Harvard, but when the war had started, he had to come to Washington to help win it. His thinning, brown hair was combed across on top in the old way and he had loosened his tie, which meant he was relaxing. He'd come home to Cambridge twice in the spring and once to Newbury last month, to help them move out there after school was over. But that was all. They hadn't been together really since Pearl Harbor.

"Good salad, Amanda," he said.

"It's mostly beans, I'm afraid," Joey's mother confessed. "Not much chicken. But they say beans will win the war." She gave a little laugh.

"Something better." Her father's voice was grim suddenly. There was a silence and Joey sorted quickly through a tumble of topics she might begin on: the rabbits in the victory garden, the story she had started, her friend Fay's broken arm. But none seemed quite right and it was a relief when her mother stood up suddenly and announced, "There's a surprise for dessert."

"A surprise? What kind of a surprise?" her father asked.

"Wait just a minute," their mother said, smiling. "You'll see." She took the salad bowl into the kitchen and Madeline stacked the plates and followed. Their mother came back carrying a pie on a wide, white platter. "It's cherry," she said. "Cherries from Newbury. I've been saving the sugar for weeks." She put it down in front of their

father and stood a moment twisting one hand within the other as she looked at him.

"Well, well," he said and picked up the pie server. "This *is* a surprise. It looks wonderful."

"We used sugar coupons from each of our War Ration Books, Poppy," Joey said. "And we picked off almost every cherry on the tree, and when we stopped for the night at the first place, the lady put them in her refrigerator, but at the second place, they were sort of grumpy. They said we could put them outside on the porch, but…." She wanted to go on and tell about the grumpy lady and her fussy, little dog, who barked at Queenie, but Madeline shook her head and she stopped.

Her father cut into the crust carefully and lifted the pieces onto the four dessert plates beside him. When everyone was served, he picked up his fork and took a bite. "Absolutely delicious," he said and took another. "By the way, did you talk to Ed?" He looked across the table at their mother. "Is he going to mow the meadow? What about the storm windows?"

"He's agreed to do both jobs," their mother said. "He'll drain the pipes, too. He's given us a good price before and he's responsible, you know."

"I hope so. I just wish to hell we'd gotten that roof repaired. But the cost. My God." He sighed and looked at Madeline. "How do you girls feel about sharing that front room upstairs?" he asked. "Is that going to be all right? Both of you in that big bed together? And just one desk? One of you could take that little room above the hall, you know. It's stuffy and the mattress is bad, but we could buy another one maybe."

"We're okay in the big room," Madeline said.

"How about the kitchen, Amanda?" Their father looked back at their mother. "I know you've worked like mad to get it clean, scrubbing all those shelves and that old refrigerator. But what about that soapstone sink?"

"That was there in 1890, I bet," Madeline said.

"Might have been." Their father gave a snort, then a tired smile. "This house is far from ideal. I know that. The furniture's awful and the whole place is dark. But it's a row house, after all. I just didn't have time to really look and—"

"It's convenient to your office, dear," their mother said. "It'll be fine. We'll make it cozy. You'll see."

"Are you building a big canon to blow up Hitler, Poppy?" Joey asked.

"What?" Her father turned to look at her and scowled.

"Like the one in *The Great Dictator?*" She paused. "I mean, is that what you're working so hard on all the time?"

"No," her father said and gave her mother a stern look. "No, it isn't."

"Then what are you doing?"

"I'm helping in the war effort." His words were toneless, but stern. "I'm helping to win the war."

"But...."

Her father's face looked closed and Joey turned to her mother, but she had pressed her lips together. Even Madeline was staring down at her plate. Joey looked at the dark smear of cherry juice on her white plate, ashamed that she had caused this dark mood to descend on the family.

There was a faint jingle of license tags and Joey ducked her head to peer underneath the table. "Are you all right, Queenie?"

"You're hot, aren't you, old girl?" her father said and pushed his chair back, so that he could look down at the dog. Joey breathed out in relief as they began to talk about Queenie's panting and whether her scratching was eczema or fleas. Her father's work was a subject she should not mention often, she realized, and only with great care.

An ambulance shrieked by outside, the sound tearing through the quiet of the summer evening. Their heads turned and they stared at the living room window as the violent noise receded into the shadowy streets.

"If I'd had more time to look," their father began again. "I might have found something with more light, a yard, and—"

"This isn't that bad, dear," their mother said. "Taking down those heavy old curtains made the living room lighter. I'm going to make some white ones soon to give us some privacy from the street."

"Those curtains were *so* dusty," Joey said. "Clouds rose up when Mum dropped them on the floor. I coughed for hours."

"Oh, Joey." Madeline rolled her eyes.

"Well, at least we've got a piano." Joey's father turned in his seat to look at the old upright in the alcove behind him. "Have you tried it out, Mad? It's pretty good and it's not really out of tune. I played the first line of "God Bless America" to the realtor when I signed for the house. I thought of singing it." He laughed. "But then I'm not Kate Smith."

"Poppy, let's sing after supper. Can we?" Joey leaned toward her father. "Please."

"Sure. That's a good idea, Joey." Her father looked around the table. "Anybody want more pie or shall we go sing?"

He sat down on the piano stool, as Joey and her mother and sister clustered behind him. "I'm too tall for this," he said. He stood again and bent over to twist the knob on the side of the stool, cranked the seat down, then sat again. "Ah. That's better." He ran his right hand over the keys, played a chord, and began a tune.

In Dublin's fair city
Where girls are so pretty,
I first set my eyes on sweet Molly Malone,

His tenor voice took the melody easily and he went on as Joey and Madeline joined in. *"Crying cockles and mussels! Alive, alive oh."* Joey heard her mother's light soprano voice carrying the tune. She herself would be an alto, her father said, but Madeline was a soprano, too.

They reached the last verse about Molly's death from a fever and

her ghost, who sang as she pushed her wheelbarrow. "That's kinda sad," their father said. "How about something cheerful?"

They moved to "Casey Jones" and then to a sea shanty. "'The Skye Boat Song,' Poppy. Please," Joey begged. They were singing the chorus about carrying the lad who was born to be king and was taken over the sea to Skye, when the ring of the phone pierced the sound of their joined voices.

"I'll get it." Their mother hurried to the telephone closet off the dining room, jerked on the light and picked up the receiver.

She came back to the piano, looking distraught, a piece of hair from her bun hanging down. "It's her," she said dropping the words into the silence that had begun when their father stopped playing. "Sarah. Your assistant."

"Okay." Their father got up from the piano stool quickly and started across the dining room to the telephone closet. Joey saw her mother clutch her arms around her and turn toward the uncurtained window in the living room.

"What? Tomorrow? Oh my God." Joey heard her father groan, then he pulled the door of the telephone closet shut and his voice was low and indistinct as he went on talking.

Their mother took the pie into the kitchen, returned and stacked the dessert dishes. Joey went to the table and collected the unused knives. "You two can get started on the dishes," her mother said. "I've put the kettle on for some more hot water."

"There was a cockroach in that sink last night," Madeline said.

"It won't hurt you," her mother snapped. She gathered the place mats and brushed some crumbs from the dark surface of the table into her cupped hand. There was a laugh, a brief, almost intimate sound from the telephone closet and Joey's mother straightened and wrapped her arms around her again.

"I've gotta go back to the office," their father said, reappearing in the dining room. "Another damn emergency." He swung one arm out to look at a large, new watch on his wrist that Joey had not noticed before.

"But, Jack." Joey heard her mother's voice rise. "You said you'd stay home this one evening at least. You promised."

"I know, Amanda. But I can't. It's an emergency. Jim Conant's in town. He wants a report on the OSRD tomorrow. I've gotta get over there and put it together tonight." He glanced at Madeline, then Joey, as if expecting some comment, then he moved into the front hall and lifted his seersucker jacket from the banister post. "I should be back by midnight," he told Joey's mother.

"As late as that?" Her voice trembled.

"I'm sorry, honey. I really am. But I've gotta get down there right now." He put one hand on her shoulder. "I'll be back," he said and cupped her chin in his hand. Joey and Madeline stood watching in the arched doorway between the living room and the hall. "This happens a lot, I'm afraid," their father said. "I've been going back to the office four or five nights a week for the past month." He pushed his arm through the sleeve of his jacket, but as he did his hand bumped one of the balloons hanging down from the overhead lamp. He glanced up and smiled. "These are great. Did you fix them, Mad?"

"No," Madeline said. "Joey did."

"It was a great celebration—that salad, the cherry pie, and those." He looked up at the balloons again. "At least we had time for dinner and some singing."

A loud roar came from a bus outside. Their father enclosed the large brass doorknob in his hand and pulled the front door open. There was a window in the door and its red and orange panes of stained glass rattled as he opened it. Joey and Madeline moved closer, so that for a moment the family stood together looking out into the summer night. The lighted bus pulled over to the stop halfway down the block and stood there making the shaking roar that had become familiar to Joey in the past three days. Its door folded back and she saw two sailors emerge, their white uniforms iridescent for a moment in the glow of the street light.

A large poster on the side of the bus showed a talking mouth with big red lips in the lower corner and a Hitler face with a huge listening

ear in the upper one. The words above it read, "Loose Lips Sink Ships." That's why Poppy couldn't talk about his work, Joey realized. It had to be a secret from Hitler.

The bus pulled into the street again, then paused for the traffic light just outside the bay window in the living room, where it stood exuding a stream of smelly blue-gray smoke. Then the red eye of the light went green and the bus moved on. "Has that noise kept you awake at night?" their father asked and looked back at their mother as he shut the door. "I warned you we were on a bus route."

"Oh, no. We've all slept hard," their mother said and Joey noticed with relief that her voice had returned to its normal cheer. "The real problem is that smelly exhaust. It coats everything—window sills and furniture. I'll be vacuuming up that dirty film until the day we beat Hitler," she said and laughed.

"Oh boy. Well, we can live with it." Their father unsnapped his briefcase and stuffed a folded *New York Times* inside, then straightened and looked at them again. "I'm sorry I've gotta go. I wish I'd had more time to help you."

"Don't worry, dear. You're doing the important work and now we're here to back you up." Their mother smiled and touched his cheek with her hand. "We're together again at last."

Their father caught her hand and kissed it. "Oh God, it's been so long." He glanced at Joey and Madeline, who were leaning on the banister. "It's so good you're all here and...." He hesitated, then plucked his hat from the hook on the wall and slapped it on his head. "I'll see you in the morning. Okay? Don't wait up for me, Amanda. Go to bed. You must be worn out with all that unpacking." He put one hand on top of Joey's head.

"Poppy." She tipped her head to look up at him, feeling his hand slide back. "Miss Abbott told our fourth grade that the war might be over soon and when it is we can go home to Cambridge. Can't we? Maybe we can even have Thanksgiving at Newbury this year." She saw her father's face tighten and knew at once that what she had said was wrong. Was he cross? Would he correct her?

"Don't count on that, Jo." His voice had a gravelly sound. "This war could go on a long time." He lowered his briefcase to the hall table with a thud and stared at their faces. "The fact is Hitler could win this thing. Not many people realize that, but it's true." He squinted a moment as though regretting his statement. "I don't mean to frighten you," he continued, speaking slowly, looking at his daughters. "We're not going to let that happen. We've got to win and we will, because if Hitler won...." He hesitated. "If Hitler won, it would be the end of civilization, as we know it."

Joey stared. Poppy sometimes made serious announcements like that. She just wished he would stay, so they could go on singing. She watched him pick up the briefcase and look at them all again. "Right now we have to put our personal lives on hold to get this job done. Understand?"

"Of course, dear," their mother said. "Of course. I know that and the girls do, too." She glanced over at them, then touched his sleeve. "Try not to be too late."

"All right." He opened the front door with a jerk and the stained glass panes made their rattling noise. "See you in the morning," he said and pulled the door shut behind him.

"Come on now." Their mother turned to Joey and Madeline. "We've got dishes to do."

"Mum," Joey asked. "Who's Sarah?"

"What?" Her mother's eyes had a frantic look. "She's...she's just someone who helps your father with his work. That's all." She stood a moment staring at the door. "Come on," she said and turned. "The dishes."

Joey glanced up at the balloons, which looked shriveled suddenly, then she followed her mother and her sister into the kitchen.

Chapter 2

THE hot summer days in Washington seemed long and boring to Madeline and Joey. They took Queenie to the dusty little park and swam in the public pool, but they had no friends in the neighborhood and often lay on their fourposter bed listening to soap operas on the radio: "Guiding Light," "Our Gal Sunday," "Backstage Wife" and "Life Can Be Beautiful." During their first week in the house, they looked forward to their father's homecoming each night, but he was usually too tired to talk much or he was so late that they were asleep when he returned. Their mother took them to the public library; then she thought up the porch project and that filled a whole week.

Joey knelt on the newspapers that were spread out on the porch floor and moved her paint brush back and forth across the scabby baseboard, slowly changing its color from a dark, crumbling gray to a wrinkled green. "This is going to look so wonderful," she told Madeline, who was painting the baseboard on the opposite side of the porch. Joey sat back on her heels and surveyed the strip of board she had painted. "Poppy's going to be so surprised. He doesn't even know we're doing this." She twisted to look over at her sister, who lay propped on one elbow, painting evenly. "He doesn't, you know. Mum promised she wouldn't tell him."

"He doesn't have time to know or care much either," Madeline said.

"You know what I bet?" Joey said. She waited, then continued since her sister did not ask. "I bet his office is surrounded by G-men, so the Nazis can't figure out what he's doing inside."

"Shush," Madeline said. "We're not supposed to talk about that." She looked over at her sister. "Hey, watch it, Joey. Look out."

A fat dollop of paint had dropped on the concrete floor from the brush Joey was holding. Another plopped down. "Oooh, heck." Joey laid the brush across the top of the open paint can, snatched some sheets of newspaper from the pile by the door, and scrubbed at the paint spills. "I'll get the rest with turpentine later," she said and sat back on her heels again. "Spills on the floor don't matter really. That straw rug Mum found in the basement will cover them." She looked down the length of the baseboard. "We're getting there, Mad. Look. It's almost done."

"We've still got to do the frame of the glider," Madeline said.

Joey looked up at the rusty glider, then dipped her brush carefully into the paint. If she lay on her side and stroked, the way Madeline was doing, she might go faster, and with the newspapers pulled up close, she wouldn't spill or not as much. Her knees were green with paint smears, she noticed, but they would come off later. She settled on her side. Stroke, then stroke, then stroke again. Her arms and neck were damp with heat, but the concrete floor felt cool. She held her bottom lip between her teeth, trying to keep the strokes even. That was the way Madeline was doing it and her side looked smoother.

After a while she glanced back at her sister. "This is going to be like a whole new room for the house. Mum and Poppy can have their drinks out here before supper."

"On that dirty old glider over there?"

"Well, Mum beat the pillow with a broom, you know, and I bet we can get some of those stains off with Clorox." She put the paint brush in the can, sat up, and looked around her once more. "This'll be so cheery and it's all outside. Like Newbury almost."

"Newbury?" Madeline's voice had an angry curl. She made a noise in her throat, then went on painting.

"Well, I didn't mean Newbury exactly, but airy and nice. It'll be a relief to Poppy after the dreary old house inside."

"The bus noises are even louder out here and we won't have any protection from the fumes at all," Madeline said. "Besides who wants to come all the way upstairs and out here anyway?"

"But Mad...," Joey started. Another spot of paint dripped down on the concrete as she lifted her brush and she rubbed at it surreptitiously with the turpentine rag, then went on painting. She painted faster, as she approached the corner, covering the nailed joints.

"At least it's been something to do," Madeline said. "What else is there? There's nowhere good to swim and Mum doesn't like us listening to soap operas all day."

"She said we could listen to one though," Joey corrected.

"Two. Tomorrow I'm going to listen to 'Guiding Light' and 'Joyce Jordan, Girl Interne' no matter what."

"But, Mad...." If Madeline abandoned the painting, Joey would have to paint that rusty glider frame by herself. "When we bring out the rug and the rest of the furniture," she began, "it might make Poppy come home more, not spend so much time in the office." She smeared some perspiration from her upper lip with her free hand. Oh boy. She'd probably gotten green on her face.

"He keeps going back to the office and coming home late," she went on. "We never see him, except at breakfast and then he's always in a rush, working on that secret whatever-it-is. I hate it being so secret all the time."

"Listen, Joey. There're spies everywhere in wartime. You know that. Pop can't even talk to Mum and...." She paused. "Oh, Joey. You've ruined your new sneakers. That paint's not going to come off."

Joey stared at a series of green drips on the top of one of her navy blue sneakers. "It might," she said. "With turpentine." There was paint on the white lacing, too, and several drips on the other sneaker;

even the white border on the outside was smudged. She pulled her breath in slowly. What if the paint wouldn't come off?

"I don't think Mum likes Sarah," she said.

Madeline was silent for a moment. "We're not supposed to know about that," she said.

"About what?" Joey asked and looked back at Madeline.

"Nothing."

Joey started to ask again, then she looked back at her sneakers. Maybe if she rubbed hard with the turpentine rag right now.... Mum might be sad about Sarah, but she would be mad if she saw Joey's sneakers.

* * *

Joey and Madeline were swinging slowly in the glider the next evening, reading the funnies as they waited for their father. They had spread a towel over the damp cushion of the glider, but the sharp smell of Clorox and wet canvas rose around them, covering the familiar fumes of paint. Joey stretched out her scrubbed legs and gave a little kick to make the glider move more quickly. Her shiny black patent leather shoes and white ankle socks looked strange after her paint-stained sneakers. Madeline was wearing her patent leather shoes, too, which she hated, but she had on her broomstick skirt, while Joey had to wear a dress.

"Want this?" Madeline asked and held out a sheet of the funny paper.

"Uh uh," Joey said. "I've already read that." She leaned back to gaze around the porch. The straw rug made a clean island of tan around the glider and the one wicker chair. They had brought up the radio, which sat on a wooden crate they had painted green. Joey looked at it critically; there was room enough in front of the radio for drinks, she thought. "It looks so good," she said. "I just wish the glider didn't smell. We could have sprayed some of Mum's cologne around, but...." She stopped. "Listen. Did you hear the door?" The sound of a cough echoed faintly. "It's him. He's home." Joey leapt from the glider and started toward the door. "Come on, Mad."

"What's the rush?" Madeline looked down at her Orphan Annie watch. "We've waited a whole hour almost. Why rush now?" But she got up from the glider and smoothed her skirt.

Joey ran through the back room and down the stairs to the front hall, where she saw her father slap his briefcase on the table and bang the folded *New York Times* on top. "Poppy, we've got a surprise for you," she shouted and glanced at her mother who had come into the hall.

"That's good, Jo," her father said.

"It's a real surprise, Poppy." She stood watching, as he pulled off his seersucker jacket and hung it over the banister post. He coughed and loosened his tie, pulled it out of his white collar and draped it over the jacket.

"You've heard the news?" he asked, turning to Joey's mother. "I was afraid this might happen. Rommel. Goddamn him. That desert fox." He frowned and followed her into the kitchen.

Joey watched her father take the whiskey bottle from the kitchen cabinet and pour an inch of the amber liquor into the two glasses that sat waiting on a tray. He flung back the door of the freezer compartment, jerked out the ice tray, banged the cubes into the sink, then picked up four and dropped two into each glass. "Want water?" Joey's mother shook her head. "Everybody knew this North African thing would be tough," he said. "But this. Oh my God."

The news was bad tonight, Joey realized, as she stared at her parents. Then she remembered the porch and felt excitement rush through her in a hot flood. "Poppy, we've got something to show you," she started. "You have to come upstairs. Right away."

"In a minute, Jo." He took a gulp from his glass and looked back at Joey's mother. "It's a total rout. A god-awful defeat."

"Yes. It sounds terrible."

Her father took another swallow of whiskey and let his breath out noisily. "The Brits can't hold out now. Not for long anyway. Oh, God." He shook his head.

"Terrible, terrible." Joey's mother glanced at Madeline, who was

standing in the doorway, then at Joey. "The girls have something to show you, dear." She lifted the tray with her glass and a plate of cheese and crackers. "They've been waiting a long time to show you something they've done."

"Okay. But first I've gotta hear the news."

"The radio's up there on the porch," she said.

"We brought it up for you, Poppy, " Joey told him. "We've been waiting for hours."

"All right, all right. I'm coming."

Joey heard the impatience in his voice as she led the way up the stairs, but she was sure that it would disappear just as soon as he saw what they had done.

"Look, Poppy. Surprise. See?" She stepped down onto the concrete floor, leaving room for him to stand in the doorway and look out. "We dragged out all those piles of yucky old newspapers in the corner and we scrubbed the screens and we washed the glider, too. It was *so* dirty. Mum had to beat it with a broom and this huge spider crawled out. Then…." She clapped her hands together. "Then we began painting and we painted the whole thing. That was the day before yesterday. We began days ago. Guess how many? Guess how long we've worked?" Joey looked back at her father expectantly.

"I don't know, Jo." He stepped down onto the concrete surface of the porch. "Where's the radio? Ah," he said, seeing it on the wooden crate beside the glider. He let himself down on the canvas cushion with its towel covering, and his weight made the glider rock forward several inches, then back again. "We can catch the end of Mutual News at least." He reached toward the radio, then paused and glanced around him. "It's a good job, girls," he said and stared at the freshly painted baseboard, the crate, and up at the glider frame. "Big job. Good for you." He turned the knob on the radio and waited. "Hey. This thing isn't plugged in." He leaned over and peered down at the loose cord lying under the glider. His frown deepened and he turned to look at Joey. "What's the point of bringing up the radio, if you don't plug it in?"

"There's an extension cord in that cupboard by the back door," their mother said. She put down her drink and placed both hands on the arms of the wicker chair, preparing to stand. "I'll get it. I saw it this morning." But Madeline, who was kneeling on the straw rug beside Joey, jumped up and leapt over the threshold. They heard the sound of her feet on the stairs, a pause, the quick sounds of her below them in the kitchen, then she was back. She stooped down, pushed the end of the extension cord into the outlet on the wall, fastened the two cords together, then knelt in front of the radio and twisted the button to ON. The dot above the ON turned orange and Joey could see through the round holes in the board at the back that the tubes had begun to glow.

"Good girl," her father said and twisted the button, making the needle move to the center of the dial.

"*Prudential Insurance brings you…Mutual Broadcasting System and.…*" The phrases issuing from the brown, wooden box with it's fabric front shaped in an arch, were broken by static. "*…brings you.…*" There was more static as their mother handed their father a cracker spread with orange cheese. "*Prudential. The insurance you can trust.*" The voice shook and was obscured by static again. Their father leaned down and turned the tuning knob. "*Firm as the rock of Gibraltar,*" the voice said. "*Now our correspondent in Cairo.*" The static came in loud, explosive pops.

"Damn." Their father leaned forward and turned the volume button. A guttural voice emerged, "*…forced the British troops to retreat,*" the voice was saying. More static, then the voice broke through again. "*Libyan port of Tobruk.…*" Phrases came in bursts. "*In this last-ditch battle for Egypt.…*" More static. "*…heavy fighting on the desert side of…twenty-five thousand men captured, vast dumps of oil and munitions.*"

"Oh, God," their father muttered and scowled at the newly painted baseboard. "Twenty-five thousand men. My God."

"Poppy," Joey began and leaned forward.

"*…Panzer tanks destroyed an unknown quantity of.…*" Static broke in again.

"Poppy, we did a miracle out here. We really did. We did so much work."

"Shush, Joey. Shush."

"But Poppy...." Joey's voice broke. Her father glanced toward her and raised one hand.

"...*desert is strewn with mines.*"

Joey felt the braid of the rug press into her flesh as she raised up on her knees. "Poppy," she paused. It wasn't a good time, but they had done so much. "Poppy," she said again.

Another voice was talking now. "*The Tobruk defeat puts the Allies in a precarious position in Northern Africa and makes the defense of....*"

"We painted the side. See? And we...."

"For God's sake, Joey. Can't you see we're listening?" Her father glanced from the radio to Joey, kneeling in front of him, and frowned. "Shut up," he said. "Don't you realize we're at war?"

Joey felt hot blood rush through her as she jumped to her feet. Her cheek was smarting, as though his hand had smacked it. "I know we're at war," she shouted. "I know that. But you shouldn't...shouldn't—" she gulped. "You shouldn't be spending so much time with Sarah."

"What?"

Joey wasn't sure whether Poppy or maybe Mum had said "What?" but she didn't wait to find out. She ran through the back room, down the stairs and into the front hall and heard the rattle of the stained glass panes as she slammed the front door behind her.

She ran up to the corner and down the street into the alley behind the row of houses, past the battered back doors leading into their neighbors' thin strips of yard, past bunches of trash cans waiting to be emptied and a rusty old cot tipped on its side, its springs hanging down. She plunged across the street into the alley beyond and stopped in the third block finally and let herself down on a broken planter. Her heart was pounding and she felt her chest going in and out with her heavy pants. She let her head hang down, surprised to see her patent leather shoes again.

As her panting began to quiet, she drew her feet in and stared down at a group of black ants crawling over an apple core lying in the weeds close by. They seemed intent on their direction. Were they pulling off bits of the apple to eat, Joey wondered, or to take home?

The sound of hard-soled shoes came toward her across the rough cement surface of the alley. It was Poppy, Joey thought, but she kept her head down and continued to watch the ants. A large black one, who looked like the leader, lifted his front legs quickly, as he moved down the side of the apple core and into the dirt beside it. Poppy was standing right there in the alley. She could feel him staring at her, heard him take a step closer, then felt his presence burn her shoulders. But she would not look up, she resolved. No. She hated him.

"Jo?"

She waited, watching the ant leader. Her arms were clutched around her knees and she could feel her fingernails pinching the skin of her calves.

"Jo?" She lifted her head. "I'm sorry, Jo. I didn't mean what I said. I...." She heard him hesitate. "I was worried about the war news."

Joey stared down at the ants. She was going to stay here. She wasn't going home.

"Come on, sweetheart," he said and waited.

Joey felt her breath come out in a long sobbing sigh. It didn't matter about what Poppy had said; it didn't matter about the porch either. She stood and he held out his hand to her as they started back along the alley, but she pretended not to notice it. She walked behind him, staring down at the broken pavement, saying nothing.

<p style="text-align:center">* * *</p>

A scream tore through the quiet of the nighttime house. Joey sat up in the double bed, clutched her knees to her chest and listened. Had it come from the kitchen? Was it Mum? Was it really a scream? She looked down at Madeline, who groaned and flopped over on her side.

Joey heard the basement door open and then the noise of her mother's slippered feet going down the stairs. There was an interval of quiet and Joey pulled her knees closer as she sat listening. She heard the basement door close, then the creak of the kitchen door being pulled shut. Mum didn't want to wake them, but what had happened? The house was quiet again. No, there was a sound, a pounding noise, *bang, bang,* then a long pause, then a bang again. Was it a hammer? What could Mum be hammering in the night?

Joey stuck her bare feet out and felt on the rug for her slippers. One foot brushed against Fluffy, her stuffed dog; she must have pushed him out of bed in the night. She picked him up and laid him on her pillow, put on her slippers, then tiptoed across the room in the glow of the street light outside and down the stairs. Mum used to fuss about her getting up at night, but it was all right; Dr. Jackson said some children were just light sleepers. Besides, Mum might need her help right now.

Joey paused at the closed kitchen door and stared a moment at the rubbed place on the edge where other hands had pressed it. She pushed it back and looked in. Her mother stood near the sink in her blue bathrobe. Her arm was raised and she was clutching a hammer in one hand and holding a nail upright in the other, as she pressed a piece of plywood against the wall with her shoulder. She brought the hammer down on the nail, *bang,* then *bang* again as Joey stared. She was covering an old hole in the plaster that Joey had peered into when she was drying dishes. But why cover it now? It was the middle of the night.

A handful of nails lay scattered on the kitchen table near an outspread newspaper. Beside it, a string of smoke was rising from her mother's cigarette in the ashtray. She had been waiting up for Poppy, who was late again.

Her mother reached for another nail and raised the hammer. She brought it down uncertainly, barely missing her thumb. *Bang.* "What are you doing, Mum?" But her mother went on hammering. Joey moved to the sink and pulled in her breath, meaning to shout her

question, but her mother's eyes were slanted with determination and her jaw was tight as she lowered the hammer again.

"You damned rat," Mum muttered. "Damn you." She turned and reached for another nail.

A rat? Was there a rat in that hole? "Oh, no." Joey heard her shriek echo in the kitchen.

Her mother looked back at her over her shoulder, the hammer raised. "Joey," she said and let her hand with the hammer drop down. "It's nothing to be scared about, dearie. It's just a little mouse. You can help. Hand me one of those nails on the table."

Joey handed her mother a nail and watched as she hammered the other end of the board into place. It wasn't a mouse. Mum wouldn't have covered over that hole just for a mouse. There were mice at Newbury who were practically friends.

Long cracks in the plaster were raying out from the holes the nails had made, but her mother ignored them and went on hammering down the other end of the board. Joey glanced at the basement door, which stood slightly open. "What if a rat came up from the basement and ran around the kitchen?" she started, but stopped at the sight of her mother's pale angry face. Joey handed over another nail without speaking and then another as her mother finished securing the board to the wall beside the sink.

In the sudden quiet, Joey could hear the ticking of the clock above the stove, which said ten after two. When was Poppy coming? "Mum, if there's a rat in the wall, its wife might be in the basement. They could come up into the living room, even upstairs." Joey's voice moved upward toward another shriek.

Her mother picked up the cigarette still burning in the ashtray on the kitchen table. "It was just a little mouse." She looked down at the checkered oilcloth on the table, blew out some smoke slowly, then raised her eyes to Joey and gave her a serious look. "You're right," she said. "It *was* a rat." She put the cigarette down again and wrapped her arms around her in her chenille bathrobe. "I'm going to set traps." Her voice was fierce. "No. I'm going to call an

exterminator. Never mind the expense. I'm going to call first thing in the morning."

"But Mum...." Joey saw her mother's face change, softening suddenly from its sternness into its familiar mother look as she took in Joey's presence again.

"How about some hot milk?" she asked. "I'll put in some of that honey we saved." She moved across the kitchen, shut the basement door firmly, and turned to the refrigerator.

Joey clutched her arms around her. Suppose a rat was hunched down in that dark soapstone sink right now or staring at them from the glass-fronted cupboard. "Mum," she began again, and her voice came out in a sob.

"Don't worry, dearie," her mother said. "The exterminator will take care of it tomorrow." She sighed and pushed back a loop of hair with one hand. Joey looked up at her. Mum was tired, she thought. Her bun was messy and there was a thread dripping down from the cuff of her bathrobe.

Her mother put the bottle of milk down on the table and hugged Joey close. "We have to be brave," she said. "It's the war. I know it's not easy, this house, Poppy working so hard. But we have to win the war and we will."

Joey pressed her face into the comforting cloth of her mother's bathrobe with its powdery smell. Right now she didn't want to be brave or talk about winning; she just wanted everything to go back the way it was before Hitler and this war.

* * *

Madeline and Joey had been to see *Mrs. Miniver* at the movie theater on Wisconsin Avenue and had walked all the way home.

"It's wonderful, Mum," Madeline said flopping down into a chair at the kitchen table. "You've got to see it. Greer Garson is so beautiful and I've got a crush on Reginald Owen. He plays the son, you know, who joins the RAF and then he falls in love with Teresa Wright. He's so handsome and he's a good actor, too."

Their mother took a pitcher of lemonade from the refrigerator,

poured three glasses, and put them on the table. "And what did you think, Joey? Was it worth the long walk?" she asked as she sat down.

"It showed Dunkirk," Joey said. "The fleet of little boats. All those soldiers trying to get away. Walter Pidgeon was worn out, taking them back to England and coming back to Dunkirk to pick up more. He and the other men worked for five days without stopping." She clutched her arms around her and looked at her mother. "Is it true, Mum? All those soldiers trapped on that beach? Did that really happen?"

"Yes, it did," their mother said. She picked up her glass of lemonade, then put it down. "It was a terrible defeat, but it won't happen again. We won't let it." Joey looked down at the table and felt her lips tremble.

"Greer Garson got trapped in the kitchen with this German pilot," Madeline said "He had a gun and—"

"And he was so hungry," Joey broke in. "He took the milk and drank it right out of the bottle."

"She's beautiful, Mum," Madeline went on. "You have to see her."

"But the boats," Joey began again. "Those men on the beach. They were so tired. The men in the boats kept going back. Walter Pidgeon could have been killed." Joey's voice shook and she realized she was about to cry.

Her mother reached out and put a hand on her shoulder. "That must have been a frightening scene. It can be very scary to see scenes of war like that."

"But it wasn't the only thing, Mum," Joey went on. "The whole family was in this air raid shelter. The mother and father and the two children and the bombs began and one of those whistling ones came really close and I knew it must have hit the house and almost them. And then, then…" Joey continued, "Greer Garson was driving home from the flower show and Teresa Wright got hit and she died." Joey's face puckered and she began to cry.

"Dearie, dearie." Her mother got up from the table and put an arm around her. "It's a movie, dearie. A movie."

"But it's true," Joey said. "In England, it's true."

"Well, it is in part," her mother said. "But our forces are helping now and we're going to bring the war to an end."

"I know." Joey hunched over as the tears ran down her face. "I know. I just wish it hadn't started."

"Yes, dearie. I do, too. We all wish that, but now we're going to work together to bring it to an end."

"Thank goodness the English have Churchill," Madeline said.

"They have Churchill and they have great courage and now at last they have our help," their mother said, straightening, "and together we will defeat Hitler soon and help them rebuild what they've lost."

Joey mopped her nose with the back of her hand and stared up at her mother. Her words sounded like something a radio announcer might say or even President Roosevelt; they were not Mum's words. "But Teresa Wright," she began again. "She...people like her, I mean, have gotten killed. We can't do anything about that."

"No, dearie," her mother said and squeezed her shoulders again. "You're right." She sank down in her chair and looked around the kitchen. "There are all kinds of losses in this war that will never be recovered," she said and let out a long sigh.

* * *

In August, Joey's mother took Joey and Madeline to visit their new schools. In three weeks, Joey would go into the fifth grade at Radley Elementary and just two blocks away was McNeil Junior High, where Madeline would be in seventh grade, a "freshman," as they were called in the new school. They shook hands with the principal at Joey's school and met the counselor at McNeil, where Madeline had to take tests. They could go by bus in the morning, Mum said, and walk home together in the afternoon or take the bus when it rained.

"It's going to be very different from Green Fields," their mother said, referring to the private school they had gone to in Cambridge. "But it's going to be an adventure. Besides," she added, returning to an explanation that had grown boringly familiar, Joey felt, "we all

have to make sacrifices. That's what war involves. Just think of the children in the London tube stations, waiting through the nights during the bombing raids."

Joey walked all the way back to the school the next morning on the pretext of exercising Queenie. She stood in the weedy parking strip with the dog on her leash and stared up at the brick building with its rows of dusty windows. Wide cement stairs led up to the front door, which was scarred with dark scrape marks. A deflated basketball lay on its side on the top step and a padlock and chain hung from the steel doorknob, since no one was there on this Saturday morning in August. To the left was the graveled playground enclosed by a wire fence. Inside four swings hung motionless. The surface of a metal slide gleamed in the morning sun, and as Joey stared, a starling lit on the railing at the top, then flew off. Joey sighed and turned to go home. The school was scary, but bombing raids in London were worse.

Queenie stopped at a bus sign and Joey picked up a fan-shaped ginkgo leaf and turned it in her hand as she waited. You would never see leaves like this in Cambridge, she thought. Oak leaves and maples, but not funny leaves like this.

The dog pulled at the leash and Joey looked down. Queenie dragged her hind end along the wet ground a moment, then scrabbled in the dirt with her paws. "Oh, yuck, Queenie," Joey said, glancing at a gooey pile of excrement. "You've got diarrhea again. Your behind's all icky. Mum'll have to give you some more medicine, and your feet are muddy, too. Honestly."

Queenie gave her tail a questioning wag as she looked up. "Come on. Let's go home," Joey said. They ran down the last half of the block and rushed up the iron steps to the front door.

Joey paused in the hall a moment and looked into the living room. Her mother was sitting on the rug with the white curtains she was making billowing around her in soft translucent mounds. "You look like you're in the clouds, Mum," Joey said and bent to unclasp Queenie's leash.

The dog shook herself, then bounded into the living room. "Oh no. Queenie, Queenie," her mother shouted. "Joey, get her. Quick. Catch her. She'll ruin the curtains. Oh, that mud, that.... Quick."

Joey flung herself forward, but the dog darted back into the fluffy mound. Joey caught her, lifted her squirming body. As she carried her into the kitchen, the dog's smell made Joey feel nauseated. She should have kept her on the leash and told Mum about the diarrhea right away, she thought, as she closed the swinging door. Were the curtains wrecked? Was Mum really mad?

Her mother was holding one of the curtains by its unhemmed edge, shaking it to see the damage. The white material was streaked with brown and there was a tear at the top.

"Can you fix it, Mum? Can you?"

"I don't know," her mother said. She leaned over to pull up another, shaking it, then holding it out straight. "I can wash this one and that, I think," she said, her back to Joey. "But.... Oh, Lord." She spread out another. "This one's torn, too, and the smell." She turned. "Honestly, Joey. She's sick again and her paws are all muddy. You could see perfectly well what I was doing. Why can't you use your head?"

"I'm sorry." Tears prickled in Joey's eyes.

"You should be. I've been working on these curtains for the last two days and I still haven't got them right." Joey heard her mother's voice shake.

"I can help, Mum. I can wash the dirty ones and...."

Her mother let the curtain she was holding drop to the rug and turned to the window.

"Oh Lord," she said again. Joey heard the familiar organ prelude to "Amanda of Honeymoon Hill" begin upstairs. *"She's lovely. She's engaged. She uses Ponds,"* a liquid radio voice was saying and Joey thought with envy of Madeline lying on their bed listening. But she and Queenie had caused this mess, she told herself, and looked down at the rumpled curtains; there must be something she could do. She moved closer to her mother.

"I could go buy some Rinso, Mum, and wash them, " she began.

Her mother stooped, bundled the curtains together and clutched the large white ball against her chest. "It's not just the curtains." She sighed and Joey felt her mother's breath touch the top of her head a moment. "It's not just that."

Mum was worrying about the war, Joey thought, and glanced out into the hall. For a moment, she felt that she was staring at a huge black curtain with pictures of planes dropping bombs and soldiers shooting. Suddenly it seemed to her that everything else, dirty curtains and scary-looking schools with gravel playgrounds, made up only a tiny square way down at the bottom.

Chapter 3

THE long summer was finally over and Joey and Madeline were
starting school. "Stop it, Joey," Madeline said as they stood wait-
ing for the bus together. "Can't you stop it? The bus'll be here in a
minute."

"I'm try—" A hiccup truncated Joey's sentence. She saw Made-
line roll her eyes upward and stare at the tall, metal bus sign beside
them, 4D in black letters, and underneath, the hours when it ran.
She had gotten hiccups before when she was scared, once at Dr.
Murphy's when she had to have a tetanus shot and once at Newbury,
when she couldn't get the jib up in the boat. But this was the first
day of school and what would happen if the other kids saw her hic-
cupping?

"Hold your breath." As Madeline bent toward Joey, her blonde
hair fell forward over one shoulder. She looked pretty, Joey realized,
and watched her push it back. Everybody would like Madeline with
her long blonde hair, but Joey had pigtails and Mum had made her
wear her Buster Brown lace-up shoes. She stuck one arm straight
up in the air and went on holding her breath hard. Madeline was
wearing her green-and-white plaid skirt and her green sweater,
which matched. Joey's red and blue skirt was all right, but her blue
sweater was old and navy was a stupid color. She let her arm down

and her breath came out in a noisy rush. She waited. Another hiccup. "Darn it." She pulled in her breath again, raised her arm, and turned away from Madeline to look down the block at their house near the corner. When would she ever see it again, she wondered? How could she possibly live through this first day?

The bus pulled in beside the curb with a roaring noise. "Come on," Madeline said as the doors folded back. Joey let her breath out and mounted the steps behind her sister, clutching her token in one hand, her new red notebook in the other. The hiccups seemed to be gone, she realized, as she mounted the high black step with its corrugated rubber covering. That was one good thing at least.

<p align="center">* * *</p>

Joey started up the cement path in front of Radley Elementary School behind some girls, who were talking together. One wore a yellow sweater and had long black braids. Joey thought of asking her for directions to room 201, the number of the homeroom to which she'd been assigned. But as they reached the heavy, swinging door, some boys pushed in around them, shouting, and when Joey got into the hall, the girls were well ahead of her, moving along in the crowd, obviously sure of where they were going.

Joey kept whispering the number of the room to herself, "201, 201," as she made her way up the gray staircase, clutching her notebook. Room 201 was the first in a line of classrooms, thank goodness. A pudgy woman in a white blouse and a blue skirt that was smudged with chalk was standing by the door. Her hair was pulled back into a loose bun that left gray wisps hanging over her ears. "This is it. Two-oh-one, and I'm Mrs. Martin, your homeroom teacher," she said when Joey held out the paper with her homeroom number. The teacher pointed to a desk in the front row as Joey stared at a mole beside her mouth. Joey would have preferred to be a few rows back, but she settled her notebook on the scarred desktop and sat down. Other students filtered in. Two girls in plaid skirts were talking busily to each other, and a short girl in a grayish-pink sweater snuck in alone and took a seat in back.

Mrs. Martin stood at her desk in front of the class to call the roll. "There are twenty-nine students in this class," she announced, and Joey thought of her class at Green Fields; it had been only twelve.

"Please stand when I call your name," Mrs. Martin said. "I want to see each student and I want everybody to get to know each other."

The room felt crowded and tense with all the seats full. A heavy girl with fuzzy black hair in the row behind Joey was whispering to a girl across the aisle, and there were four boys sitting way in back at a long temporary desk made of a sheet of plywood and two saw-horses. They talked and laughed behind their hands, ignoring Mrs. Martin, who had asked for quiet as she began reading the names. "Mary Appledore, Carl Anzberg."

"Hi. I'm Dodo," the girl across the aisle with short dark pigtails whispered.

"Oh." Joey stared. "I'm Joey."

"Dorothy Beatley," Mrs. Martin said. The girl named Dodo stood, gave an embarrassed smile and sat down again. When a big boy called Ben-something rose up in back, the boys clapped and shouted until Mrs. Martin had to call for quiet again. There were two names beginning with H; the L's were getting close. When Mrs. Martin said "Josephine Lindsten," Joey stood, feeling hot, smiled quickly, and sat down again.

At recess, Joey sat on the concrete steps beside Dodo and tried to make herself small. Balls bounced near them on the gravelly play-ground and boys shouted and ran past. "The whole school is much more crowded than last year," Dodo said. "It's all the war workers coming to Washington. That's why they had to put up that tempo-rary desk in back."

Mum had been right when she said Radley would be different from Green Fields, which had only two hundred students and dif-ferent buildings for each class, plus one for art and one for music. At Radley, the big three-story brick building with its high windows and dirty staircases was crammed with five hundred students, Dodo said. Maybe more.

When the bell finally rang for the end of the first day, Dodo stood and started toward the door of the classroom with several other friends. But Joey paused at the top of the stairs and stared down at the corridor below. It was crowded with kids, girls banging open their locker doors, boys at the drinking fountain, flicking water at each other, boys and girls swarming toward the front door. Two boys were throwing a baseball back and forth between them as they pushed past Joey down the stairs. Another boy yelled and charged after them. Even after her wait, the staircase was so crowded Joey couldn't get close to the railing. She walked toward McNeil Junior High to meet Madeline, but a block away from the school, she stopped and stared at two sparrows taking a dust bath. If only she could flutter her wings in the dirt, Joey thought, she would fly up and never go back to Radley.

Recess was the worst time of the day. The boys played ball in the cinder gravel and some of the girls jumped rope. Joey watched them, knowing she could jump as fast or faster even, but she was afraid to butt in. On Thursday she did two cartwheels on the sidewalk. She could have done four in a row, but she was worried that her underpants showed, and hurried back to Dodo.

On Friday, Mrs. Martin announced that they were going to study European History and she asked Polly, a blonde girl in a green skirt, to help her pass out the books. Joey watched enviously as Polly moved along the aisle between the desks, pressing her chin down on the top of the stack of books she was carrying. She had clearly been at Radley the year before, because she spoke to people by name and laughed. When she had given out all the books, she flipped her hair back and walked down the aisle to her desk.

The dark blue books were titled *A History of Europe.* Joey opened her dog-eared copy surreptitiously, noting the black-and-white photos and the ink underlinings. When everyone had a book, Mrs. Martin announced that they were to start with the history of Russia and every night they would read ten pages and answer questions on them in the morning. The czars had been very important, she

said, but now Russia had a different government and was one of the Allies.

Bobby Malone, a boy at the table in back, began scuffing his feet; his companions on either side laughed and began scuffing, too. Mrs. Martin sighed, stood up and moved out from behind her desk. Her body looked lumpy in her chalk-smeared dress, and as she raised one hand, Joey could see a dark oval of perspiration under her arm. "All right. War songs." She raised both arms, holding them like a conductor.

They began with "Anchors Aweigh" and went onto "The Marines' Hymn." They sang one service song after another. There was no piano to accompany them and Mrs. Martin didn't have a pitch pipe, so they yelled out the songs as the long, black hands on the round clock above the blackboard climbed to two-forty-five. Only fifteen more minutes and she could leave school and go home, Joey thought. She sang loudly with the rest, glad to leave Russia behind. At Green Fields they would be embarking on projects: maps of Russia showing the mountains, or chronological charts of the czars. Someone would research Chekhov maybe, or Tolstoy. But here the battered blue texts were all they had and they were being ignored. *"We will fight our country's ba-a-ttles on the land and on the sea,"* she sang. It was war. Forget the czars and their empires. What everybody wanted now was to beat Hitler and win the war.

<p style="text-align:center">* * *</p>

Joey came downstairs into the living room one evening and looked over at her father, who was sitting on the couch, his elbows on his knees, staring down at the rug. "Hi, Poppy," Joey said. "How are you?" His shoes lay under the coffee table, one on its side, and a gray twist of smoke was rising from a cigarette that protruded from his fingers. Joey glanced at his feet in his dark socks and moved closer. She twisted one of the threads dripping from the side of the armchair as she waited for him to reply. Maybe he didn't feel like talking. Maybe he was really tired tonight. Two cocktail glasses sat on the coffee table, both empty.

"I have to look up Stalingrad in the encyclopedia," she said. "It's for Current Events, that battle that's going on there. I told Mrs. Martin that there were two sets of old encyclopedias in this house, so she asked me to look up Stalingrad in each one and compare what they said."

Her father lifted his head to look at her. "Stalingrad's a desperate city right now, Jo. It's fighting for its life." He paused. "It has a great history. You better look up Volgograd. Its name's changed. Those are pretty old encyclopedias." He stared at the bookcase in the corner with its glass cover. "They won't have it under Stalingrad."

There was a rattle of china and Joey turned to see her mother coming into the living room with a tray. "I thought this would be easier," she said, settling the tray on the coffee table in front of Joey's father. "You can eat right here. No need to put your shoes on and come into the dining room."

Joey's father straightened and pulled the tray closer. "Thanks," he said and let out a long sigh. "Boy, I'm beat tonight. Hungry, too." He peered at the tray. "What's this? Smells good."

"They had a little chicken in the market today," Joey's mother said. "Too small for roasting, but good for stew." She gave a little laugh. Joey watched her mother pause by the coffee table. "Like another cocktail? I would." She gathered the two glasses and went back into the kitchen.

This was a dumb thing to be doing, Joey thought, trying to find out stuff about a city somewhere off in Russia, when she could be upstairs with Madeline, listening to "Fibber McGee and Molly." She stooped down beside the bookcase and lifted the glass cover. She'd offered to look, because this past week she and Dodo had stayed after class, cleaning the blackboard and talking to Mrs. Martin. It was quiet in the room with almost everybody gone and Mrs. Martin seemed to enjoy their company.

Should she start with the *Britannica* or the *Americana*? She tried to pull out a volume of the red *Americana*, but the books were pushed in too tight, so she tried the tan row of *Britannica*s instead

and pulled out the one labeled VET to ZYM. The top was dirty and she blew the dust up with a big puff.

"What are you doing?" her mother said, coming back into the room. She stopped on the rug beside Joey, holding two full glasses.

"She's looking up some facts about Stalingrad for Current Events," her father explained. He spread his napkin over one knee and picked up his fork. "Read what it says," he directed, looking back at Joey. "I was there once years ago for a physics conference. I can tell you something about what it looked like then."

"Remember that song you used to sing about the Volga boatmen, Poppy? Is that where they were? In Volgograd?" Joey pronounced the foreign word uncertainly, then sat back on her heels, pleased at the possibility of a diversion.

"Read what it says there first, then we'll talk," he said.

Joey opened the volume and turned the thin pages with their double columns of tiny print. "There's a whole lot about the Volga River," she said, "but I don't see Volgograd."

"Try the next page," her father told her. "Volga, then Volgograd."

"Another long day for you," she heard her mother murmur as she settled on the couch beside Joey's father and picked up her drink. "Does anyone at that Office of Scientific Research and Development realize the long hours you're working?"

"It's the war. Everybody's working long hours." He sighed and scowled at the rug. "The goddamned military. If they would just let us do the science. Those War Department guys are so damn...." He took another bite. "Good stew," he said, his mouth full.

"I put in a long day myself," Joey heard her mother say. "Six hours of bandage rolling. Different though." She laughed apologetically. "It doesn't take any brains. But then I often wonder if I have any anyway."

"Ah, that bandage rolling's important too," Joey's father said. "But you mustn't wear yourself out." He took another bite of stew and added. "I had a cheese sandwich for supper last night. Tuesday, too, I think. This is a real improvement."

Joey found Volgograd and began reading. There were two columns on one page and the print was tiny.

"Does Sarah go out and get sandwiches for both of you?" she heard her mother ask.

"Sarah?" her father repeated and Joey raised her head. "Yeah. Pretty much. Any more of that stew?"

Her mother went into the kitchen and returned after a few moments, carrying his plate. She put it down in front of him and sat on the couch again. "Does Sarah work as late as you do?"

"Most of the time," he said and dug his fork into the new mound of stew. "Depends on the project."

"She's got an apartment on New Hampshire Avenue, doesn't she? It's near Dupont Circle." Joey saw her father turn his head to glance at her mother. "I thought it would be nice to invite her over for dinner some night," Joey's mother went on. "She might like to have a home-cooked meal and meet the girls."

"No, Amanda. No." Joey father's voice was loud suddenly. "I mean...." His tone dropped. "I mean, we'll see. Right now we're so damn busy." He paused. "Maybe later on."

Joey saw her mother swirl the last bit of liquid in her glass, then drink it down quickly. "You're evading me, Jack. You're doing just what I—"

"Shssh, Amanda." Joey, who was watching, felt herself grow hot suddenly and realized that both her parents were looking over at her.

"Volgograd, SE European city on the Volga River, stretches for 35 mi. along the west and east banks...." Joey sighed. When Mrs. Martin had asked about her family, she had told about their move from Cambridge, about Green Fields, and the rented house in Washington, which was full of gritty dust because it was so close to a bus stop. She'd told about how they'd had to leave their victory garden in Newbury, which was growing well, and how Queenie was having a hard time adjusting to city life. Somewhere in all that talk she must have mentioned that there were two sets of encyclopedias in

the rented house, the *Britannica* and the *Americana,* both old. Madeline always said she talked too much and this time that was true. Nobody in the class cared about Volgograd or Stalingrad really and if Mrs. Martin made her tell what she had found in the *Britannica,* everybody would think she was a teacher's pet.

The phone gave its muffled ring in the closet off the dining room. Joey turned her head. Her father looked up quickly and stared into the dim dining room. Joey's mother stood. "I'll get it." She came back into the room after a couple of moments. "It's for you, of course," she said and her eyes drew together in a squint as she looked at Joey's father. "I wish she would at least respect the few hours you have at home with your family."

Joey stared up at her mother, startled by the anger in her voice, but her father seemed not to have heard. He stood, dropping his napkin on the rug, and started into the dining room, his stocking feet making a soft noise on the bare floor.

Joey looked back at the tiny print in the volume lying open on the rug. She didn't need all those facts, she thought, and skipped down the column. *"Founded in 1589 as a Russian stronghold and called Tsaritsyn, it fell to the Cossack rebels under Stenka Razin (1670) and under Pugachev (1774)...."* She heard the phone ring again and lifted her head. But Poppy would get it; he was right there in the phone closet.

"In the nineteenth century Tsaritsyn became an important commercial center and...." It was strange the way the city seemed to get closer as she read, becoming almost interesting. Her mother took the tray into the kitchen and Joey heard the water in the sink as she read on. How sad that Stalingrad was getting all torn up with fighting. She heard the squeak as her father pushed open the door of the telephone closet. He crossed the dining room with long, energetic steps and stood in the middle of the living room rug, his hands on his hips.

"Guess who I just talked to?" he said to Joey's mother, who had come to the doorway of the living room. "Know who I was talking with?"

"Sarah," Joey's mother said in a tight voice.

"Oppie," he announced, ignoring her frown. "Robert Oppenheimer himself. He was calling *me*." Joey rocked back on her knees and stared up at her father.

"I mean, I knew what he wanted, of course. I've been working on it like crazy for the past week. But that he should call me himself. At home. Even apologized for disturbing me."

"But why did Sarah call?" Joey's mother's question came out in a whine and Joey turned to look at her.

"Sarah?" Her father looked confused. "Oh, that's just because I wasn't in the office. She wanted to make sure I was home, before she told him where to call. It was long distance, you see." Her father swung his arms out in a wide stretch as though he might raise himself toward the ceiling. "It's terrific to have his direct support like this. It's a lift, I tell you. A real lift."

Joey stared up at her father. Oppie was a funny name, but his call had cheered Poppy.

<p style="text-align:center">* * *</p>

Two weeks later Joey heard the front door open downstairs and turned in the fourposter bed. There was the rattle of the stained glass panes and then her father's cough. He must be hanging up his jacket, because she could hear the metal end of Queenie's leash click against the wall. Her mother's voice rose, the tone worried, but Joey could not hear the words. Then came Poppy's muffled words, apologizing for his lateness probably or telling her some piece of war news. It must be eleven or later, because she and Mad had been listening to "The Lux Radio Theater" until ten.

She heard her parents go into the kitchen, heard her father bang the tray of ice cubes in the sink. There was a pause, then one of them stepped on the creaky floorboard near the piano as they came back into the living room. "If they would just listen to me at the War Department." Her father's voice was angry. "Just read those damn reports. I mean, what's the point of all this, if…?" His voice descended to a mutter. She imagined him sitting on the couch, taking a

swallow of his drink. Mum was on the couch, too, or in the old gray chair. There was the sound of more wordless talk, then the familiar voice of the radio rose. Joey stared up at the long cracks in the ceiling plaster as she listened to the familiar phrases floating up the stairwell: *"Nazi fighter planes...," "Allied Air Command...," "Battle of El Alamein...."*

The war had changed everything, Joey thought, and it was all Hitler's fault. She and Madeline had left Green Fields and all their friends. They had left Newbury and the lilacs and the victory garden and now they were in this smelly, old house with its ancient furniture, its dark kitchen, and cracked plaster and she had to go to crowded Radley with its dirty corridors and staircases and those stupid boys in the back of the room scuffing their shoes and throwing spitballs.

"Don't push me, Amanda. I can't decide now. I just can't." Joey's father's voice was clearly audible all at once. "I tell you I can't make up my mind right now. Sarah's crucial to the work. We just have to keep going this way a while longer. I know it's hard, but right now, honest to God, Amanda, I can't do anything else."

Joey pulled herself up in bed and listened, but his voice had stopped. She shivered, then wrapped her arms around her, for the room seemed cold. This was war, of course, and whatever Poppy was mad about, even if it *was* Sarah, was nothing really compared to the soldiers captured or dying in the desert and the bombing of London night after night—right this minute probably.

She pulled up her knees. What did Poppy mean, he couldn't decide? Joey thought of Newbury. If it were still summer, they would be there right now, scraping barnacles off the little boat, weeding the vegetable garden. That's what would be happening, if it were summer still, if it weren't for Hitler.

Madeline rolled over and opened her eyes. "What're you doing?" she said, squinting up at Joey.

"Nothing. Listening to them," Joey said. "Poppy didn't get home 'til late and now he's mad at the War Department."

"So what? That's nothing new. Lie down. I wanta go back to sleep."

Joey lay back and pulled Fluffy close. She hadn't mentioned the talk about Sarah, because it seemed so sad.

Chapter 4

JOEY walked slowly behind Madeline, who was talking busily to her friends, Allie on one side and Ruthie on the other. Ruthie was pretty and Joey would have walked beside her and Madeline or at least close behind them if they'd been alone. But she didn't like Allie, who had a loud voice and slapped her dirty book bag over her shoulder as though she might swat someone with it. She had an orange streak in the middle of her dark hair, which Madeline said was peroxide, and she wore red nail polish. Ruthie wore polish, too, but her nails were neat, while Allie's were broken and long.

Joey scuffed through a pile of leaves, then bent suddenly to pick up a large acorn. The shell would make a good salad bowl for the dolls, she thought, except that she almost never played dolls anymore. Allie let out a screech of laughter and Joey looked up at the three figures now almost half a block ahead. Madeline was laughing, too. But she stopped suddenly, as though she felt Joey watching her.

"Come on, Joey. Hurry up. We can't wait for you, you know."

They weren't waiting anyway, Joey thought. Madeline didn't care, except that Mum would scold her if Joey wasn't with her when she got home. Everything was so easy for Madeline. She had made friends

with Ruthie and Allie the very first week and she'd told Joey that she was probably going to get all As on her report card in November. She'd always been good in Math, which Joey hated, and English and History were easy at McNeil, she said. So was Science, and Home Economics was a laugh. She knew her way around McNeil's corridors and classrooms and every afternoon she came out of the heavy front doors talking with others as though she had been there for years, while Joey waited for her on the steps, watching. Some of the boys pulled packages of cigarettes from their pockets and stopped on the steps to light up. The girls were in groups mostly. When she had a friend to walk with, they could walk home together, Mum said. But she must not walk alone, not now, not in crowded Washington with so many servicemen. Joey couldn't walk with Dodo, since she took the N4 bus north, and the two girls who walked toward Q Street were ones she didn't know or they didn't want to know her, it seemed.

* * *

Midterm report cards had come. Mrs. Martin had given each person his card in a tan envelope and they were all to bring them back the next morning signed by either a mother or a father. Madeline pulled her report card from her notebook and handed it to Mum when they got home. Joey thought of lying; she could say she didn't get a report card and then go upstairs, rip it into little pieces and flush them down the toilet. Madeline had all As, except for a B+ in History. "Very good, dearie," her mother said. "I'm proud of you. Now Joey, where's yours?"

Joey hesitated. "Ah, ah." She opened her book bag slowly and took it out. "Here."

"You got an A in English," her mother said. "And an A- in History. That's nice. But what's this D in Arithmetic, and Joey, for goodness sake, an F in Athletics? How did that happen?" Joey's mother leaned forward, frowning, as Joey looked down at a gray stain on the linoleum floor. "Joey, you need to explain."

Madeline was opening the bread box, but she stopped and looked back at Joey.

"I don't like Arithmetic and I hate Athletics," Joey said in a low voice. The stain came from a leak in the refrigerator, which Poppy had tried to fix last summer, but it still leaked some.

"Joey, come sit down," her mother said. "And Mad, make your sandwich quickly and take it upstairs. I need to talk to Joey alone."

Joey sat down at the table with a sigh and looked over at the thin strip of paper, lying on the blue-and-white checked oilcloth. There was a column of subjects on the left side and the corresponding letters marked in ink on the right. "I know Arithmetic is hard for you. It was for me, too. I should have drilled you on your multiplication tables." She frowned. "I meant to a month ago and I will now. But Joey...." Her mother put one hand to her forehead and pushed at her hairline a moment with her long fingers. "How could you get an F in Athletics?"

"I don't go," Joey said. "I'm never there."

"What do you mean you're not there. I thought you had to be there."

"Not me," Joey said. "I hate it. I don't go."

"But Joey...." Her mother straightened and clasped her hands in front of her. "What do you do? Where do you go?"

Joey raised her head and stared at the sink a moment. Would a lie work or had she better just tell? "I stay in Mr. Peterson's closet," she said slowly. "It's warm."

"Who's Mr. Peterson and where's his closet?" her mother demanded, her voice loud with irritation.

"He's the janitor. He keeps his cleaning supplies in the closet on the first floor, but on cold days he's down at the furnace mostly."

"And you're in his supply closet? Why? Why don't you go outside with the others?"

"It's cold and the boys are mean. They shout and throw balls that can hurt and I...." Joey looked down and her voice trembled. "I don't have any friends, except for Dodo, and she has asthma, so she can stay in homeroom all period."

"We've got to do something about this," Joey's mother said and

pressed her lips together. "I'm going over to school tomorrow and talk to that Athletics teacher."

"Oh, Mum, no." Joey brought hands together in a praying gesture.

"But, Joey, this is a bad report card. We can work on your Arithmetic together and you can get a better grade in December. But Athletics. Joey, you simply have to go out there with the others."

"But, Mum...."

Her mother leaned back and looked at her. "What do you do in that closet all period?" she asked.

"I read. Mr. Peterson always leaves his newspaper there and I read about Montgomery in North Africa and the things going on in the Pacific. Of course, I always read the funnies first."

"Joey, you mustn't do that anymore. I realize Athletics is hard for you. But it's part of your curriculum at Radley; it's part of your job." She paused a moment and looked at the yellowish plaster of the wall, where a long crack snaked downward. "We all have hard things to do, some of them very hard." She let out a sigh. "But we have to do them. Now I don't want to hear about you sitting in the janitor's closet anymore. You join with the others tomorrow and tonight we'll work on your multiplication tables."

Joey wasn't sure whether or not her mother had gone to school to talk to Miss Cameron, the Athletics teacher, but the day of her next Athletics class Miss Cameron announced that the girls in the class would meet in the cafeteria. She dragged two tumbling mats from a closet and the class lined up. Everyone was to do a somersault and then a cartwheel, if they could. Joey waited her turn. She did her somersault fast and came straight up, then cartwheeled quickly down the length of the room.

"That's fine, Josephine," Miss Cameron said. "I think indoor Athletics is more to your liking. Now if you'll just come to class each time, you can improve your grade."

* * *

Joey sat watching her mother stir scrambled eggs in the frying pan

at the stove. Madeline was reading the Sunday funnies, which Joey had already read. Her father gave a long cough, as he sat with his forearms resting on either side of the editorial page. A cigarette was burning between the fingers of his right hand and he coughed again, a deep raking sound.

The back door was partly open to the leaf-strewn alley and Joey watched a starling hop among the spread of yellow leaves under the ginkgo tree. As she stared, she began a trick that had become habitual; she was here in the kitchen looking out at the golden tree, but in London buildings were smoldering and in Russia, men lay bleeding in the snow. How could that be? Madeline had told her to stop thinking about all that stuff; it didn't do any good. But how could you help thinking about it?

"Remember before the war, Poppy," she began suddenly. "Sometimes you used to get up from the breakfast table and say, 'How about driving out to Newbury today? Anybody want to go?'"

"What?" Her father raised his head and peered at her.

Joey felt her father's gaze. "Well, it didn't happen often," she said and saw that Madeline had raised her head from the funnies. "That was before the war," she explained, feeling awkward. "Of course."

Her father folded the paper, stretched and looked out of the door. "It's a good idea," he said. "We could go for a drive somewhere. It's a beautiful day." He turned and looked at Joey's mother at the stove. "I have to go back to the office this afternoon, but how about a little drive this morning? We've got enough gas."

"You have to work today?" Joey's mother picked up the frying pan and plopped some scrambled eggs on his plate, then on the other three plates. "I don't want to go," she said and banged the saucepan into the sink. She turned the faucet on hard. "You go, if you want to use all that gas."

"We won't use much. Gas rationing won't start for another month and the girls could stand a little outing."

"Fine," she said and lit a cigarette. "Enjoy yourself. Go. I'll stay here."

"Ah, come on, Amanda. It'd be good for you to get out," Joey's father said.

"You take the girls." She stood with her back to the sink, lifted her cigarette to her mouth, then blew out a stream of smoke. "I have things to do here."

"I don't know about an expedition," Madeline began. "I told Ruthie that...."

"An expedition?" Joey broke in. The proposal seemed to burst before her, filling the kitchen with bright sparkles. She pushed back her chair and stood. "Oh, Poppy. Wonderful. Can we take Queenie?"

"Sure. Sit down and finish your eggs, then we'll get started."

"You better start soon if you're going to your office later," Joey's mother said and turned to look out the door.

* * *

The drive to Great Falls in Maryland seemed long to Joey and the smoke from her father's cigarettes filled the car so that even when he rolled down the window, the car still smelled smoky and sour. They walked onto the bridge that crossed the falls, where the water rushed and tumbled down in a roar. Joey saw leaves and bits of branches twisting in the huge rushing cascade, pushed and driven down into the river below. Her father and Madeline leaned on the rail to look down, but she drew back, frightened. What if the rail broke and they fell and were sucked in? Joey felt relieved when her father led them to a nearby picnic table and they all sat down. They had not thought of bringing sandwiches and Coca-Colas, like the family several yards beyond them. They could have brought some potato chips at least, but they hadn't.

"Well, here we are," her father said. He reached into his breast pocket and brought out a half-empty pack of Lucky Strikes.

"Lucky Strike means fine tobacco," Joey said in a deep voice, wanting to make him smile, but her father only nodded and Madeline looked down at her fingernails.

"So." He lit the cigarette, inhaled, and threw the burnt match onto the gravel path. "So. Everything's going pretty well at school?"

Madeline nodded. "It's a lot different from Green Fields, I bet."

"Sure is," Madeline said in a low voice. She smiled briefly and looked down at the picnic table.

Joey waited a moment, thinking Madeline might tell about her As on her Algebra quizzes and playing on the basketball team. But Madeline sat tracing a vein of wood on the table top with her forefinger and added nothing.

"Mrs. Martin, our homeroom teacher, knows a lot about Shakespeare," Joey offered.

"That's good," her father said. "Good."

Joey felt his unease sitting across from her and she plunged on, hoping to soothe him somehow. "We just might do a production of *Twelfth Night* in December. Not a production really, because of the war and everything." She pulled at her knee sock. "But a reading, sort of." She paused, uncertain whether either her father or her sister were listening. "Anyway that's what Mrs. Martin called it."

She looked up at her father. It wasn't a good subject; she was just filling the air between them with words. She looked at Madeline, wanting her to speak. There must be something they could say, something they could tell their father that would make this long drive worth his time and worth all the gas he'd used. *Help me, Mad,* she wanted to shout, but Madeline was staring at a ragged forsythia bush, looking bored or mad maybe.

Their father took a long pull on his cigarette and glanced around at the half-circle of trees beyond them, then back at the falls. "You know, kids," he said. He brought his cigarette to his mouth, took another pull, and squinted at the dusty path. "War is a tough time for everybody. You know that."

Joey straddled the picnic bench and gazed across at her father as he blew out a stream of smoke.

"I'm working night and day, like a whole lot of other people here in Washington, like people all over the world right now. We're going to beat Hitler, but we've got to work hard to make that happen. Very hard." He coughed and looked back at the falls. Joey broke off a piece

of meadow grass sticking up beside the bench and bent it in half. "I'd like to spend more time with you two, the way we used to, you know. But...." His voice had thickened suddenly and he stopped and and looked out at the shaggy bushes, then down at the ground.

Joey started to interrupt, to say they knew he was inventing something important to help defeat Hitler, but her father went on. "I don't like the way things are, but it's just the way it's got to be for the present. I can't help it." He waited. He seemed sad, Joey thought, almost as though he was ashamed of what he was doing, instead of being proud that he had been asked to do something that was crucial to winning the war. Madeline straightened and Joey looked across at her.

"The thing is, Pop," Madeline began, "Mum is worried about you working late so many nights and...." She squeezed one hand within the other and Joey saw her bite her bottom lip a moment before she went on. "She...she's not happy. I mean, if you could come home more, tell her more." Madeline stopped.

"I know, Mad. It's a hard time for her, for all of us, and I'm depending on you girls to help her. You've always been close. We've all been close and that will go on and...." There was a long pause. A crow flew overhead, screeching, and in the distance Joey could hear the pounding water of the falls.

She looked back at her sister, wanting her to continue, but Madeline had lowered her head, so that her face was almost hidden by the fall of her long hair. The spurt of courage that Madeline's brief speech had taken had left her limp, Joey realized, and it seemed to her that she must do something now.

She raised the stiff piece of grass to her lips, tipped her head back and began in a loud voice, *"The state of this nation is good. The heart of this nation is sound."* She took the grass from her mouth and glanced at it a moment, seeing a black cigarette holder like the one FDR used. She pretended to blow out smoke, then went on. *"The spirit of this nation is strong, the faith of this nation is eternal,"* she continued. Her voice had grown louder so that the woman in the

family at the nearby picnic table turned back to stare at her.

Joey could see Madeline's tight look of annoyance, but her father's mouth was turning upward in a smile. *"We will defeat the tyrants and drive them from their ground,"* she finished firmly. She tipped her head back again, keeping the grass cigarette holder in her mouth at its jaunty FDR angle.

"When did you learn that, Joey?" her father asked.

"I read it in the newspaper. I memorized part of a Churchill speech, too. Want to hear?"

"No. We do not," Madeline said and looked down at the table again.

A large black dog came bounding up the path and Queenie rose, growling. She broke into loud barks, straining at her leash, which was tied to one leg of the picnic table. "Easy, girl. Easy," Joey's father said. He stood, untied the leash and gathered Queenie in his arms. There was a whistle and the intruder dog disappeared, as their father patted Queenie, ruffling her fur. "You're getting a little old to defend us, Queenie girl," he told her. He turned back to Madeline and Joey. "Well, kids, I guess we better go home." He started down the path towards the parking lot, carrying Queenie in his arms, talking to her still. Joey followed Madeline, envious of the attention Queenie was receiving.

She sat in the back seat with Queenie behind Madeline and her father, and as she stared at the back of Madeline's blonde head, she realized all at once that her sister had tried to do something important. She had wanted Poppy to talk about what was wrong, to tell them what he felt about Sarah. Joey closed her eyes as a wave of sickness flooded through her. She had clowned at the very moment when Poppy might have explained things a little or eased them maybe. Now that possibility was gone.

* * *

Joey opened the closet door in the bedroom she shared with Madeline and lifted her nightgown off its hook. She was singing and continued to sing as she pulled the nightgown over her head.

There'll be bluebirds over
The white cliffs of Dover
Tomorrow. Just you wait and see.

"Oh, shut up, Joey," Madeline said. "You sound awful." But Joey ignored her sister and went on singing as she buttoned the nightgown in front.

There'll be song and laughter
And peace ever after....

"The White Cliffs of Dover" was Joey's favorite war song, even if it did go up too high, and she would just go ahead and sing it if she wanted to. She pulled the bedspread back, then turned. Madeline was standing in the closet doorway, looking oddly exposed in her white camisole and underpants.

"You know something, Mad?" Joey began. "You're getting breasts. Did you know that? I mean you flop. You did this afternoon when we were running down the hill."

"I don't," Madeline said. "I'm not." She clutched her arms around her and looked toward the window.

Joey stared down at the the bedspread; she shouldn't have said that. She looked up, considering an apology, and saw that her sister was staring at the window. It looked different with the new blackout shade. It had taken almost the whole of Saturday to put the shades up in all the windows, but that was what they had to do in case Nazi planes began bombing Washington.

"Would the Nazis really come?" Joey had asked her mother.

"Probably not," Mum told her. But Mum didn't know everything and what would they do if bombs started to fall? Suppose they couldn't find Queenie? Madeline was still standing by the closet looking furious, her arms folded across her chest, her hands cupping her breasts.

"I don't flop," Madeline said. "And anyway it's none of your business."

"Maybe you ought to get a bra," Joey said, then pressed her lips together; now she had definitely said too much.

Madeline stood with her back to Joey, still hugging her arms around her. Joey waited. After a long interval, she heard Madeline sigh.

"I do need a bra," she said and sat down on the bed. "But you know how it is with Mum right now. This bandage rolling she's doing and her worry about Pop and.... You know."

Joey moved to the bottom of the bed, feeling hot with importance. Madeline had confided a secret worry to her; there must be some way she could help. "Maybe we could go buy a bra," she said in a half-whisper and gripped the wooden rod at the bottom of the bed. "You and me."

"How? The stores that sell them are way downtown and Mum would never let us go down there alone."

"They have them at the five-and-ten," Joey announced and felt heat pour across her shoulders. "I saw a whole counter of them when Dodo and I went there to buy construction paper."

"You did? Are you sure?"

Joey squinted slightly, trying to visualize the soft mounds of pink and white bras on the counter toward the back of the store across from the socks and girdles. "Positive," she said and breathed out slowly. "Tomorrow's Saturday," she continued, amazed at her bravery. She tipped her head for a moment the way Mum did when she was making a suggestion. "We could go down together and I'll show you."

Madeline looked hard at the rug, then up at her sister. "All right," she said. "Tomorrow."

* * *

"Look, Mum." Joey stood in the doorway of her mother's room late in the afternoon. The bedroom was shadowy, for the black-out shades were pulled down at both windows. Joey moved to the bed and stood looking down at her mother, who lay on her back, one arm over her eyes. "Are you awake, Mum?" Joey bent down and

inhaled something that smelled like whiskey. She straightened quickly, feeling a jab of guilt. "It's almost time to start supper."

"Oh, Lord. I know." Her mother swung her stocking feet to the floor and sat up. "I had a little headache," she said, staring up at Joey.

"Look at Mad," Joey said and pointed to Madeline standing in the doorway. Her mother looked over at Madeline, who pushed back her unbuttoned blouse and stood with her arms at her sides, stretching back to display a pink satin bra.

"Oh," her mother said, and Joey heard the sharp intake of her breath. "Oh, dearie. Where did you get that?"

"At Woolworth's," Madeline answered and flicked the little bow in the middle of what the lady in the ten-cent store had called her "cleavage." There was a narrow strip of pink lace at the top, which Madeline said was itchy, but the inside was soft. "Joey and I went down together. It's right on M Street. Not far." She paused. "I needed it, Mum. It was getting embarrassing."

"You went to Woolworth's for a brassiere?"

"Well, you've been busy with your bandage rolling and not feeling well and...."

"Oh, dearie," her mother said and Joey heard her voice shake.

"What's the matter, Mum?" Joey asked. "Are you mad?"

"I'm not mad," her mother said. "I'm just...." She raised both hands to her face and bent her head into them a moment. "I'm sorry," she said. She dropped her hands and looked from one to the other. "I haven't been a good mother." She glanced around the room a moment. "It's the war. Things have been hard and...." She put her hands over her face again and Joey stared down at the flowered border of the rug, filled with a sudden terror that her mother might cry.

But her mother stood, felt for a Kleenex in the pocket of her skirt, then turned the waist band so it was straight. They watched as she moved to the window. One black-out shade showed almost an inch of window and she pulled it straight down to the sill. "Look," she said turning back to them. "Monday, right after school, let's all three

go downtown to Woodward and Lothrop's together. We'll get Mad some more bras and Joey needs socks and you could both use new skirts, too."

"And maybe a new sweater?" Madeline buttoned her blouse quickly, covering the bra. "My green one is practically two years old."

"We'll see, dearie," her mother said. Joey watched her mother start toward the stairs, then she followed her sister into the bathroom and sat down on the side of the tub. Madeline was combing her hair at the sink. "Mum was sort of mad about the bra, I guess. But anyway it's good we'll get new skirts, and you might get a sweater, too, maybe." She waited for her sister's response, but Madeline was frowning into the mirror. "I mean, going to Woodies will be fun." Joey paused, confused.

"Fun." Madeline spat the word back at Joey, then drew the comb through her hair, parting it with an angry precision. "If Pop would just talk, explain instead of all this stupid uncertainty." She seemed to be talking to her reflection, unaware of Joey sitting behind her. "I mean everything is such a mess and…." Madeline stopped mid-sentence and flung the comb into the sink. It made a crackling sound as it hit the porcelain surface and she stormed out of the bathroom and down the hall.

Joey thought of picking up the abandoned comb and combing out her pigtails, but the tangles would hurt.

* * *

One night toward the end of October, Joey's father pulled a map of the world from his briefcase. He mounted a kitchen chair after supper and flattened it against the kitchen wall, as Joey waited below him, holding a roll of tape. "It came in my mail with a bunch of stuff," he said. "It's pretty good. Thought it'd teach you and Mad some geography. Give you a sense of the global proportions of this war."

"It's nice," Joey said. "Thanks, Poppy." She felt uneasy with her father these days and wished Madeline were home, but she was having supper at Ruthie's.

"All right now. Let's get this corner." Her father reached down for a strip of Scotch tape.

"Do you really think you should use tape on that wall?" Joey's mother said, appearing in the doorway, a glass in one hand. Why was she drinking a cocktail now, Joey thought? Cocktails were for before supper, and supper was over an hour ago. "It can peel the paint when you take it off, you know," she added.

"On this dirty, cracked surface?" her father said. "What the hell difference does it make?"

Joey stared up at him. Was he mad at Mum? At her? She began unpeeling the Scotch tape, but it clung to the roll.

"Watch out, Jo. Don't pull it that way, damnit. It'll break. Pull it out straight." Joey felt her eyes prickle; he shouldn't yell at her. She hadn't asked for the stupid map. It was his idea.

"Okay," he said, taking the straight piece of tape she held out finally. "That's good." His voice had softened. He taped the last corner to the wall and stepped down from the chair. "Now, you can see the extent of this thing," he said, looking up at the map. "There's Pearl Harbor." He pointed to the small shape of the Philippines in the huge blue spread of the Pacific. "Midway Island's just about there. See? Now here's North Africa, and that red dot's London," he added and paused. "There's Russia and Stalingrad. See?" He looked at her and then back at the map. "You can see now that it really is a global war. I mean, my God. There's almost no place on earth that isn't involved."

"Yes." Joey stared and wished again that Madeline were here. "The thing is, Poppy," she began. "The war's gotten so big. How can it stop?"

Her father frowned. "It won't stop until we win."

"But, I mean...." Joey bent to scratch her leg. "If we're fighting and bombing all the time, how can we talk to Hitler? How can we make peace with him?"

Her father lowered himself into a chair at the kitchen table. "What?" he said and looked at her wearily.

Joey repeated her question, aware all at once that even her father might not know the answer. "I used to ask myself that question," he said and sighed. "But now...now we're in this thing." He glanced across the kitchen suddenly and Joey followed his gaze. Her mother had pulled the whiskey bottle from the cupboard and was pouring herself another drink.

"Amanda," Joey's father said. "Not now. You don't need...." He started to get up from the chair.

"It's just a little one," she said. "Just to help me sleep."

"All right." Joey's father pressed one hand to his chin as he watched her leave the kitchen and start toward the stairs.

He glanced up at the map, then back at Joey. "We have to win," he said. "That's the whole point. Now that we're in it, we have to win." He put his elbows on the faded oilcloth, covering the table, and let out another sigh.

"Will it take a long time?" Joey asked. "Will a lot of people be hurt?" She waited. Minutes seemed to tick by.

"I don't know," her father said and covered his face with both hands. "I don't know," he said again as Joey watched him push the wrinkles in his forehead up toward the line of his thinning hair. "It may take a long time, Jo, and a lot more people will die."

Chapter 5

J OEY was hunched over on the rug in the bedroom, pasting a newspaper picture of Field Marshall Montgomery into a brown, spiral notebook, when Madeline came into the room, her hair wrapped in a yellow towel. "What are you doing?" she said, peering down at her sister. "You're going to get paste on the rug."

"No, I'm not." Joey sat back on her heels. "I'm writing a war journal and I'm illustrating it. See? I'm putting in pictures from the newspaper and *Life*, too."

"Are you doing it for school?" Joey shook her head. "Then who's it for?" Madeline asked.

"Me," Joey said and looked back at the open notebook. But that was not really true, she thought. If Poppy saw the headlines she'd copied, the pictures she'd pasted in, and especially the drawing she'd made of the Boeing Flying Fortress, he would see how serious she was about the war.

"But what's the point?" Madeline moved around the bed and stood looking down at the spiral notebook on the rug. "All kinds of magazines and newspapers have pictures of Monty." She pulled the towel off and began rubbing her wet hair.

"Field Marshall Bernard L. Montgomery," Joey corrected and gave Madeline a stern look.

"Oh, Joey. Honestly." Madeline picked up a brush from the bureau, bent her head forward and began brushing. After a moment, she flung her wet hair back and sat down on the bed. "So what great insights are you putting in this journal of yours?"

"It's not insights," Joey said and pressed down the top edge of a second picture of Montgomery with the heel of her hand. "It's a record of my experiences in the war."

"I see." Madeline gave a superior smile and leaned back on her elbows. "I'm sure it'll be invaluable to future historians." Joey glanced at Madeline, who had flopped back across the bed, so that her hair hung down over the side. She was pleased with the sound of that sentence, Joey thought. "Ruthie's coming over after her piano lesson," Madeline said.

"I'll make Ovaltine," Joey started. She only needed one more box top and then she could send away for an Orphan Annie ring. "We have enough milk." She waited, knowing that Madeline might not even want her in the kitchen when Ruthie was there.

"We'll see," Madeline said, sounding like her mother. She sat up and gathered her damp hair in a pony tail. "I'm not sure she'll really come," she added and let her hair fall. "She just said 'maybe'."

Joey looked back at the journal. Madeline always had friends. At Green Fields there had been Becky and Janet and lots of others. Joey had Fay, of course, but nobody here, nobody but Dodo and she lived way off in Bethesda.

Madeline stood and moved to the door. "I could make some toast." Joey offered and heard her voice tremble slightly. "We still have some blackberry jam."

"We don't want toast. If she comes, I'll make the Ovaltine," Madeline said and left the room.

Joey flipped to the first page of her journal and read the headline she had copied in ink. "November 4, 1942. Montgomery breaks through at El Alamin." The name looked funny. Oh. She had left out the E in Alamein. She fixed it hurriedly, put the notebook, paste, and scissors on the desk by the window, and stood a moment staring at

Madeline's book beside them: *Intermediate Algebra.* That was a grown-up subject, all right. Joey glanced at the low bookcase with her own books: *Little Women, Little Men,* and the library copy of *Under the Lilacs.* The March family had lived through the Civil War, but somehow they had done much better than her family was doing in this war, Joey thought.

She sighed and looked out the window as a bus drew into the stop across the street and stood, exuding its gray cloud of fumes. If only she were Jo March in *Little Women,* then she would know what to do. Should she take her journal to the kitchen, if Ruthie was coming? Yes, she thought, and hugged the notebook to her chest as she started downstairs.

Joey settled at the kitchen table and looked over at Madeline, who had started warming the milk for the Ovaltine. "You know, Mad," she began, "I'm really annoyed with Mrs. Roosevelt."

"You are?" Madeline had stooped to light the burner, but she straightened to look back at her sister and lifted one eyebrow. "Why? I'm sure Mrs. Roosevelt would want to know your reasons." Joey heard the condescension in Madeline's voice, but decided to ignore it.

"Listen to this," Joey began and opened her journal. "This is what she said last night in her column. 'I had not read my paper the other evening,'" Joey began in a high, aristocratic voice. Madeline turned from the stove again and smiled. "'And so I went out to a concert in the way in which I would ordinarily have gone, and to my horror....'" Joey raised her voice in a squeak. "'The next morning I read the new rules and realized I had unwittingly broken one of them by using the car for pure pleasure, even though I had gone to a war benefit.'"

Madeline stood gazing at her sister, as a drop of milk fell from her raised spoon. "Joey," she said. "You're a character. You know that?"

"Well, the Office of Civilian Defense had announced the rules just the day before," Joey said. "Monday, I mean. Only absolutely

necessary cars can drive at night, because of headlights and gas. Radios and newspapers all over the country were blaring that and surely somebody in the White House heard the announcement. I mean, wouldn't you think with all those secretaries and assistants *somebody* could have warned her? But no. The First Lady just drove off through the empty streets of Washington, completely unaware that she was breaking the new rules."

"Well, even important people make mistakes," Madeline said.

"I know. It's only a trifle. I worship Mrs. R." Joey put both fore-arms on the table. "I think that's why I criticize her," she said. "I mean, you always do criticize more the people you love the most." She paused a minute, trying to think how to smooth out her last sentence, then asked suddenly, "Mad, do you think we should criticize Mum?" She stared at her sister. "About her drinking too many cocktails, you know?" She waited. "And, I mean...."

Madeline put the spoon down on the top of the stove with a thump and crossed to the table. "No, Joey," she said and leaned over to look straight at her sister, her expression stern. "No. Definitely not," she said. "Right now criticism is what Mum doesn't need. So don't you say anything about her drinking or anything else." She turned back to the stove and picked up the spoon. "Understand?"

"All right," Joey said and thought again of Mrs. Roosevelt. She was so splendid and strong; she would never waste time fussing over the kinds of worries Joey's family had.

* * *

Joey stared around her at the crowd in the lobby of the National Theater, as she and her mother moved slowly toward the exit. A bandage-rolling friend of Mum's had given her two tickets to a Saturday matinee of *A Christmas Carol*. Madeline was going to a movie with Ruthie, so Joey had gone to the play with her mother. She had protested that her black Mary Jane shoes with the white knee socks made her look childish and her long-sleeved blouse was itchy under her dirndl. But now, dazed and excited by the play and the people pressed close to them, she had forgotten those complaints.

Two sailors in white uniforms stood nearby laughing at a third sailor, who tossed his round hat up in the air and caught it, as Joey stared. Right beside Mum, an Army officer with a gold star and two stripes on his epaulets was talking to a tall woman with a fur piece around her neck and a veiled hat that masked her face. "Altogether quite a charming performance," the officer said, as Joey inhaled the sweet scent of the woman's perfume, which mixed with the smell of cigarette smoke rising around them.

The smells, the red plush panels lining the lobby walls, interrupted here and there by large war posters, and the heat added to Joey's sense of dizzy wonder, and she let out her breath in a long exhalation as they waited. The front doors of the theater were hung with two layers of thick black curtains, so that as audience members left they had to pull back one curtain, enter a dark space, and pull back a second. "Can't have lighted marquees in wartime," Joey's mother said, as she and Joey moved another few inches toward the front. "In New York they have a stage door canteen that provides free refreshments for servicemen. But here they give discounts to all the servicemen on their tickets."

"That's good," Joey said and reached for her mother's hand as they followed the lady with the fur piece and the Army officer through the opening in the first curtain, then the next.

"There's a bus now," Joey's mother said when they emerged from the curtained doorway. "Hurry. I think we can catch it."

The bus roared up, its huge cat eyes of headlights glowing in the late afternoon grayness. Joey mounted the steps behind her mother and followed her down the aisle to a seat beside a window. "There's the Washington Monument," she said, pointing. "But there's a red light on top, Mum. Couldn't Nazi pilots see that?"

The bus lurched around a corner and Joey saw a black iron fence, a big dark building, and then the White House all at once. "Mum," she said, staring at the darkened windows, "Is Mrs. R. inside, do you think? Is she?"

"I'm not sure, dearie," her mother said, leaning over to peer out.

"She might be, but I think she's on the West Coast right now, visiting training camps."

The bus turned into Connecticut Avenue and Joey sat back and sighed. "I can't believe all I've seen," she said. "I mean, those red seats going down, the aisle, the lights dimming, and then...." She let out a long sigh. "The play itself."

"It was beautiful, wasn't it?" her mother said. "I loved the set and the actor who played Scrooge was wonderful."

"And Bob Cratchit," Joey added. "And Mrs. Cratchit. Remember when she was so worried about the pudding? She sort of stooped and...." Joey leaned forward on the bus seat and wrung her hands. "Oh my," she said in a high voice, "suppose it should not be done enough! Suppose it should break in the turning out. Suppose somebody should have gone over the back wall and stolen it while we were merry with the goose." She looked back at her mother and noticed that an elderly colored woman standing in the aisle was smiling.

"The thing is though they were so poor. The Cratchits couldn't pay for a doctor for Tiny Tim. I mean, they didn't have the money and...I mean, if Mr. Scrooge hadn't changed and gotten generous, Tiny Tim could have died, Mum. He would have."

"Yes, dearie. You're right. There was terrible poverty in London then." She turned and Joey gazed at the passing shops, some closed, others with their black-out curtains pulled down. "Oh, it's good to get out," her mother murmured. "Out of the house for a while."

"Poor London," Joey said. "Poverty then and bombing now." She sucked at the tip of her mitten. "There's so much to think about. I mean, the play was a kind of miracle, wasn't it?" She looked up at her mother. "I want to see lots and lots of plays, Mum, and be in them, too, someday. I mean, you know?" She clasped her mittened hands together. "Maybe I'll be an actress when I grow up, Mum, instead of a writer."

"You should think about acting, dearie," her mother said quiet-

ly. "You would be very good, I think. You could be a writer and an actress, too, you know."

* * *

Joey's mother stood at the stove that evening turning slices of Spam in the frying pan, as Joey and Madeline sat at the kitchen table waiting for supper. "Well, what parts did you like best?" Madeline asked and glanced over at her sister, who was still wearing her blue dirndl and her long-sleeved, white blouse with its lace trim. Joey looked down at the oilcloth cover on the table.

The sizzling sound of the Spam filled the silence a moment and the smell of grease spread out in the kitchen. "Well?" Madeline waited. "Didn't you like it?" Joey put both elbows on the table and covered her face with her hands. "What's the matter? I thought you'd love *A Christmas Carol*. You've read it or you've heard it read at least."

"It was wonderful," their mother said. "Beautifully acted and a wonderful set." She lifted the Spam onto three plates, then added a spoonful of stewed tomatoes and some carrot straws. "It was a full house, too," she said as she sat down in her chair at the end of the table and unfolded her napkin. Madeline began cutting her Spam, but Joey covered her eyes again and continued to sit with her elbows on the table.

"Ruthie's mom buys Treet," Madeline announced. "She says it's cheaper than Spam and has more taste."

"Really? Maybe I'll try it next time," her mother said. "Come on now, Joey. Eat. You barely touched your lunch. You were so excited."

"I don't want anything." Joey dropped her hands and pushed back her plate.

"I thought seeing that play might make you want to go to Hollywood and be an actress," Madeline said in a taunting voice. "Didn't it? Don't you want to go?"

Joey dropped her hands and looked at her sister. "You don't understand, Mad. If I wanted to be an actress," she said, "if I really did and I might someday...." She stood up suddenly, pushing her chair back with a scraping sound and glared at her sister. "I wouldn't stay

here in this smelly kitchen talking about Spam and Treet. I know that."

"Sit down, dearie," her mother said, but Joey locked her arms around her and glared.

"What's the matter?" Madeline said. "I asked you a perfectly logical question."

Joey darted to the door, but she heard her mother's voice behind her. "Leave her alone, Mad. It was a major experience and she needs to settle it."

* * *

A week later, Joey pulled the braided string with her house key over her head and unlocked the front door. "I'm home," she called out in the front hall.

"Come upstairs, dearie," her mother called back. Joey put her books down on the table, peeled off her jacket, and climbed the stairs to her parents' bedroom.

Her mother was perched on the edge of the old overstuffed chair by the window, stroking Queenie, who lay on the chair seat. She was still wearing her coat and her black hat with the feather, as though she had not had time to take them off. "Queenie's sick, dear," she said, looking back at Joey. "I just brought her home from the vet."

Joey stooped down beside the chair. "What's the matter?" she said.

"She's in pain. The doctor gave her some pills." Her mother stroked the fur space between the dog's eyebrows gently, as if smoothing away a frown. "I have to give her another pill at six." She glanced at the clock on the table beside the bed, then at Joey, and stood. "I've got to go to the cleaners to pick up your father's good suit. He's got a big meeting tomorrow. I'll be back as soon as I can."

"OK, Mum. I'll stay with Queenie. She'll be fine."

"Well, I.... Now be very gentle, Joey. Don't try to move her or...." Her mother stood, looking down at the dog. "I'll hurry, but it might take a while. The traffic's always terrible at this hour."

"Don't worry, Mum. I can take care of her."

"Joey." Her mother raised one hand to press down her hat. "She's very sick."

"But she'll get well, won't she? The pills will fix her."

"I'm not sure, dearie. It's not something that can be cured easily." She glanced at the clock again. "I've got to go, Joey. I should be back by five at the latest."

Joey sat down on the rug and pushed her legs out beneath the chair. "Queenie," she whispered. She heard the front door close downstairs with its familiar rattle and then the quiet, as it began to settle over them. "You have to get well, Queenie," Joey said. "We all depend on you." Queenie let out a long sigh and closed her eyes. There were gray hairs in her soft muzzle and in the black fur covering her short arms and tufts of gray stuck out from her armpits. Joey's father called her a Scottish spaniel, but no one really knew her lineage.

Joey stroked her head awhile, then it occurred to her that she could read the funnies while she continued to pat the dog. She ran down to the kitchen, snatched up the newspaper and hurried back up the stairs, taking them two at a time. "Here I am," she said and spread the funnies on the floor. "I'm back."

Joey began to read "Dixie Dugan," keeping one hand on Queenie's front paws. The dog let out a moan and Joey looked up. "Oh, Queenie." She pushed back the paper, got up and perched on the arm of the chair. "It's been so hard for you here," she whispered as she stroked the dog's back softly. "Harder for you than for any of us." She paused, surprised at her thought, but it was true. Queenie had never liked this house with its long steep stairs and tiny back yard and, of course, it had been impossible to explain to her about the war. She had been so happy at Newbury, chasing rabbits in the meadow, coming back with burrs tangled in her fur. "Remember when you'd lie on the rug sleeping and let out little yipping sounds?" Joey asked, almost expecting an answer. "Mum said you were dreaming of rabbits."

The dog lay inert, her eyes closed. Joey leaned down lower and

stroked her forehead between her eyebrows the way her mother had done. The dog's head felt hot beneath the graying fur and Joey leaned closer. "Don't die," she whispered. "Queenie, please. Don't die." She looked down at the newspaper on the floor: "...ALLIES LAUNCH OFFENSIVE ON STALINGRAD." She saw an image of men stooping down, shooting, one man's forehead bleeding, a grenade exploding nearby, but she pushed it from her. The war, the war, she thought, and screwed her eyes shut. Russia was so far away and those soldiers spoke a funny, foreign language, while Queenie, who had been their dog for years, was right beside her in the chair. "Please, Queenie," she whispered, and stroked the dog's forehead again. "Don't die."

* * *

Joey was curled on her side of the bed when she heard the front door rattle as her father closed it, then heard his cough in the hall below. His shoes squeaked as he came up the stairs. Queenie, Joey remembered with a start. She slipped out of bed and went to the open door of her parents' room.

"What's the situation?" her father asked, nodding at the dog, who was still lying in the chair. "How is she?" Joey watched her mother stand and move to the chair, stroke the dog, then return to sit on the bed. "You took her to that vet, didn't you?"

"Yes." Joey's mother crossed her legs slowly, as she looked up at him and Joey noticed an empty cocktail glass beside the bed. "She's very sick, Jack. The vet said she has cancer." Joey sucked in her breath, but kept silent, standing in the doorway.

"My God," her father said. "Cancer? Is he sure?"

"He gave me some pain killer pills for her, but he says that's all he can do. He says she's dying."

Joey watched her father move to the chair and stoop down. He put his broad hand on Queenie's head. "Oh, God," he whispered. "Not dying."

Joey saw him fondle Queenie's ears, but she did not lift her head the way she usually did so that he could scratch beneath her chin.

She barely moved, and even from the doorway, Joey could hear her irregular breathing.

"Oh, God." Her father straightened and massaged the small of his back with one hand. "This goddamn war," he said and stared at the window with its black-out shade. "Sometimes I feel as though this damn war is taking away everything we ever loved. Know what I mean?" He looked back at Joey's mother.

She nodded and Joey saw that her eyes were shiny with tears. Should she run into the room and hug her mother or go press herself against her father's side? She paused, feeling the chilly darkness of the hall behind her, and tiptoed back to bed.

* * *

Madeline and Mum were sitting at the kitchen table talking in low voices when Joey came home from school two days later, but they stopped when she came in. "What is it?" Joey demanded. "What's happened?" She looked from one to the other. "Is it Queenie?" For an instant, Joey had the sense that her mother and sister had been talking of something else, something even worse, but she persisted. "Did she die?"

"Yes, dearie." Her mother stood and put one arm around Joey. "This morning after you and Mad left, I was stroking her head and I...." She stopped a moment, then went on. "I lifted her onto my lap. I knew the time was short. She was panting and then she just let out a little hiccup and I felt her body go limp under my hands." Her mother clutched her arms around her in her black, wool sweater.

"Where is she?" Joey asked. "I want to see her. I want to say good-bye."

"You can't, dear. I took her body to the vet. I had to. We couldn't bury her here."

"But..." Joey looked up at her mother. "Oh, Mum." She pushed against her mother's side, feeling her softness under the sweater. Her mother's arm went around her again and Joey felt her hand push her hair back from her forehead.

"Does Poppy know?" Joey asked. "Have you told him?"

"I called the office," her mother said. "He was in a meeting, but I left the message with his assistant."

With Sarah, Joey thought, and stared, but her mother glanced at the clock. "Oh, Mad, your music lesson. We'll be late." She glanced back at Joey. "You get your homework started. We'll be back in an hour."

Joey sat down at the desk she shared with Madeline and sighed as she opened her spelling book. Some gray hairs were sticking to the front of her blue sweater. Queenie hairs, she thought, and picked them off slowly, making a soft pile at the edge of the desk. She looked down at her spelling book, feeling the emptiness of the house below. "I before E, except after C or when sounded like A, as in 'neighbor' and...."

A metallic swinging sound came from below, then the splattering noise of papers hitting the floor, as the postman jammed the mail into the slot in the front door. That was a sound that always made Queenie bark. Joey waited. Silence. She put her head down on the spelling book. Everything had changed.

Chapter 6

JOEY shifted her notebook to the other arm, put her collection of leaves on top of it, and unlocked the back door. She would paste the leaves on construction paper, she planned, then cover them with some of Mum's colorless nail polish, if Mum would let her use it.

She stopped, surprised to find the light already on in the gloomy kitchen and her mother seated at the table with another woman. Joey stared. The woman sat with her plump arms spread out on either side of her teacup in its saucer as she leaned forward, talking to Joey's mother. She was wearing a dark wool dress and her grayish hair was ruffled on top, as though she had just taken off her hat.

"Mona," Joey shouted and started across the kitchen. "I mean, Mrs. Hartley."

The woman pushed her chair back and stood. She was shorter than Joey's mother and her hips bulged below her patent leather belt. "You can always call me 'Mona', sweetheart. How are you?" Joey inhaled a mixture of face powder and perspiration, as she pressed her cheek against the wool of Mona's sweater. "You've gotten tall," Mona said. "Taller than Fay, I think."

"Is Fay here? Did she come with you?"

"No," Mona said. "But she'll come soon. We're coming down to Washington, too."

"You are? When?" Joey lifted one hand from her notebook and some leaves fluttered down to the floor. "Darn," she said and knelt on the linoleum to gather them. "When are you coming?" she asked, straightening.

"Right after Christmas. Just as soon as Henry finishes reading exams and your mother finds us a place to live." Mona glanced back at Joey's mother with a teasing smile and sat down at the table again. Joey's mother rolled her eyes upward and laughed.

"Oh, Mum, can't we find them a house near here? Please, Mum. Please."

"I'd love that as much as you would, dearie. But houses are hard to find. We're just going to have to work at it and see."

"I want Fay to go to Radley with me. I want her to be in the same homeroom and—"

"Put your things down, Joey, and take off your jacket," her mother said. "Not there," she added, as Joey plopped her notebook and the leaves on the drainboard. "Out in the hall."

"The real problem, Mona, is exhaustion." Joey heard her mother's voice in the kitchen as she peeled off her coat. "He's working eighteen hours a day and he's under terrible pressure. It's impossible for him to balance his personal life with his work."

"Here's the blackberry jam we were saving," Madeline said coming into the kitchen from the dining room. "Is it all right for Joey to have tea?"

"You know it is," Joey whispered furiously. She glared at Madeline and sat down beside Mona. "Can't you come sooner than Christmas?" she asked. "Is Mr. Hartley going to get a war job in Washington?"

"Yes, Joey. He's going to work in the Office of Price Administration, but he has to finish his teaching first."

"Oh, the OPA," Joey said. "We know about it. They issue our ra-

tion books. We have Ration Book One and now we're going to get Ration Book Two. We'll have to be really careful about meat and cheese and canned vegetables and...." She paused. "Does Fay have Miss Thorpe this year? Does she like making maps? I thought that would be fun in the fifth grade."

"I think she's quite happy in her class this year," Mona said.

"Who's her best friend now?" Joey asked. "Lizzie, I bet."

"Excuse us," Madeline said and stood suddenly. "Joey and I have homework to do. Call us later, Mum. We'll set the table. You're staying for supper, aren't you, Mona?"

"Yes, indeed," Mona said. "See you in a little while, girls."

"Why did you do that?" Joey asked when she and Madeline reached their room. "I hadn't even finished my tea."

"They need to talk," Madeline told Joey. "Mona's only got a few more hours here. She's taking the night train home."

"What did Mum mean about Poppy's work life and his personal one?" Joey asked.

"Oh, you know. The war and Pop's tiredness and everything. They need to talk about all that stuff. And Mum needs to warn Mona about the crummy house she might have to live in."

"And the crowded school for Fay."

"Well, that's Radley. She'll probably go to another school," Madeline said and sighed as she turned to the window.

Joey waited a moment, then said, "I hope Mum'll tell Mona about Sarah."

"You shouldn't think about that, Joey," Madeline said and sat down on the fourposter bed. Joey watched her lean back and look up at the long crack in the ceiling. "She has told her," she said slowly. "I heard her. I just hope it'll help."

* * *

Joey kept thinking about Mona and especially Fay. Even if they had to live way out in Bethesda and Fay had to go to a different school, they could still see each other on weekends and play dolls maybe, the way they used to. "Have you found a house for Mona?" she asked

her mother one afternoon, as her mother emerged from the telephone closet.

"No, I haven't and the real estate woman hasn't either. This city is just so crowded right now. There's one possibility in Arlington, but it's expensive and it's a long way off." She sank into a chair at the kitchen table and put both hands to her forehead.

"I wish it weren't so hard, Mum. I mean, I need Fay and you need Mona."

Her mother dropped her hands and looked at her. "You're right, dearie," she said and gave Joey a sad smile. "We both need our old friends, don't we?"

* * *

There were only three more weeks until Christmas. "When can we get a puppy, Mum?" Joey stood in the kitchen where her mother sat at the table with one elbow on the outspread newspaper, her forehead pressed against her hand. Maybe this wasn't a good time to ask, and yet a puppy would cheer Mum up; she had loved Queenie. "Poppy said we could get one after Queenie died and that was almost a whole month ago and if we got one now, it could be our main Christmas present. We might even name it Santa Claus."

A glass of whiskey sat on the table beside the newspaper. Her mother cupped both hands around it quickly, as if to hide it from Joey. "Ruthie says you can get puppies free at the pound," Joey went on, pretending not to notice the glass. "It's pretty close. Mad and I could walk there." Her mother looked at Joey for a minute, then let her eyes close slowly. This was the wrong time.

Joey wandered back into the living room and stood by the window, staring out. This would be such a different Christmas from the Christmases in Cambridge. There had been the Christmas play at school and the party afterward, and then on Christmas Eve she and Mad had gone caroling with the neighbors. She thought of how they had worn their matching red hoods and red embroidered mittens. Madeline got cross because the candle wax dripped down on her

mittens and she thought hers were ruined. That was back in the days when she didn't mind dressing like Joey.

Joey gazed around the shadowy living room. Where would they put a Christmas tree? Poppy loved decorating the tree, fixing the lights, hanging the tinsel and the little carved figures, the fish and the red apples and all the different angels. In Cambridge, he and Mum used to finish the tree while she and Mad were caroling and when they came back, there it was, all lighted and beautiful, glowing in the bay window. She had told Mum that what she wanted this year was a diary with a little lock and key. But was that what she really wanted? A puppy would be much better than a diary.

Outside on the street, a man in a Navy uniform stepped out of a bus, tucked a rolled newspaper under his arm, and started down the sidewalk. She saw a silver bar on his shoulder. Were there two? Was he a captain? She peered harder: just one bar. Only a first lieutenant.

"Come set the table, Joey," her mother called.

Joey took three forks, three spoons, and three knives from the drawer in the dining room buffet and started to put them on the place mats, but went back to the kitchen doorway, clutching the handful of silver. "You know, Mum. I've been thinking." She stood looking in at her mother, filled with an urgent need to lift her mother's mood somehow. "Maybe we shouldn't get a big tree this year. Mrs. Roosevelt isn't going to buy a big one, you know." Her mother raised her eyes and Joey hurried on. "She plans to buy a little tree, a potted one maybe and—"

"What will Mrs. Roosevelt do with a potted tree?" Her mother was looking straight at Joey and her face had softened into a pale smile.

"She's going to put it on a table in the private quarters of the White House and then, on Christmas Eve, she and the president will hang just a few of their most favorite decorations on it." Joey paused. Mrs. R's column had said nothing about decorations, but Joey was so pleased to have her mother's attention that she rushed on. "They

have a little red star they've had for years and a little angel with yellow hair." Joey bit her lip, feeling guilty about the lies, but Mum was smiling straight at her now.

"We could have a little tree like that. There are some outside on the sidewalk at that market near school. I walk past them every day. I could get one for us, Mum. You could give me the money and then you wouldn't have to bother. I could bring it straight home and it wouldn't cost as much as a real tree, I bet."

"We'll see, dearie. Maybe we'll do that just before Christmas."

"I could do it tomorrow. We could surprise Poppy."

"We'll work it out, dearie," her mother said. She looked over at the cups on the drainboard and sighed, as if trying to decide whether to dry them or leave them there. "Don't depend on surprising your father. He's got another crisis with his work right now."

Joey glanced at the empty glass beside her. Would that much whiskey make Mum fussy or sad? Maybe not. She went back to the dining room and laid one knife and one fork on either side of each place mat, then put down the spoons in an exact line with the knives, as if setting the table carefully might make something better.

* * *

Joey turned in the fourposter bed and started to pull the quilt over her shoulder, but realized suddenly that Madeline was sitting up, clutching her knees against her under her flannel nightgown. Her head was raised, listening. Joey saw the orange rim of light around the unused door that opened into their parents' room. A heavy, black bureau stood in front of it, so that when they went into their parents' room, they had to go out into the hall first.

Poppy and Mum were talking in their room, she realized. Joey slid up into a sitting position beside Madeline. "What's happening?" she whispered. Madeline shook her head and pressed one finger to her lips. Joey heard a sobbing noise and sucked in her breath; Mum was crying. She pressed both hands to her mouth and listened. "But why, Jack. Why?" It was her mother's voice. "Why after all these years?"

There were whispered words she couldn't understand, her father's voice, then her mother's voice, louder now, saying, "I can't go on this way, I tell you." Her voice was shaking. "I can't." Joey felt her mouth tremble.

Her father's voice was low and hard to hear. "Time," she heard him say in a hoarse whisper. "Just give me a little more time, for god's sake. The war. The work. It has to come first."

The sobbing noise came again. Joey pushed one leg out of the bed, then pulled it in again and cupped her trembling chin with both hands. She looked at Madeline. What could they do?

The sobbing stopped and they listened in the dimness, but there were no more voices. In the bluish light from the streetlight outside, Joey could see the dark shapes of the bedposts, the black mass of the bureau against the door, and the desk by the window with Madeline's three-ring notebook and her own war journal. Joey glanced back. The orange outline of the door was gone. Joey waited, then let her breath out slowly, relieved that the rim of light, connecting them to their parents, had disappeared.

Madeline lay down with a sigh and pulled the quilt up around her shoulders. Joey looked back at her, then lay down too and tugged at the quilt on her side. They couldn't talk now, and even if they could, what would they say? Madeline didn't know what was happening any more than she did. They would just have to wait. Joey pressed Fluffy against her chest and watched the shadows on the ceiling change as a bus pulled into the stop and then roared on.

Chapter 7

IT was a dark Saturday afternoon and Joey was wrapping a pair of white Angora mittens in red paper, her Christmas present for Madeline. The terrible sound of Mum's crying that she had heard that night a week ago still hung over her like a heavy cloak. Madeline had said she was crying because of Sarah, that Mum and Poppy might get a divorce. But Mum hadn't said anything about that and Joey kept watching her, trying to seem casual and unaware. "I need some green ribbon, Mum," she announced, coming into her mother's room.

Her mother was leaning over the bed, folding a sheet of white tissue paper over a red sweater. "What?" she straightened partway, holding one arm across the sweater. "You startled me."

"It's all right. You showed me the sweater Saturday. Remember?"

"I did? I showed it to you?"

"Yup. Right after lunch when Mad went off to basketball practice. She'll like it. It'll go with her skirt."

"Oh, I don't know." Joey's mother sighed and turned to gaze at the boxes stacked unevenly on her bureau. A striped tie was draped over them, its price tag dangling down. "I don't know. I feel I haven't done very well this year." She sighed again. "I don't like much of anything I've bought."

"Don't worry, Mum. We'll like them." Joey moved to the bureau to peer at the boxes.

"Stop it, Joey." Her mother's voice was harsh. "They won't be a surprise if you look."

"I'm not looking really. I'm just taking a tiny peek."

"Well, stop it." Her mother snapped. "Go back and do your own wrapping. I've got to finish all this before supper. Here. Take the ribbon."

Joey took the ribbon and turned to the window. "Mum, look," she shouted. "It's starting to snow. It's really snowing." She leaned toward the window, pressing her nose to the cold glass. "I didn't even notice before. I thought it was just sleet. But it's snow. Oh boy," she said and sang, "*'I'm dreaming of a white Christmas.'* This'll be just like Christmas in Cambridge after all."

"No." Her mother's voice was sharp, as she felt around under the pile of tissue paper for the Scotch tape. "It won't be like Cambridge at all." She turned. "Go along, Joey. I have to finish."

"Mum." Joey was back in the doorway a few minutes later. She crossed the rug and stood holding one of the knobs at the end of the bed. "You told us last night about that lady in your bandage rolling group. Remember? I want to write it in my war journal." Her mother looked away, but Joey went on. "You said that she heard yesterday morning that her son was killed in action in North Africa, but she came to bandage rolling that afternoon anyway. Is that right?" Joey twisted the knob of the footboard in both hands, while she waited for her mother to confirm the story. "I want to write that down, see? Because that's a good example of courage on the home front, I think."

Joey saw her mother roll her eyes briefly, then heard her give her a tired sigh, as she took one of the boxes from the bureau. "Well, don't you think so?" Joey asked. "I mean, you told us about it last night."

"Joey, please." Her mother pressed her lips together and shut her eyes. "Just go in your room now. Will you? And leave me alone."

Joey heard the phone ring below and she rushed downstairs. "It's for you, Mum," she shouted from the front hall. "Hurry. It's long distance."

Her mother went into the phone closet and closed the door. "Oh no," Joey heard her mother say. "Mona? Another miscarriage? She's already had two. When was it?"

Joey stood by the piano, stretching her fingers over the white keys silently, as she stood listening. It was something bad, and just before Christmas, too. "I'll definitely be there," Mum was saying. "I'll just arrange things here and come." Joey waited. There was talk about trains and when she would arrive. Would Mum go away at Christmas? She said goodbye finally, then Joey heard her dial a number. She said something, then hung up the receiver and went into the kitchen.

"What is it, Mum?" Joey asked, standing beside the soapstone sink. Her mother reached up to the cabinet where the liquor was and took down a bottle. "What's a miscarriage? Is Mona dying?"

"For heaven's sakes, Joey. Stop eavesdropping." Her mother turned and her eyes glared. "Mona's sick. She's had an operation and…. I've got to get hold of your father right away. I tried, but he's in a meeting, or that's what I was told," she added angrily. She poured some liquor into a glass and gulped it quickly.

"Are you going to Cambridge to see her? Are you going to be away for Christmas?"

"No, not for Christmas. Now look." Her mother glanced around the kitchen, then at the window. "Go outside, Joey, and shovel the walk," she said abruptly. "There's a shovel in the garage."

Joey worked a while in the cold, but there wasn't that much snow yet. The shovel made a loud raking sound when she pushed it along the concrete surface of the sidewalk and when she looked back, she saw the dark ugly path she had made in the soft whiteness. People shouldn't shovel the snow or drive in it or walk even, she thought. They should just look at it a while. But Mum had told her to shovel and Mum was worried about Mona. A broom would do better,

she decided, and started back to the house. She would get the broom from the kitchen.

"What do you mean you've got to go to Chicago Tuesday? That's Christmas Eve." Mum's voice was loud and Joey could hear it plainly from just inside the kitchen door. "I have to be with Mona, Jack. She's my oldest friend and she needs me." Joey reached for the broom in the corner behind the hot water heater and clutched the handle as she stood listening.

"Can't you postpone that meeting? This is serious." There was a silence, then Mum's voice rose. "No. I can't possibly do that. Miss Fitzgerald's mother's very sick. She's got her hands full already." Poppy must have suggested that Miss Fitzgerald, the lady next door, could babysit for them. It was good that wasn't going to happen, because Miss Fitzgerald wore laced boots and her house had a funny smell. "Oh Jack, for heaven's sake. Mad's not even thirteen. I can't leave her in charge." There was a pause, then Joey's mother said, "That's it then. I just can't go to Mona. She's my oldest friend, but you're not going to help me." There was another interval and then Mum demanded in a sharp voice, "Why does she have to go with you?" There was more talk that Joey couldn't hear and then, "Oh, Jack," and a moan.

"All right then." Her voice was brisk and angry again. "We'll see you Christmas morning, if we're lucky that is. Goodbye."

Joey stood holding the broom with both hands. Wasn't Poppy going to be here for Christmas Eve? Her mother came into the kitchen.

"Oh Lord, Joey. Look at you, dripping snow all over the kitchen. Where are your galoshes, for heaven's sake? Why didn't you put them on?"

"I forgot. I began shoveling, but the shovel doesn't work very well and—"

"Clean up that mess on the floor, Joey Lindsten, and put on your galoshes before I throw them at you," her mother shouted. Joey pulled a rag from under the sink and knelt down to soak up a melted

pool of snow lying on the cracked linoleum. She squeezed out the rag in the sink, then stuffed her feet into her galoshes.

"I'm going to sweep the snow," Joey said and took the broom.

"I don't care what you do," her mother said. "Just get out of here."

Joey carried the broom outside. There were large, black footprints on the sidewalk. Someone had walked by while she was in the kitchen and all at once the snow looked dirty and old.

* * *

Joey's father was playing the piano in the dining room. He had gotten home in time for Christmas Eve with them and they had had Christmas breakfast and then presents in the living room, but he had explained he might have to go back to the office in the afternoon. "*'On the first day of Christmas my true love gave to me...,'*" he sang as he played.

"*'Five gold rings,'*" Joey sang out loudly. They arrived at the twelfth day finally and sang through the whole long list of the true love's presents fast as her father played, garbling the words and laughing.

"I hate that carol," Madeline said. "It's so dumb. Play 'Lo, How A Rose E're Blooming,' Pop."

"All right." He flipped the pages of the carol book on the piano stand and they sang, as he played softly. Joey turned to look back at her mother; this was a favorite of hers. But she was in the kitchen basting the turkey or making the gravy perhaps.

"Now 'Good King Wenceslas,'" Joey announced as the carol ended. Her mother had come to the door of the kitchen and stood watching them, a wine glass in one hand. Darn it, Joey thought. Why did she have to drink now? They'd had a good morning gathered around the little tree on the coffee table. There were wool scarves for both Madeline and Joey, and Madeline liked her mittens and her red sweater. Joey had gotten the diary with the lock and key she'd asked for, but there was no puppy, of course. Poppy had brought silk stockings for Mum and a silver and turquoise pin. Why wine? Poppy was here now, even if he had to go back to the office later.

When they got to the second verse, Joey flung out one arm in a

commanding gesture and gave her father a kingly look. *"'Hither, page, and stand by me,'"* she sang in a loud, deep voice as she pointed to him. *"'If thou knows't his telling, Yonder peasant who is he? Where and what his dwelling?'"*

"'Sire, he lives a good league hence,'" her father began in a high wavery voice that made Joey smile. *"'Underneath the mountain....'"* Joey turned to make sure her mother was smiling, too, but Mum had returned to the kitchen.

"Watch out." Madeline's shout was high, a shriek almost. Joey turned; she had been so busy being the king that she hadn't even noticed that Madeline had left the piano, too.

Her father pushed back the piano stool and rushed into the kitchen. He grabbed two potholders. "Here. I've got it," he said and lifted the hot pan with the browned turkey from the oven rack, which was half pulled out. He put it on the counter. "There," he said and slid the turkey onto the platter. It flopped to one side, but he righted it and stuck a sprig of parsley in the neck opening. "I'll take it in." He lifted the platter and carried it into the dining room.

"I bet you won't carve it, much less eat it," their mother said, ignoring Madeline, who was bringing in the serving dishes of rice and peas and then the china gravy boat, while Joey trailed after her with the dish of cranberry sauce. "You'll leave in ten minutes to go back to that office probably." She had clutched her arms around her and her eyes had that blurry look that always seemed to come with drinking.

"Come on, Mum. Sit down." Madeline took her mother's arm and led her to the other end of the table. Their father settled the platter securely on the cork mat at the end of the table and lifted the carving knife.

"All right," he said in a loud voice. "White meat for everybody but Joey. You want a drumstick. Right?" he asked looking at her. He ran one finger along the edge of the knife, plunged the fork into the top of the breast, and began to carve just as the phone in the closet started ringing. He turned his head in its direction and grimaced.

"See? I told you so," their mother said. "Just say no, and if it's her...." Her face flushed as she watched their father put down the carving knife and fork and toss his napkin on the table.

He crossed to the phone closet in several long steps and and lifted the receiver on the third ring. "Yes, of course," Joey heard him say. "I know. Certainly. Yes, it's Christmas. We've just started Christmas dinner. No, of course. I understand." There was more talk and he came back into the room looking tired. "It was Oppie," he said. "There's confusion about that report from the Chicago lab. I've gotta get back to the office." He sighed heavily and put both hands in his trouser pockets. "I'm really sorry, but I've got to. That's all." He looked down at the semicircle of their staring faces. "It's an emergency." His eyes sought out Madeline's. "Oppie wouldn't call on Christmas if it wasn't. I told him we were having Christmas dinner, but...." His shoulders sagged and he put one hand to his forehead.

"I suppose you're going to get her to come help." Their mother's voice was high and loud. "Aren't you?"

"She knows the files," their father said wearily and turned. "Look. You go upstairs and have some rest and we'll have the dinner tonight."

"We're going to the British Embassy tonight. Remember? Besides the turkey'll be dry. Meat's going to be rationed next, they say. We probably won't get another turkey for months, unless you and she can defeat those Nazis soon."

"It's an emergency, Amanda. I warned you this might happen. It's not my choice." He glanced around him. "I've got to get going. That reception thing is tonight, is it? At the Embassy? I'll try to finish and get back here." He looked down the table at her. "Why don't you go upstairs and have a nap. Sleep a while and you'll be fine."

"I'm fine right now. I'm just mad about the turkey."

"Mum, I think...." Joey started, but stopped. Her voice was too shaky.

Her father picked up the long, silver knife. "I can carve the bird at least. Then I'll go." He started to cut into the breast.

"We're okay, Pop," Madeline said and stood. "You'd better go." She glanced down the table at her mother. "We'll see she gets to bed."

* * *

Joey sat at the kitchen table on Christmas night, making a list of the thank-you notes that she had to write: "Aunt Helen for stationary, Uncle Bill for the little wooden dog." She looked up hearing her mother on the stairs. Mum had gotten dressed for the party, but what if Poppy didn't get home in time? It was awful that he'd had to go back to the office just as they were starting Christmas dinner, but it wasn't his fault. Why was Mum so mad? Why did she fuss at him and keep drinking that dumb wine? It had to do with that Sarah person, of course. Still Mum shouldn't be fussy on Christmas day.

"Don't try to write in that light, Joey," her mother said coming into the kitchen. "Go upstairs to your desk where you have some good light."

Joey took in her mother in her long dress, the one with panels of green and blue. She had pinned her pearl circlet to the wide shoulder strap, or Madeline had, and she was wearing her gold bracelet. But something was wrong. Strands of hair hung down from her bun in back and her face looked peculiarly naked without lipstick or powder. "Go upstairs," her mother repeated sharply, as if she felt Joey's appraising stare. "Don't write here. You'll ruin your eyes."

"All right, all right. I'm going." Joey stood and watched as her mother crossed to the liquor cabinet and sloshed some amber-colored whiskey into a glass. "Poppy'll be here soon," Joey said, hoping she was right.

"He'll get here when he gets here," her mother said "and not a minute sooner." She turned and started toward the door, but stumbled and Joey saw her catch herself on the door jamb.

"You could lie down on the couch," Joey suggested. "You could have a nap until he comes." Her mother moved through the dim dining room to the living room, not seeming to hear. She sank down on the couch, lifted her legs, and stretched out with a sigh. Joey

watched her a moment from the doorway, relieved. She was safe there, she thought, and started up the stairs.

When Joey heard her father's cough in the hall below, she abandoned her thank-you notes. Everything would be all right now that he was home, she thought, and started down the stairs. But she stopped. Mum's voice was angry; they were arguing about that party.

"It's too late now anyway," her father was saying.

"I've been waiting since five-thirty and nobody's been in your office since six. I phoned twice. Where have you been, damnit?"

"Oh God, Amanda. Do you have to police me?"

Joey watched her mother rise from the couch and lurch across the room into the hall. She grabbed the newel post and turned back to him. "We'll be late, but we'll go. Just wait a minute. I have to put on some lipstick," she said and started up the stairs, ignoring Joey on the bottom step. "I'll be right down."

Joey stood in the living room looking at the little tree in its pot on the coffee table. Mum had tied a red ribbon around the base and they had hung the two little angels on it this morning. But it looked pathetic now.

"I wish we'd bought a real tree," she said to her father. "We could have, Poppy, you know."

"Well, it's too late now." Joey followed her father as he moved through the dining room into the kitchen. He took a glass from the cupboard and poured himself some whiskey from the bottle that stood on the counter, then bent over the spread of newspapers on the kitchen table and pulled out the editorial page.

"Mum's going to lie down, Pop," Madeline announced, coming into the kitchen. "Want to do the new puzzle?" Her father looked up and Joey followed them back to the living room, where Madeline began unfolding the legs of the card table. She drew it close to the big chair, then spilled the pieces of the jigsaw puzzle from the box, as Joey stood watching. Why start a puzzle now? Weren't Mum and Poppy going out? The puzzle wasn't even Madeline's present; it was Poppy's. But Madeline seemed bent on distracting their father.

She sat down in the big chair and her father drew up another. "Bring a chair from the kitchen," she directed Joey.

But there was a noise at the top of the staircase, a bumping sound, then a scream. Her father jumped up and his chair fell backwards with a crash. He darted to the staircase; Madeline was just behind him. Joey saw her mother crumpled on the hall floor. Her head was pressed against the table leg and she looked strangely loose and messy, like an abandoned doll.

Their father knelt and bent over her. Madeline crouched beside him, but Joey hung back, afraid. Had she cried out, "Mum, Mum?" She wasn't sure. Two strands of black hair were plastered across her mother's cheek and a place on her forehead was beginning to ooze blood. Joey twisted to look back at the long, steep staircase, then at her mother again. The toe of her shoe was sticking through a tear in one of the blue panels of her dress.

"Should I call an ambulance, Pop?" Madeline whispered, close to her father's elbow.

"No. Let's wait a minute."

Her mother moaned and opened her eyes, then raised up on one elbow slowly. She glanced at Joey's father kneeling beside her, then down at her feet. "Oh Lord," she said. "I'm all right, I think." She pulled the dress off her shoe and pushed her leg out. "I'm all right," she said again and lay back. "I don't think I broke anything."

"Your head's bleeding," her father told her. "Do you feel dizzy?"

"No," Joey's mother said and sat up part way. "Oh, Lord," she moaned and slumped down again. "I'm not dizzy," she told him. "I'm fine."

"Get me some gauze, Mad," Joey's father ordered.

Madeline ran up the stairs. Joey heard her open the medicine cabinet in the bathroom, then she was beside them again, holding a packet of gauze pads. Their father took one, bent over their mother and blotted the blood on her forehead. "It's a surface wound, I think." He blotted it with a second pad. "Looks as though you just nicked the skin a little." He reached up and put the bloodied gauze

on the hall table, then sat back to study Joey's mother, who sighed and closed her eyes.

"The cut's the least of my problems," she said wearily.

"I'm going to move you to the couch," he told her. "Okay?"

"No. I can walk," their mother said. She pulled herself a little higher, then turned to grasp the edge of the table.

"Wait." Their father pushed his arms under her and lifted her up. Joey stepped back and watched, as he carried her mother into the living room and lowered her to the couch.

She heard her mother sigh, then saw her turn on her side. Her head dropped forward and she made retching noises. Madeline ran to the kitchen and returned with a mixing bowl and a dish towel, but Joey just stood staring. Her mother leaned over the bowl on the floor, retched again, then lay back with a moan. She closed her eyes and covered her face with one bare arm. Joey, who was still staring, saw a tear ooze out from under her elbow and run down the side of her cheek.

A long moment passed. Joey's mother lifted her arm. "I'm sorry," she said in a low voice. "So sorry." Her eyes rested on Joey a moment and she pulled herself up on one elbow. "Oh, dearie, what a terrible Christmas." Joey opened her mouth, but her voice did not come. Her mother lay back and closed her eyes again.

Her father fixed a pillow behind her head and smoothed back her hair. Joey and Madeline waited. After a while their mother swung her feet to the rug and sat up. She looked around her, then down at the empty bowl. "I'm going upstairs and lie down," she said in a low voice. She glanced at their father, who was sitting forward on the overstuffed chair watching her, and then at the bowl again. She pressed both fists down on the couch, making the madras spread pull into long wrinkles, then lifted herself and stood up shakily.

"Careful now," their father said. He stood beside her and circled her waist with his arm, but their mother jerked forward, shaking his arm off her back, and started toward the stairs alone. Joey clutched

one hand within the other as she watched. *Don't fall again, Mum. Please.* Her mother stopped at the banister post, gripped it, and paused, as though she might turn back to say something, but she put her foot on the step instead and started up the staircase. The hem of her dress was torn, Joey saw, and a piece of blue silk was trailing behind.

* * *

Joey stood at the bottom of the stairs listening with Madeline. They heard their father speaking in soothing tones, heard him in the bathroom getting iodine from the medicine cabinet maybe.

"It's good we don't have to call an ambulance," Joey whispered. "That she only has one cut, I mean."

"She could have broken her neck," Madeline said in a low, furious voice. Joey felt herself tremble and sat down on the second step. People who broke their necks usually died. Madeline leaned against the banister. They heard their father cross the room and pause in the bedroom doorway. "You're going to feel better soon," they heard him say, then he went back into the room. There was the sound of her mother's voice. Her father said something, then he closed the door with a clicking sound and Joey got up from the step as he started down the stairs.

He stopped partway, seeming surprised to see them waiting there. "Listen," he began. "Your Mum's all right. She's tired mostly." Joey felt him stare at them and knew they were staring back. "Come on in the kitchen, kids." He led the way through the dining room.

"What'd you do with the turkey?" he asked. "Didya put it in the refrigerator?" Madeline nodded and he sat down at the table. "Good girl." He gazed at them as they sat down opposite him. "Now, look," he began. "Don't be scared about this. Your Mum's okay. She's been worried and tired." He let out a long sigh, glanced up at the map on the wall, then back at them. "We're all tired and under strain," he said. "Your mother drank a little wine, thinking it would relax her, but it was too much. She was disappointed that I had to go back to the office and so was I." He sighed again.

"But Poppy." Joey twisted one pigtail, ignoring the tight pull on her scalp. "Why was she so mad?"

"There are many frustrations with this war, Joey. The uncertainty of the North African campaign and...." He looked down suddenly, closed his eyes with a wincing expression, then covered his face with one hand. After a moment he raised his head and glanced up at the map again.

"And Stalingrad?" Joey offered and stopped. That was dumb. Mum wasn't mad about Stalingrad. She glanced across at Madeline, but her sister was silent.

"Joey, honey, I can't talk anymore right now. Later. All right? Right now I'm going to go have another look at your Mum." He stood and put one hand on her head. "Everything's going to be all right," he said. "It'll be all right."

Joey felt the comforting weight of his hand on her head, then it lifted and was gone. What does that mean, she thought, as she watched him leave the kitchen. Was 'it' the war or was 'it' their family? What would be all right? Did Poppy know?

1943

Chapter 8

J OEY and Madeline lay on their fourposter bed listening to the radio the day after New Year's. "Red River Valley," the theme song of "Our Gal Sunday," had just ended and a smooth voice was asking, *"Can this girl from a mining town in the West find happiness as the wife of a wealthy and titled Englishman?"*

Joey stared at the fabric-covered window on the front of the radio, wondering what would happen in Sunday's complicated life today and whether she would ever be really happy. But Madeline slid from the bed and turned the button to OFF.

"I'm sick of listening to this stupid radio," she said and stalked to the window. "And sick of this stupid vacation, too."

Joey stared at her sister's back in her red sweater as the sick, helpless feeling that had come with Mum's fall a week ago began to spread through her again. It wasn't a stupid vacation; it was a scary one, as Madeline knew well. Joey clutched her knees against her sweater. "She told us the morning after Christmas that she was going to stop. Remember?"

"Sure, but it's not that easy." Madeline's voice was stern. "People who drink always make promises and then they break them. Still, she hasn't had a drink all week long. Not since it happened."

"How do you know?"

"I measure the bottles. Pop hasn't been drinking either. I measure the bourbon every morning and then the sherry."

"You do?" Joey stared at her sister. "How?"

"A ruler. I keep it in the cupboard behind the flower pots."

Joey drew in her breath. She had watched her mother every day, worrying about whether she would keep her promise, but Madeline had actually done something; she had measured the bottles. Joey let her breath out and felt her shoulders slump. She would never have thought of that.

"I just wish she hadn't gone next door this morning," Madeline said. "I mean, we barely knew that old lady. It's too bad she died and everything, but Mum was going to take us shopping and now there might not be time."

"She took Miss Fitzgerald some soup," Joey said. "Her mother'd been sick a long time."

"Well, she was practically a hundred." Madeline sighed.

The front door opened below with its usual rattle and they heard their mother shout, "Girls, girls! Something wonderful's happened."

Joey turned to glance at Madeline and they both started toward the upstairs hall, but their mother had rushed up the stairs and was already at the door to their bedroom. "Guess what?" she said and sat down on the bed, breathing hard. "Oh, this is so amazing!"

"What, Mum? What?" Joey asked. She plonked down beside her mother, who squeezed her hands together in excitement and looked from Joey to Madeline.

"I went over to Miss Fitzgerald's," she started, then stopped a moment, waiting for her breath to even. "I said all the usual things. I mean, I liked the old lady. She was a reader and we talked about books several times and—"

"But what happened, Mum?" Madeline stood clasping the bedpost. "What happened?" she asked again.

"Well, I said nice things about missing her and all that and when Miss Fitzgerald spoke about returning to Ohio, I realized all at once

that she was planning to stay there. So I...." Joey's mother stopped and leaned forward. "I was embarrassed, of course. I mean, it wasn't the moment to ask such a question and yet, I just said, 'Is there any chance, Miss Fitzgerald, that you might be willing to rent your house to some very dear friends of ours for the duration?' And she asked about Mona and Henry and I told her what wonderful people they were and that Mona was my closest friend and a model housekeeper, which isn't exactly true, and that Henry would be doing essential war work and that they had been house-hunting for over two months and had found nothing. She looked serious and then she said, 'I'll do it. I mean, he's important to the war effort and she's your close friend and you were kind to Mother. If they'd like the house, I'll rent it to them beginning next week.'"

"Her house? Her own house that's attached to ours?" Joey asked and her voice rose in a squeak.

"Yes, dearie. Yes, yes." Her mother clutched her knees. "It solves a huge problem. Mona and Fay and Henry will be right next door. Right there." She pointed out into the hall and all three stared a moment at the wall with its paper of faded castles ringed with pink roses, the wall that separated them from the house next door. "It'll change so much." She slipped down from the bed. "I'll be back," she said. "I've got to call Mona right now." She moved to the door, then turned. "Oh, girls, I'm so happy," she said. "This could save us all." She beamed at them a moment, then rushed from the room.

Joey heard the clatter of heels on the uncarpeted stairs as her mother hurried down to the phone. She wanted to join her mother's exuberance, but she looked back at Madeline. "'Save us all'?" she said. "She means the drinking, doesn't she?"

"Yeah, that and everything else. Having Mona nearby'll help her get back to herself again. She'll talk to Mona and Mona'll help her with her problems."

"Sarah?" Joey said.

"Yeah," Madeline said. "Sarah, definitely."

<p style="text-align:center">* * *</p>

Christmas vacation was almost over and the Hartleys had moved into the attached house next door. "Mum, come see what Fay and I made," Joey shouted, as she heard her mother open the front door of the Hartleys' house. Her mother came into the kitchen, carrying a flowered quilt. Joey felt her mother's gaze and glanced down at herself in one of Mona's aprons, which was tied around her waist, and then at the spatula in her hand. Her friend, Fay, hovered beside her, wearing an apron, too. She was taller than Joey, and as she bent over the iced cake on the table, one of her blonde pigtails swung down so that the tip almost brushed the surface of the cake. She straightened and Joey saw flecks of sugar on the surface of her small wire-rimmed glasses. "Look, Mum." Joey pointed to the round cake, iced with white, sitting on a blue platter. "Isn't it swell?"

Her mother moved closer. "Happy B-day to Mad," she said, reading the slightly crooked blue words out loud.

"We had a whole lot of trouble with the 'M'," Joey said. "Mona had to scrape it off twice. It was so shaky. But it's all right now, don't you think? You didn't tell Mad about the party, did you, Mom?" Joey gave her mother a stern look.

"No, dearie. She'll be completely surprised. She thinks it'll just be the three of us for supper at home." Her mother moved closer to the table. "That cake is wonderful, but where'd you get all that sugar?" She turned as Mona came up from the basement panting. Mona put down a wicker basket of clothes and lifted one arm to push a clump of curly gray hair back behind her ear. The bib of the red-striped apron she was wearing was pulled slightly askew over her heavy breasts, and beneath it was a black sweater with the sleeves pushed up.

"Sugar," she said and laughed. "I hoarded some and brought it along. Don't you dare tell Henry." Her mouth opened into a toothy smile and she laughed again. "Oh, thanks," she said, taking the quilt from Joey's mother. "You're sure you don't need it?" Joey's mother shook her head and Mona went to drape the quilt over the banister

in the hall. "I forgot that Washington can be just as cold as Cambridge," she said, coming back into the kitchen.

"Seems colder at times," Joey's mother said. "These old houses are so drafty."

"Drafty and dirty." Mona pressed both hands to the small of her back, then pulled off her apron. "I've spent two full days cleaning this kitchen, including that long morning you put in yesterday, and I still haven't finished the cupboards. I've used a whole can of Dutch Cleanser." She laughed and her face crinkled with gaiety as though cleaning the dirty kitchen was suddenly a funny joke.

"You've got to be careful, Mona," Joey's mother said. "You've only been out of the hospital three weeks, you know."

"Oh, Amanda. You know me. I'm strong as a horse, really. I just don't seem able to…to hold onto what I conceive." She glanced quickly at the two girls at the kitchen table. "Isn't that wonderful?" she said and pointed to the cake. "These two have been working on it all afternoon. I didn't do much at all." She raised both hands to her hair and smiled at Joey's mother, then at the two girls in their smeared aprons. "How about some tea? I need a breather."

"Lovely," Joey's mother said and Joey watched her sit down in a chair by the table and glance around the kitchen. Mum was much prettier than Mona, Joey thought, taller and more serene, but Mona had a happy laugh and she could make people feel cozy. "You know, I'm still dazed by our luck," Joey's mother said. "I mean, of all the places in this city that you could have found, to think you're right next door." She sighed happily as she glanced at Mona, then back at Joey. "Now girls, if you've finished the cake, why don't you go upstairs and play a while so the mothers can talk."

"What about?" Joey asked as she began untying the strings of her apron, which had been knotted twice around her waist. But, of course, she knew.

* * *

Joey and Fay had arranged books in two lines on the rug in Fay's room. Each book made a bed and each had a doll or a stuffed animal

lying on top of it with a Kleenex sheet drawn up to its chin. Three of Fay's dolls were on one side, her long floppy rabbit was on the other, and beyond it, her limp teddy bear with only one black button eye. Joey's dog, Fluffy, was at the bottom of the second row, lying under his sheet. The doll named Lucy had a match stick thermometer sticking out of her mouth, since her mouth really opened, and the rabbit had a band of Kleenex wrapped around his arm with a piece of elastic hanging from it for a blood pressure machine.

"I'll be back in a minute," Fay said. She was kneeling beside Lucy's bed, but she got up quickly, yanked at one knee sock and ran out of the room. Joey heard her voice on the old house telephone in the hall. *"Joyce Jordan, call surgery,"* Fay said, using a line from one of their favorite soap operas. *"Call surgery.* They're ready to operate on Lucy," she said, coming back into the room.

"But it's the rabbit," Joey said. "He's scheduled for an appendectomy at four this afternoon." She said the word "appendectomy" slowly, pleased with herself for remembering it, and yet as she sat back on her knees and stared up at Fay, whose blouse hung down below her navy blue sweater, she had a sudden sense of Madeline watching. Madeline would say that playing hospital with dolls and stuffed animals was childish, and maybe she was right. Maybe after today she would tell Fay that she had gotten too old to play doll hospital.

"An appen...." Fay hesitated. "All right. I'll go call surgery again. They must have made a mistake."

Light shone through the window, making two rectangles of warm sun on the rug. The house felt odd, because it was like their own house and yet it wasn't. It was on the corner, so it had windows on the side and got more light than theirs. But it was also because Mona had already made it feel homey with this braided rug on the floor, the striped spread on Fay's bed, and the red and blue pillows. Mum said it was a miracle that the Hartleys had gotten this house, and it was.

Joey looked across at the toy box under the window, at the white

painted desk, and the shelf beside it with Fay's books. Lucky Fay to have a room all to herself, a bed where Lucy and Evelyn, her two favorite dolls, could lounge on the bright pillows all day. Fay had her own bureau, too, where she could spread out her animal collection.

"How do you spell appendectomy?" Fay shouted down the stairs.

"That's a hard one," Mona's voice called back. "You better come down here."

Joey followed Fay down the stairs and into the kitchen, where her mother was sitting at the table with Mona. "Why do you want to know?" Mona asked. She was stirring her tea, but she put down her spoon in the saucer and looked at the girls.

"We need to write out the surgeon's orders," Fay explained. "They've made a mistake." Mona laughed and Joey's mother joined in, tipping her head, then smiling at Joey and Fay. The kitchen was big, like theirs, but brighter with windows on one side, and Mona had hung red-and-white checked curtains, and there were two geranium plants on the window sill. Joey sighed. If only their kitchen had windows. There was the back door, of course, but you couldn't keep it open all the time, not in winter anyway.

Still it *was* a miracle, Joey thought. Now their best friends from Cambridge were right next door. Joey could knock on the wall beside the stairs and Fay could hear. She could even hear if Fay cupped her hands around her mouth and shouted, "Joey" into the wall. But they shouldn't do that often, of course.

* * *

The two lighted candles that stood on the dining room table brought the five faces around it into a magical closeness that Joey didn't want anyone to break. A last slice of birthday cake sat on the platter amidst a clutter of crumbs and the burnt candles were heaped together on one side. Crumpled wrapping paper lay on the floor of the dining room and a pink ribbon dangled from the chandelier above. Madeline had put on her new hair band and was pushing the turquoise bracelet Mona had given her up and down her arm. They

had been laughing at Mona's tale of a chocolate birthday cake she had tried to bake for Henry, which had collapsed when she pulled it out of the oven, so that Georgia had to make a new one.

"How is Georgia?" Joey's mother asked. "You said she'd gotten a war job somewhere."

"Oh, yes and how I miss her. Remember Rufus, her boyfriend?" Joey's mother nodded. "Well, he enlisted right before Labor Day. Georgia worked for us another month and then she announced she'd taken a job in a munitions factory in Lynn. Ratheon, actually. She says she's enjoying it and earning lots of money, but I tell you it was an adjustment for me, cooking all the meals, doing the laundry. Spoiled little wifey that I am." She spread both hands over the slight bulge of her stomach and laughed.

"Like Leola," Madeline said. "She's working at the arsenal in Watertown."

"She left back in May, didn't she?" Mona said. "About a month before you came down here?"

"I call her Rosie the Riveter now," Joey said and paused, thinking of the warm Cambridge kitchen, smelling of vanilla and cinnamon, and the round yellow cookies with brown edges that Leola used to pull from the oven on the hot cookie sheet. They would never make those here in the war, she thought. There was no sugar and no time.

"I miss her," Joey's mother said and leaned back. "It sounds ridiculous to complain that I miss my maid when bombs are falling on London. But I do. Leola was a friend and she made so much possible." She stopped and sighed. "It's a big change."

"Enormous," Mona said. "I mean, I can vacuum and do the laundry and I can cook a pretty decent meal, but...." She paused. "You know, looking back what startles me, Amanda, is the time we had then, six months ago or last year. I used to stretch out and read novels in the middle of the day, for heaven sakes, and you and I took two art history courses together."

"And every Wednesday," Joey's mother said, "we used to play

bridge with Betty and Anita all afternoon and drink sherry flips."

Sherry, Joey thought, and bit her lip, as she saw her mother look down at the rug, then reach out and pick up a crumpled piece of tissue paper and smooth it on her knee.

"We have to change our standards," Mona said and pointed to the wicker clothes basket still sitting near the kitchen door. "I told Henry, I'm not ironing anybody's underwear. Just shirts and they'll be a lick and a promise." She paused and gazed down at the remains of the cake. "Planning menus, ordering the groceries by phone, having time to read, shop, go to the beauty parlor. Honestly. It was a different world, wasn't it?"

Joey heard the tinge of sadness in Mona's voice and thought again of the Cambridge kitchen and the hot brown-edged cookies on the cookie sheet.

"A world that's gone for good maybe," Joey's mother said slowly.

"Actually it's sort of a relief at times," Mona said. "I mean, I used to worry about Georgia's moods, you know, whether she was bored or why she was irritable some mornings and now at least that worry's gone."

"But other worries have filled the gap," Joey's mother said and smoothed the tissue paper again.

"I thought your daddy would be here by now." Fay leaned over to look into the living room. "He knows it's Mad's birthday and your Mum told him we were all over here."

"No, Fay, honey. No," Mona broke in. "We didn't expect him. He's doing a big war job and he had to work late tonight."

"Well, so did my daddy, but tonight's not my birthday. If it was though, I bet he'd be here."

"Lots of fathers and mothers, too, are doing war jobs and putting in long hours," Mona said. "We have to get used to long hours and other things until the war is over." Mona looked across at Joey's mother, who folded the tissue paper into a neat rectangle and pushed back her chair.

"We have to go home, I'm afraid. School tomorrow. Joey, you and

Mad help Fay clear the table. Then we'll be off." Joey stacked the dessert plates as her mother moved into the front hall with Mona. When she came back from the kitchen, she heard Mona saying, "It's the pressure he's under, Amanda. You've just got to take it day by day. Things are getting better. The Germans are retreating from Russia and...." Mona stopped and they put on their coats and said their goodbyes. They went down the iron steps to the brick sidewalk and up almost identical steps to their own house.

Joey came down to the living room in her nightgown to say goodnight. Her mother was stretched on the couch with the newspaper spread on her lap. "Mum," she said and put her hand on her mother's arm. "You know what I think?"

Her mother looked up. "No, dearie. What?"

"I think a new time is beginning for us. With Mona and Fay here, I mean."

"I think so, too, dearie," her mother said. "I hope so."

Chapter 9

JOEY led Fay up the concrete steps of Radley Elementary School and pulled open the heavy door. The familiar odor of disinfectant and steam table food rushed toward her as she held the door back for Fay. "It's good it's open. Sometimes, if the bus comes early, it's still locked and I have to sit outside on the steps and it's really cold. That's the lunch room," she said pointing to two lighted windows in the closed double doors. "We have lunch in there and your locker will probably be on that side over there. Mine's here. See?" She unbuttoned her coat and pulled her key on its braided string up from under her sweater. She pushed the key into the round metal padlock, turned it with her cold fingers, and pulled open the door. "You put all your stuff in," she explained and tugged off her coat, hung it on the metal hook inside, and reached for a book on the shelf above. "You can put your books here too, and your lunch, of course. But you have to be careful. Smelly things like bananas really stink up the whole locker and make you feel like barfing." She draped her knitted scarf over the hook, slammed the door shut and locked it again. "If we're not in the same homeroom, we'll meet right here at recess. All right?"

"Don't you think we'll be in the same homeroom?" Fay asked,

and her voice trembled as she stood close to Joey in her blue coat, the ends of her pigtails caught in the folds of its hood and a dot of mucus hanging from her nose. "You said we would."

"I don't know really," Joey said. "I hope so. Look. Come here." She led Fay to a second door, but it was locked. They stood side by side at the window next to it staring down at the gravel-covered play area. "We can get balls from that bin over there." Joey paused, feeling flushed, then straightened. She had never gotten a ball at recess herself. Most of the days last fall, when they were supposed to go outside, she had sat hunched over on the steps, pretending to be part of whichever group of girls was sitting there. She had smiled nervously at their jokes, as the boys tossed balls back and forth, all the time secretly counting the hours until she could go home. And there had been those times in the beginning when she had sat in Mr. Peterson's closet. She had hated the lockers, the lunch room smells, and the lines they had to wait in out in the hall. Yet now she was showing it all to Fay as if it was quite ordinary, even fun.

"We better go," she said and led Fay up the black metal stairs and down the hall to her home room. "Mrs. Martin'll tell us what room you're in when we get there. Cross your fingers it's 201." They joined a girl sitting on the floor, just outside the homeroom, her back against the tiled wall, her book bag flopped down on the floor beside her. She was always early, a loner with black pigtails that stuck straight out. Joey had barely spoken to her, but now she smiled, as if they were friends.

"Mrs. Martin not here yet?" Joey asked. That was obvious; if she had been, the doors would be open and the lights would be on inside. Joey and Fay backed up against the wall and slid down the smooth tiled surface, squatting on their haunches beside the waiting girl.

A bell rang somewhere, a loud, persistent clanging. Then they heard the front door crash open and shouts and voices as people flooded in below. Joey and Fay went to the stairwell and looked down at them. "Here, Chuck. Catch," one boy yelled and tossed a

football to a boy in an orange woolen cap, as two others in black leather jackets and scarves began stamping up the metal stairs. Fay turned to Joey, her eyes behind the slightly foggy lenses of her glasses were filled with fear. "It's all right," Joey reassured her. "You don't have to bother with most of them. Just our class. There's thirty-two in it now."

"There were only ten in Miss Fogg's class."

"Well, it's bigger here."

"Don't you ever get homesick for Green Fields?" Fay whispered.

"Not really," Joey said. "After a while, you'll get to like this. It's more…" she hesitated, reaching for a word. "It's more realistic. I mean, with the war and everything." She paused, uncertain what she meant. Right now she only knew that she was hugely grateful just to have Fay beside her.

* * *

When Joey came into the kitchen after school one afternoon in late January, she was surprised to see her mother standing at the stove in her green wool dress with its short matching jacket and her amber beads hanging down. "Mum," Joey said. "Where have you been?" She put her books down on the kitchen table and looked at Madeline, who was already sitting at the kitchen table. Was the green dress a good sign or a sign of something ominous?

"I have some news, dearie." Joey did not reach to unbutton her navy blue coat, but stood staring at her mother. What news? What did she mean? Madeline had stopped measuring the bottles several weeks ago. She said there wasn't any point; Mum had definitely stopped drinking. But why was she dressed up in the middle of the afternoon and why were her eyes shining in that excited way? Joey swallowed, feeling guilty. School had gotten better because of Fay and the awful things at Christmas seemed far behind. But now maybe something bad had happened, all because she'd forgotten to worry.

"Take off your coat, Joey, and come sit down."

Joey glanced at Madeline, but Madeline was looking at their

mother. Joey pulled her arms out of her coat, flung it on the couch in the living room, and returned to the kitchen to sit down. Joey's mother poured Ovaltine into three cups, put them in their saucers on the table, and sat down. "I'm going to take a job," she said and smiled at Madeline, then Joey. "A war job," she explained. "Mona and I have talked the whole thing over. On the afternoons I have to work late, you girls will go next door and do your homework at Mona's and have supper with Mona and Fay and Henry, too, when he's home for supper."

Joey stared at her mother. "A war job?" she said and looked across at Madeline, who didn't seem surprised. Had she heard this already? Did she think it was all right?

"What kind of war job?" Joey asked. "Will you make weapons, like Poppy?" She looked down quickly, embarrassed. Of course, Mum wouldn't make weapons.

"No. I'm going to work at a place called the United Nations Service Center, dearie. It's an old hotel near Union Station, where all the trains come in and it's for servicemen. Soldiers come on their way to training camps or to Europe. To the Pacific, too, and they need beds and food and sometimes babysitters and space for their wives, if they've brought them along."

"But what will you do?" Joey persisted, annoyed that she was asking the questions while Madeline remained silent.

"I'm going to help run the telephone bank."

"What's that?" Joey felt herself taking the news in slowly. How many days would Mum be working late and not be here when she and Madeline got home? "Oh, you're going to help with the telephones, because you used to have a job operating telephones before you married Poppy and had us," Joey said, answering herself. "Right?"

"That's right, dearie. First I'll have to learn about all the improvements they've made and get used to the new switchboards. But when I do, I'll be training volunteers and...."

Joey glanced at her sister, certain that her mother had told

Madeline all this before she came. She stared, annoyed, but also reassured. If Mad thought it would be good for Mum to do this job, she was probably right. "Why do they need phones?" she asked.

"Because when soldiers and sailors come into the Center one of the first things they want to do is call home. They want to talk to their wives or their mothers before they leave for Europe or the Pacific or, if they're on their way home, they want to let their families know."

"Oh." Joey breathed out slowly. The news still seemed strange. She would walk home from school with Fay some days and go straight to the Hartleys, where they could listen to "Backstage Wife" and "Joyce Jordan" up in Fay's room, because Mona didn't mind if they listened while they did their homework.

"Mona is devoted to you two, you know. She always says you're like her own daughters and she feels that this will be her way of helping with the war effort."

"She may not be so devoted when she gets to know us better," Madeline said.

"What does Poppy think?" Joey asked. "Does he know?"

"Yes, dearie," Joey's mother said. "He thinks it's fine. I think he's even a little proud," she added and put both forearms on the table as she looked across at Joey and Madeline. "You see, girls, this is something I can do for the war and for myself, too. I think that's important for us all," she added quietly.

* * *

Joey's mother stood at the stove stirring chipped beef into a white sauce. She had been going to her new job every day for two weeks, but her routine still felt odd to Joey. "I think this was about the busiest day I've ever had," she said. "One thing happened after another."

"Like what?" Madeline turned from the counter where she was slicing some carrots.

"Well, first a two-year-old got lost in the lobby. It was scary. I was afraid she'd gotten outside, but I found her hiding behind some chairs that were piled with coats. Then I had four new volunteers

to instruct and none of them had had any telephone experience."

Joey, who was sitting at the kitchen table, stared at her mother. She looked different somehow, not just because of her new blue dress, which showed above her apron, but different in some other way, too. She seemed taller, her hair was glossier, and her face was brighter, almost glowing.

"And in the afternoon an odd thing happened," her mother went on. "I was sitting at the switchboard with the earphones on and there was a long line of servicemen waiting to call, mostly Army, and then I looked up and there was a young submarine lieutenant. He looked sort of familiar and I stared at him a moment. And guess who he was?" She held the stirring spoon out straight and looked from Joey to Madeline with raised eyebrows. She waited. "Give up?" she asked and glanced down at the frying pan.

"Mum, how can we possibly guess who you met at the Service Center?" Madeline slapped the plate of sliced carrots on the table. "We don't know any servicemen, and what's more we've never even seen the place where you work."

"Well, next Saturday you're going to. I'm going to show you how to get there by bus and then I'll give you the grand tour and we'll all have lunch in the officers' mess."

"Can I wear my red skirt?" Madeline asked.

"Yes. That would be nice," their mother said.

"Who was the submarine lieutenant?" Joey asked.

"Oh, yes. It was Peter O'Malley. The young man who came to Newbury last spring to help me with the garden. Remember?"

"He planted that vine with the white flowers," Joey said.

"That's right, dearie, the clematis, and he helped me with the rose garden."

"Is he going overseas?" Madeline asked. She was sitting with both elbows on the table now, but she leaned back in her chair. "Does he know where's he's being sent?"

"Yes, to the Pacific. His sub's the *Sailfish*, though maybe I shouldn't mention her name. I couldn't think who he was for a moment. I mean

in that long line of men. When it was his turn he said, 'How's that Nelly Moser we planted, Mrs. Lindsten?' and I clicked that it was Peter. Nelly Moser was the kind of clematis we chose."

She dished the chipped beef onto the three plates waiting on the counter and added a spoonful of peas, set the plates down, and settled into her chair. "He said our talks about which clematis would be best for the old stone wall seemed a long way off." Their mother looked down at her plate and gave a short sigh. "He was certainly right about that."

"I remember him," Madeline said. "Sort of thin. He wore faded dungarees and a denim jacket. How old is he, Mum?"

"Let's see." Their mother picked up her fork and paused. "Eighteen. Nineteen maybe. He knew a lot about flowers. He wants to be a landscape gardener someday. I hope he will; his ideas about the rose garden were good and the rhododendrons, too. Pass me the pepper, will you, Joey?" She sprinkled some pepper on her chipped beef and looked up at them again. "Now he's off to the Pacific," she said. "I got his mother in Haverhill for him, routed the call through Boston. Sometimes that routing can be tricky late in the afternoon." She looked across at Joey.

"Eat, dearie, before your food gets cold."

Joey picked up her fork and stared down at the whitish mound. "Peter doesn't seem like a soldier to me," she said. "I mean he knows about flowers, not guns and things like that."

"I know, dearie. But right now all young men are needed."

Joey poked at the chipped beef. "But Mum, if he goes to the Pacific, he might be killed."

She paused, sucking at the thought like a thin Lifesaver in her mouth. A man wounded on a submarine wouldn't lie bleeding in a field somewhere, he would drop into the ocean, and if it was night, the water would be cold and dark and maybe no one would find him.

Joey looked up at her mother and felt her thought of Peter fade. Mum was talking away, smiling at Madeline, happy-seeming in this new job.

* * *

Madeline and Joey stood at the bus stop beside Union Station and squinted at the flapping flags on a hotel building beyond the swirling traffic. "That's got to be it," Madeline said. "She told us to look for the flags." It seemed miraculous to Joey that they were almost there. They had taken the D2 bus, following their mother's instructions, and Madeline had remembered to ask for two transfers and had produced them when they mounted the D4 bus at Dupont Circle. Joey walked beside her, trying to seem matter-of-fact, but she kept turning her token in her coat pocket to make sure it was there for the bus ride home.

As they crossed the wide street, Joey felt a rush of relief for the sign beneath the flags was clearly visible—*The United Nations Service Center.* A group of sailors in white uniforms pushed through the revolving doors and Joey glimpsed one man's shaved head before he jammed on his round white cap. Madeline moved through the doors and Joey followed. Hot, smoky air enveloped them as they stood looking around the crowded lobby. A line of brightly colored silk flags hung down from a balcony above. Joey recognized the Union Jack and the French Tri-Color and the red Canadian flag with its coat of arms and a small Union Jack in the corner, but there were at least eight others she didn't know at all.

Servicemen were all around them, talking, standing in lines. Several soldiers were flopped onto chairs near the door and two were sleeping on the floor, their heads cushioned on their duffel bags. Others stood talking or smoking, arms around girlfriends or holding children by the hand. A sailor near them was rolling up his shirt sleeve to show two other sailors a large blue eagle tattooed on his upper arm. Joey stared, glanced away embarrassed, then stared again. Two infantry men moved past them and Joey gazed down at their high, laced boots.

"Mum should be over there," Madeline said, pointing. "See? There's the phone bank."

They moved through the crowd, past a soldier holding a baby

wrapped in a crocheted blanket, past a woman bending over a crying child, past more sailors sitting on their sea bags on the floor, toward a large switchboard on the left side of the lobby. Phone operators sat in front of it, wearing headsets, plugging in wires and unplugging them, while a ragged line of sailors and soldiers, some with duffels, others, officers perhaps, holding briefcases, waited to phone.

"There she is." Joey pointed to her mother. "See her? She's standing over there. See?" Their mother was leaning over a young woman, who was seated at the switchboard, a black headset clapped over her blonde hair and a mouthpiece just inches in front of her bright red lips. Their mother was wearing her dark green suit and her brown bead necklace hung down as she stooped.

"Mum." Joey waved. Their mother straightened, saw them, and smiled. They made their way past a family talking with a woman at a desk to where their mother stood.

"Oh, girls. Wonderful. You made it. You followed my directions all right. Another fifteen minutes and I was going to call the MPs." She laughed. "These are my daughters," she said to the woman at the switchboard, who smiled and lifted the headset off. "This is Madeline and this is Josephine. They've come to see where I work." The woman smiled again. "Mrs. Tercel's just started and she's doing beautifully. I'm going to leave you for a little while, Mrs. Tercel, and show my girls around. I'll be back in an hour. Mrs. Springer will help, if you get worried about anything." The woman settled her headset back on her head and Joey glanced down at ends of the wires poking up through the round holes in the counter, waiting to be plugged into the switchboard in front of her. How did she know where to plug them? How did Mum? Their mother stepped out of the semi-circular enclosure and put her arms around Madeline and Joey. "Did you have any trouble with the buses? You didn't have to wait too long at Dupont, did you?"

"Mum, what are all those flags?" Joey asked staring up.

"I haven't had time to learn them all, but that's Australia and Belgium beside it and Russia, of course." She glanced back at the

phone bank. "This is Mrs. Tercel's first day. Her husband's just left for Guadalcanal; they've only been married a week."

A captain moved past them. The brim of his white cap was decorated with scrambled eggs, like the officers' hats Joey had seen in pictures, and behind the brim was a gold band and the Navy insignia. She stared. Two narrow rectangles were pinned above his breast pocket, one an orangey yellow with red vertical stripes and the other a dark green with blue verticals. "Mum," Joey whispered and pointed to the man's back. "He's got service stripes. That top one's for the Pacific, isn't it?"

"That's right, dearie, but don't point. You see those stripes often here." She turned. "Let's go up to the office first. You can leave your coats there, then I can show you around and we'll have lunch."

They followed their mother through the crowd to a bank of elevators. A door opened, revealing a heavy-set enlisted man with a butch haircut, who frowned and said, "I thought this thing was going down."

"We'll go down with you and then we'll go up," their mother said and smiled at him, as she led the girls inside. "Are you going to get some lunch?"

"Yes, ma'am," he said and looked at her hard. "You work here, don't you? I saw you at the phones."

"Yes, I do," Joey's mother said. "I hope you're finding everything you need."

"Oh, I am. I've booked a room and after lunch I'm going up there and take a shower. First hot one in a month and after that I'm going to crawl into bed and sleep until tomorrow or next week maybe." He slapped his soft rectangular cap against his arm. "This is some center. I'm just back from Africa. El Alamein, and I tell you this place is what I needed." He nodded emphatically as the doors opened. "It's swell. You people are doing a great job."

"Thank you," Joey's mother said. "It's a big undertaking, but we're trying." The soldier nodded at her again, then stepped out of the elevator.

When the doors opened at the second floor, Joey followed her mother and Madeline down a hotel corridor, past a line of closed doors to a room where a gray-haired woman sat at a scarred wooden desk talking on the phone. Two other women stood conferring beside a long chart taped to the wall.

"Esther, Nancy," their mother said. "I want you to meet my girls." Madeline and Joey shook hands as they were introduced to the women near the chart. Joey stared up at it, noting that it was marked off into boxes that were crowded with writing. Some names were crossed out, others written in ink or pencil, and at the top, Joey noticed, there were times and shift names—Morning, Swing, Graveyard. Joey found her mother's name in the horizontal band marked "Telephone Duty," with the title, "Telephone Director." Joey wanted to ask her mother if she taught all the telephone volunteers, but the woman at the desk replaced the phone receiver and Joey's mother introduced them to her as well.

"I think we've solved that crisis," the woman at the desk told Joey's mother. "A cancellation on the swing shift tonight, but I found a replacement, thank heaven. Your idea of a team of substitutes makes sense, Amanda. Let's take it up at the meeting Monday."

Joey and Madeline followed their mother upstairs to a room marked "Library," where a thin woman with glasses was kneeling on the floor pulling books out of a large cardboard box and stacking them in piles. She struggled to her feet and reached her arm out when Joey and Madeline were introduced. "Oh, your mother's talked about you two," the woman said. "I'm Mrs. Becker. Are you having a tour of the Center?"

"Yes," Joey's mother said. "I'm going to show them the nursery next and then we're going to have lunch in the officers' mess." The room was divided into narrow aisles by rows of green metal shelves, which were filled with books.

"It's wonderful to have these donations," Mrs. Becker said, "but it takes a lot of time to sort them and get them on the shelves. Let me show you around, girls."

She led them down the middle aisle, labeled "Mysteries" to the fiction shelf. There was a smell of dust and bindings. Many of the books were dark and worn-looking, but there were new spines here and there, Joey noticed. More cartons of books were stacked by the window and Joey was surprised to see a sailor in a white uniform stretched on a shabby couch, his head lolled to one side, breathing in even snores. "I wish we could get another couch or a big chair," Mrs. Becker whispered and looked at Joey's mother. "The men are often so tired. They start to read and fall right to sleep."

"Maybe we can," Joey's mother said. "I'll mention it Monday at the meeting."

"The rule is," Mrs. Becker told Joey and Madeline, "you can take a book you're reading with you just so long as you promise to give it to another serviceman somewhere when you're finished."

"You must lose a lot of books," Madeline said.

"Yes, but the point is just to keep them circulating, so they distract as many men as possible. Mysteries have always always been good," she said, "but right now Lloyd Douglas's *The Robe* is very popular."

When they reached the nursery, one baby was asleep in his mother's lap, but another began to scream as the newcomers entered. There was a strong smell of diapers and heated formula, and Joey glimpsed a soldier stretched on the floor, who groaned and brought his knees to his chin at the screaming sound. Joey's mother turned and they backed out.

The officers' mess was much less crowded than the enlisted men's mess they had visited below. They ordered hamburgers and Coca-Colas from a large man behind the counter, who joked with Joey's mother. A colonel sat alone at a side table, writing in a small, black diary. When they put their trays down on the table beyond him, he stood, settled his hat with its silver eagle on his head, tucked his diary in his breast pocket, bowed slightly and left.

"It's a huge place, Mum," Madeline said. "I didn't think it was as big as this. Fourteen floors and how many rooms?"

"Two hundred and eighty," her mother said. "A hundred and ninety are single, ninety are double, but singles are our big need. We need to convert some more of the doubles into singles. But we need some large double rooms for families, too. I'd like to be able to put some small refrigerators in those."

"What about the nursery? Don't you need another room for the infants, the ones that fuss and need attention? I should think they'd keep the other children awake," Madeline said.

"You're right," her mother said. "We do."

Joey watched as two Naval officers came into the mess and went up to the counter. The taller one took off his hat, raked his hand through his dark hair a moment, and put his hat on again. "Mum," Joey whispered and leaned toward her mother. "Are most of these men going to the front? I mean are they going straight from here into action?"

"Some of them, dear. Most maybe, though some are returning and some are going to training camps."

"But most of them are going straight into war, aren't they? Like those men maybe?" She pointed quickly at the two men who were standing at the counter.

"Yes, dearie. Most are going to war."

Joey put one elbow on the table and leaned her chin in her hand. She thought of the photographs of the Russian battle front that she had seen in *Life* magazine, men lying in fields, crouching over machine guns, their faces black with mud. They had to beat Hitler, of course. But how could they stand to go?

Chapter 10

A WEEK after their visit to the Center, Joey stood whispering a song to herself, as she waited for Madeline to unlock the front door.

> *You must remember this,*
> *A kiss is still a kiss,*
> *A sigh is just a sigh*
> *The fundamental things apply....*

She and Fay had seen the movie twice and that first line, "You must remember this," evoked the whole scene: Humphrey Bogart with the cigarette burning between his fingers as he gazed at sad, beautiful Ingrid in her hat, while Sam played the piano. Joey had to hum the tune noiselessly, because of Madeline, but even so it made her feel close to Ingrid, as if she were in Morocco, too. *"A kiss is still a kiss...."*

As she followed Madeline into the front hall, the fantasy dropped from her like a loose scarf; the house felt full of tension. There was a smell of fresh cigarette smoke in the air and she could hear her parents' voices in the bedroom above. "Why's he home in the middle of the afternoon?" she asked. Madeline shrugged and plunked her books down on the hall table. Joey added hers and they

hung their coats on the hooks by the door and started up the stairs.

Their mother was bending over a suitcase that sat open on the bed and their father was standing in the doorway of the closet, pulling a suit jacket off a hanger. "Where are you going, Poppy?" Joey asked. She stared at her father, holding the jacket, and then at her mother beside the open suitcase.

Their father turned to them with an excited smile. "Hi, kids," he said. "I've got some news for you. Good news." His blue eyes glittered. "I've got a new job. A great new job." He glanced at the jacket he had pulled from the hanger, as though he had forgotten why he was holding it, then put it on the bed beside the suitcase and added the trousers.

"What is it?" Joey asked. "Where're you going?"

He picked up a pair of brown shoes from the floor and held them out to their mother. She tucked some rolls of underwear along one side of the suitcase and straightened. "Do you really want to take those?" she asked. "They're awfully old."

"Yeah, but they're comfortable. They're terrific, in fact. Just what I need for the lab."

"Poppy." Joey darted into the room and caught her father's arm. "Where are you going? Tell us." She heard the whine in her voice and felt her mother's eyes. "How come you're home, too?" she said, turning to her mother.

"I got someone to take my shift this afternoon. Your father has to leave right away. I'm going back this evening."

Her father put his arm around her waist. "A good thing's happened, Jo," he said. "I've got a different job and I'm excited and proud that I've been chosen."

"Is it to do with your secret weapons?" she said, knowing she shouldn't ask that question. "Are you going somewhere else to work on them?"

"Yes, but I can't tell you where." He glanced back at Madeline who was frowning at him from the doorway. "It might be six months, girls. Not much more."

"Six months?" Joey's voice rose in disbelief. "But Poppy." Joey twisted out from his arm and looked at him directly. "How can you be gone that long? Leave us for half a year?" She heard her voice tremble.

"It's going to be all right, Jo. You girls and your Mum will be fine. I'm going to work hard at some things I really know about, something that's vital to the war effort and…." He glanced over at their mother. "Don't put in both suits," he said. She had taken a brown suit from the closet and was folding it to add to the gray one he had put down. "I won't be wearing that kind of thing much. Just work clothes mostly. Now, girls," he resumed, looking back at Madeline, who was still in the doorway. "This is my part in the war effort. It's what I can do to help defeat Hitler."

"But where are you going, Poppy?" Joey asked.

"I can't tell you, Jo. I just said that." He looked back at their mother. "Security has to be absolutely tight. Oppenheimer decreed that from the start."

A cigarette lay burning in a brass ashtray on the bureau, its gray smoke spiraling upward. Their father stood, picked it up and inhaled deeply.

"Lucky Strike green has gone to war," Joey said suddenly, wanting to make him smile, but he glanced back at their mother.

"Better put in those heavy socks and my flannel PJs. What about aspirin? Did you put that bottle in? I'll need it and those sleeping pills, too."

Joey leaned against the bed post, watching silently, aware of Madeline still standing in the doorway. Poppy couldn't tell them where he was going, of course, but why couldn't he be more…more sad or something? Six months was a long time.

"I'll call when I get there," he said to their mother. "Let you know how you can get hold of me." He was at the bureau now, raking through a clutter of combs, left-over change, and pencils in his top drawer. "Damn. I wish I could find that little compass I had. Like to have it with me. Ah ha. Here it is." He clutched the small brass

instrument suddenly. "This could be good luck," he said. He rolled it in a sock and dropped it into his briefcase on the floor. "I just hope to God I can measure up to their expectations," he said to their mother. He latched the briefcase and lifted it. "Boy, this thing is heavy. Have to keep it with me. Can't check it, of course. Travel's terrible right now."

He put one arm into the sleeve of the dark suit jacket that matched the trousers he was wearing, pulled the jacket on, and brushed at some lint on the lapel. "Communication's going to be really limited, you know," he said looking back at their mother. "I mean at the lab itself. They have to be very strict about that and…." He stopped. "Look. Would you girls mind going down to the kitchen for a minute? There're a couple of things I still have to tell your mother." Joey and Madeline nodded and walked slowly downstairs.

"I think he's going to a city somewhere where it's cold," Madeline told Joey, as she leaned back against the kitchen counter. "A lab probably, where other physicists are."

"He seems so excited," Joey said. "Like leaving us is wonderful."

"It's a very important job. He'll be using his physics now. He won't be just another office worker in Washington. We're going to take in boarders while he's gone. Service people. Mum says it's unpatriotic not to. Everybody's desperate for rooms in Washington."

"Where'll we put them?"

"The third floor maybe. Mum'll figure it out."

"Oh." Joey nodded, not quite understanding. "Is Sarah going with him?"

Madeline frowned and clutched her arms around her. "I don't know," she said and looked out of the window in the back door. Joey followed her gaze to the dangling cord of the black-out shade and the naked ginkgo tree beyond. "Maybe," Madeline added. "She's his assistant after all."

Their father carried his suitcase down the stairs, banging the banister posts as he hurried, and their mother followed with the briefcase. A government limousine was coming to pick him up at four,

Poppy said. He leaned down and unbuckled the brown leather strap that went around the suitcase, pulled it in more tightly, and buckled it again. "Okay," he said and put on his overcoat and then slapped his creased gray hat on his head. "'Bout ready now, I guess." He looked at their mother. "I'll call you tomorrow night, if I can." He jerked the door open to peer out at the street, then closed it again. "We'll talk. Stuff's going to work out. We've got to win the war first; that's the main thing now." He rocked back and forth a moment in his wrinkled shoes. "Oh, hey. About Newbury. Did you call Ed? Did you ask him to take a look at that roof?"

"I talked to him last week, Jack. I told you what he said," her voice was sharp with irritation. "There's some leakage. He's done what he can."

Joey glanced up at her mother; why was she cross now when Poppy was leaving? She ran to look out of the bay window in the living room. "It's here," she shouted. "It's come. A big black car. It's right outside."

"You sure?" Her father opened the front door again. "Yup, that's it." He leaned down to lift his suitcase, then stopped and straightened. "Kids," he said and stared at Joey and Madeline, standing together in the living room doorway. "Listen, kids," he started and his voice cracked. "I want you to...."

Joey and Madeline moved to him and he put an arm around each, pressing them against him. "I'm going to miss you two," he said. He bent and nuzzled Joey's head, lifted one hand to stroke Madeline's hair a moment, then straightened and let his arms drop. "Write me, kids. Okay?" He turned to their mother and kissed her cheek quickly, then looked back at Joey and Madeline again. "I mean it. Write. Your mother's got the PO number." He picked up the brown suitcase, then the briefcase. "I want to hear from you."

He opened the door and started down the iron steps in front. A man in a black suit got out of the limousine and took the suitcase. "Bye," their father shouted and got into the car.

"We'll write, Poppy," Joey called out suddenly from the top step

as if the slam of the limousine door had woken her to a new reality. "I'll write you every day." But the limousine was already pulling away from the curb.

<p style="text-align:center">* * *</p>

One afternoon a few days after her father had left, Joey came home from school and found her mother carrying a clump of dresses on hangers up the stairs to the third floor. "You and Mad and I are going to move upstairs," she announced. "I'm going to rent our bedrooms down here." She glanced back at the master bedroom, then at the stairs leading up. "I'll take the small room in front up there," she said. "And you and Mad can have the bigger one. It has a double bed and the long table by the window will make a good desk. We'll bring up the bookcase from your room." She nodded at the room Joey and Madeline shared. "You can get started packing your things now." She lifted her arm, holding the hangers higher, so that the hems of her dresses didn't brush the uncarpeted steps, and continued up the stairs.

Joey leaned against the bedpost and gazed around her room. Last summer when they had first moved in, she had felt uncomfortable in this space with its dark paneling and its musty smells and the creaky bed she had to share with Madeline. But now all at once it seemed luxurious. The room upstairs was smaller and the windows were high attic windows, not like the two long windows here, looking down on the street. Their bedstead upstairs was brass and one of the knobs was missing. The table didn't even have a drawer, so where would they put their pencils and bus tokens, for heaven's sake?

Joey sighed. She shouldn't complain, of course; girls in London were being bombed every night. She knelt down by the bookcase and started stuffing her books into the cardboard box Mum had brought up. She put Fluffy and her photograph of Queenie on the top and carried the box to the bottom of the stairs. "The real problem about living upstairs," Mum said, coming downstairs to help her, "is that the one bathroom in the house is on the second floor."

"We could make rules for sharing it," Joey told her mother, "and I could write them out and pin them up for the boarders."

"Later, dearie. First we have to see who the boarders are and what schedules they have for their work."

* * *

Colonel Harry Fenton, a tall graying man in a pressed uniform with a silver eagle above the brim of his Army hat, answered the notice in the newspaper the first evening. He had reddish cheeks and pale eyebrows, Joey noted, and a trail of little moles that led from the side of one cheek to his chin. He followed her mother upstairs to inspect the front bedroom that Joey and Madeline had vacated. "This is fine," he said. "Luxurious, in fact."

"Well, there is the problem of the bathroom," their mother began. "As I told you, there's only one and I plan to rent the two other rooms on this floor as well."

"That's not an inconvenience for me, Mrs. Lindsten. I assure you. I've been sleeping on a mattress in my office for over a month." He left and returned later with his suitcase. Joey heard him go down the hall to the bathroom, and when she went in minutes later, a white terrycloth robe was hanging from the hook on the back of the door.

A major moved into the master bedroom the next morning, but Joey was at school and didn't see him. She stopped at the half-open door of the room that used to be her parents' and peered in at the Army duffel bag on the bed and the briefcase beside it. They might not meet until the weekend, Mum said, because the major was working the graveyard shift and would probably sleep most of the day. Joey rushed up the stairs to her third floor room, flushed with excitement. All these unknown lives were suddenly pressed close beside them in their own house.

* * *

When Joey came home from school on Friday, a man in a white shirt and dark blue Navy trousers was unpacking a black suitcase in the narrow room above the front hall. "Hi," she said, pausing in the doorway. "I'm Joey. I live here. What's your name?"

The man turned. The tanned skin around his dark eyes crinkled, giving him a bright, almost mischievous look. "Hi," he said. "I'm Tony. Tony Argillo."

"My mother works at the United Nations Service Center downtown," Joey began. "Right near Union Station where all the trains come and all the service people. It's tremendously important." She stared at the cleft in his chin and at the neat part in his black hair. "Mrs. Roosevelt came to visit it just a week ago. They serve about a thousand men a day. Next week Mum'll be on the graveyard shift."

"I know. I met her at the Center this afternoon," he said. "She told me about the room. She said you're to go next door for supper after you finish your homework. There's a note on the kitchen table."

"Okay. I think we're having spaghetti. Do you like spaghetti?"

"Oh, sure. My dad's Italian. I've made spaghetti since I was big enough to reach the stove. I'll make you my kind some night soon."

"Good." Joey smiled. "I hope you don't mind the bed." She caught one pigtail and twisted it quickly. She shouldn't have mentioned the bed: if he knew it was bumpy, he might go find another room. "I mean...."

"Your mother told me the mattress was bad, but that won't bother me. I can sleep anywhere."

Joey let out a sigh of relief. "I'm ten," she said. "But I'll be eleven next summer. My sister's thirteen and she's in junior high. My best friend is Fay and she lives right next door." Joey turned to point at the wall beside the stairs. "Right through that wall there."

"That's convenient. How did you arrange that?"

"I didn't. Mum says it was a miracle, because her best friend is Fay's mother."

"It all sounds very friendly here." Tony leaned one white shirt-sleeved arm against the door frame and smiled down at Joey.

"It is. I mean, it would be if it wasn't for the war. My father is in a secret place working on secret things, but he's not in action. Still we're very proud of him. Are you going into...." Joey stopped. Maybe it would be rude to ask if he was going into action soon. If he

wasn't, he might be ashamed, and if he was, he probably couldn't talk about it. "We're saving waste fat for explosives and tin cans for ammunition, and paper, too, for the war effort. We wash the cans out, then we stamp them flat on the kitchen floor and I always wonder whether maybe they're going to be part of a B-17 Flying Fortresses or a B-29 Superfortress." Joey paused, worried that she had mixed up the names of the bombers. "Do you like Washington?"

"Never been here before. I'm from New Jersey. Haven't traveled much really."

"We'll show you around then. Mad, that's my sister, and I can be your guides. I'm allowed to go to the Smithsonian with Mad some Saturdays and Mad knows how to go to the Capitol, too. That's right near where our mother works and there's the new art gallery and lots of other things. We were going there on a school trip, to the art gallery, I mean, but Mrs. Martin, our homeroom teacher, couldn't get enough parents to help, so we didn't go. I like writing. Do you? I'm going to be a writer when I grow up or maybe an actress. I've read all of Louisa May Alcott's books and lots of Greek myths."

"Joey." It was Mona's voice calling from below. "You're having supper with us tonight, honey, and…." Mona stopped at the top of the stairs, clutched the banister, and breathed out heavily. "Hello. You must be the new boarder. I'm Mona Hartley, the neighbor next door." She reached out and shook hands. "We're in and out a lot between these two houses. We're old friends from Massachusetts. Have you got everything you need? Towels? I know your bed's made up clean. Amanda said you're in Naval Intelligence. Is that right?"

"That's right, I'm at the Navy Department right now and I just promised Joey here that I'd make Italian spaghetti some night soon for anyone who'd like it."

"That would be wonderful. But now, Joey, you must come on over to us and let Officer Argillo finish his unpacking."

"All right," Joey said. "But just one thing. Are you an ensign or a chief warrant officer? I'm keeping a war journal and I try to write down everything about the war."

"I'm a warrant officer." Tony held up the dark jacket he had draped over the back of the chair and pointed to the silver bar with three bands on the shoulder. "Actually, it's hard to tell the difference."

"It really is," Joey said. "I got a book from the library about insignia, but...."

"Come along, Joey."

"All right. Good bye, Warrant Officer Argillo."

Joey waved, then rushed down the stairs and into the Hartleys' house, full of news to tell Fay about their new boarder.

* * *

A week passed and it seemed to Joey that the boarders had changed everything. The empty feeling of the house that used to envelop her when she came home from school in the afternoon was gone. Now, when she unlocked the front door and stepped into the front hall, she might hear the radio in the kitchen, where the major was making himself a sandwich, or the buzz of the colonel's electric shaver coming from the bathroom above. She might chat with Lieutenant Rogers, who was in the back room, though he wasn't very talkative and would be transferred soon, and she always stopped on her way upstairs to peek into Tony's room. She would stand in the doorway, calculating the time until he got home, smelling the peppermint Life Savers he kept in his drawer and his Old Spice shaving lotion. Sometimes she went straight to the Hartleys' next door, where she'd have milk and graham crackers or Oreos maybe, then start her homework with Fay. But it was good to know that her own house was busy and full.

* * *

Joey was lying awake one night two weeks later, feeling her teeth chatter. She had listened to "The Inner Sanctum" with Madeline, and though it had scared her, she must have slept a while, she realized. But now she was awake again, watching the shadows on the ceiling in their third floor room, listening to Madeline's breathing beside her. She peered at the little clock Mona had given her with its green luminescent dial. Quarter after four in the morning. She listened,

wondering if Mum had gotten home. Way downstairs she heard the kitchen door squeak and a voice talking. Joey yawned silently, thought about getting up, decided against it, then got up anyway.

When she pushed the kitchen door open, she was surprised to see Colonel Fenton standing at the counter, her mother's yellow half apron, trimmed with red rickrack, tied around his waist. He was stirring something in the tan mixing bowl and her mother was sitting at the kitchen table watching.

"I'm using that powdered stuff," the colonel said. "It doesn't really taste like scrambled eggs, but with a little tarragon and these onions it'll be a nice late-night snack or an early breakfast."

"It certainly will." Joey's mother leaned back in her chair. "This is luxurious for me, coming home so late to a treat in the kitchen." She smiled, put one elbow on the table and rested her chin in her hand.

Joey leaned against the door jam, hesitating. She could either go into the kitchen or continue to peer in, like a Nazi spy. "Hi," she said and let the door swing shut behind her.

"Oh, sweetheart." Joey's mother looked over at her. "Awake again? This is my nocturnal daughter," she said to the colonel and laughed. "Sit down, dearie. Colonel Fenton is making scrambled eggs. Would you like some?"

"No." Joey shook her head and saw her mother frown. "No, thank you," she added and looked down at the dark linoleum, then up at the colonel again. "Are you on the graveyard shift this week, too?"

"Yes. They just changed me over. The swing shift's more to my liking, though."

Joey sat gazing at the colonel, who seemed a large presence in the kitchen with his sloping shoulders and his slight pot belly that pushed the apron outwards at his waist. He took the egg beater from the drawer and a whirring sound rose up as he turned the handle.

"I worked the graveyard shift in February," her mother said, as

the whirring noise subsided. "But it always takes a few days to get back into the rhythm of it again. How was your day, or night, rather? You're working at the War Office, aren't you?"

"My responsibilities are rather routine," the colonel said and poured the beaten egg mixture into the frying pan. "At least they're much like my civilian ones."

"What are they?" Joey asked and stared. Poppy would never ever say that his war work was "routine"and Poppy had never worn an apron in his life.

"I'm in the Quartermaster General's office. I deal with supplies—uniforms and blankets, medicine and such. Back at home in Cincinnati, I'm in the supply department at Proctor and Gamble, head of it actually, so this doesn't seem all that different."

"How about some toast to go with those eggs?" Joey's mother said and took a loaf of white bread from the bread box and put two slices in the toaster. "Oh, Joey," she said, as she opened the refrigerator and pulled out a whitish rectangle of fat on a tan plate. "You forgot to color the oleo."

Joey gave her a sullen look and glanced at the toaster. It wasn't fair of Mum to criticize her in front of the colonel. Besides, why did coloring the oleo always have to be her job? It used to be fun, pouring in the little packet of orange powder, squishing the white stuff through her fingers until it turned yellow. But now it was boring and Madeline should do it sometimes.

The toast popped up and Joey watched her mother spread the white margarine and sit down again. "Sure you don't want some toast?" she said, looking at Joey, but Joey shook her head. She felt cross and knew it was more than just the oleo.

The colonel scooped the eggs up, making pale yellow mounds on the two plates. He placed one in front of Joey's mother and the other at the place opposite her at the table. "Soap's a good clean business," he said and took off the apron. "I've been with the company for nineteen years."

"Cincinnati must be a nice place to live, too," Joey's mother said.

"We're just outside. Pleasant suburb." He shook some pepper over his eggs and passed the shaker to Joey's mother.

Joey watched her mother pick up her fork. "This is delicious," she said. "What herb did you say you used?"

"Tarragon mostly and a dash of curry."

"Do you cook at home?" Joey asked. "In peacetime, I mean." She glanced at the apron slung over the empty chair and thought of her father again. "Does your wife let you into the kitchen?"

"I have a housekeeper, but I enjoy cooking for my sons when they're home. My wife died six years ago. My boys are both in boarding school now."

Died? Joey looked down at the creases in the oilcloth on the table. What should she say? She glanced at her mother for help, but the news had darkened the kitchen and Joey's mother was gazing down at the oilcloth, too.

"I'm so sorry," Joey's mother said and raised her eyes, but Joey continued to stare at the table, ashamed of the embarrassing sadness she had opened and afraid to look up at the colonel. Couldn't he get a deferment as a widow—no, a widower—she thought. But maybe he wanted to be here, even if his contribution to the war effort was "routine." How awful for his boys not to have a mother. The colonel was talking about them and she listened. His younger son was just a little older than Madeline and the older boy was almost seventeen. They were both keen on sports, baseball and hockey. They played tennis at the country club, too, and the boys had even been known to beat their old man. The colonel laughed and went on to talk about the country club and his golf game.

Joey looked down at her feet in her slippers. The colonel was nice, though she liked Tony better. But what she really wished was that Poppy was here and the war was over.

Chapter 11

SUMMER had come and Madeline had gone to camp in Vermont for a whole month. Mum had bought her three white shirts and three pairs of navy blue shorts and she had shown Madeline how to sew name tags on them and on her underwear and socks, too. It was a long job, but Joey hadn't helped. She hated sewing and she was jealous; Madeline was having a huge adventure of her own, while she, Joey, had to stay home. Mona had promised to take Joey and Fay to the public pool and they could go to afternoon movies, too, she said. But it wasn't the same. Madeline got to go all the way to Vermont on a train.

Joey walked home from the pool with Fay one hot afternoon in June, her wet bathing suit wrapped in a towel under her arm. They had gone to *The Road to Morocco* the day before and the world of the movie still seemed close. "Remember when the camel Bob Hope was riding turned its head and spoke?" Fay said. "Remember the way Bob Hope's eyes bulged?"

"And then that slick man rode up," Joey said.

"Yeah. He was the one who got Dorothy Lamour."

They climbed the steps to Fay's house, dropped their towels and bathing suits in a heap on a kitchen chair, and began pulling things

out of the refrigerator: a bottle of Coca-Cola, a plate of leftover meatless pie, and a jar of tomatoes. From a street nearby came the faint jingle of a Good Humor truck. Joey looked at Fay and dug down into the pocket of her shorts. "Five cents," she said and put a nickel on the kitchen table. "We've got to have fifteen more." Fay rushed to the pottery bowl on the hall table, which yielded two pennies and a key. "Seven cents," Joey announced. "Come on. Let's go to my house. There might be some money on the kitchen table."

They tore into the kitchen and stopped, surprised to see Tony bending over the newspaper. "The Good Humor man's here," he said straightening. He pulled some change from the pocket of his uniform pants, spread it out in his palm and picked up a quarter and a nickel. "One for me and one for each of you," he said and handed the change to Joey. "I want vanilla, okay? I don't like the chocolate ones."

"Wow. Thanks," Joey said.

"Wow," Fay echoed. "We'll be right back."

"It's so darn hot," Tony said, when they returned holding the three Good Humors upright on their sticks. "Let's go up to the porch."

Fay and Tony sat on the dusty glider, licking their Good Humors slowly, while Joey sat cross-legged on the straw mat beyond them. "Did you used to get Good Humors in New Jersey when you were little, Tony?" Joey asked.

"All the time. Summer nights, I mean. My brother and I, we'd hear that bell way off and we'd tear through the house scrounging pennies and nickels and then we'd fly down the street to get them before the guy drove off in his white truck with those little bells jingling."

"Just like us," Fay said. "Only we're not little."

"Everybody likes ice cream, young and old," Tony said and caught a thin sliver of chocolate in one hand as the brown cover of his Good Humor split apart. He ate the chocolate, licked his palm, then licked the naked white side of the ice cream. "Summer and ice cream kinda go together."

"Here you are, Fay." Mona appeared in the doorway. Her face was damp and her upper arms in her sleeveless blouse looked flabby and white. "Come on, honey. We've got to have supper early tonight. Your father's got an air raid warden meeting."

"Oh, heck." Fay rose from the glider reluctantly. "Do I have to come now?" she protested and sucked on her Good Humor stick as she followed her mother inside.

The sense of being alone with Tony in the sudden quiet filled Joey with excitement and she felt an urgent need to engage him in serious conversation.

"Do you believe in God?" she began and licked the last of her ice cream, leaving the stick bare.

"I don't know, Joey," Tony said and dropped his Good Humor stick in the ash tray, then leaned back in the glider. "I was brought up Catholic. I'm supposed to believe in God."

"I'd like to believe in Him," Joey said and sucked the top of her Good Humor stick. "But what I keep thinking is, if there is a God, why does He let men have wars and fight and die? Why did He let Hitler be born? I mean, you know?"

"That's a big one," Tony said. "I think about that, too. I worry about my brother. The one in North Africa. The one I used to run to the Good Humor man with. I hope God's watching out for him. I pray He is."

"I could pray for him, too," Joey said. "Do you think it'd help?"

"I don't know, Joey." Tony sat forward suddenly and put both elbows on his dark trouser knees. "I honestly don't know."

* * *

There were only ten days left until Madeline returned, but Joey was enjoying the intervals she had alone with Tony. She sat opposite him at the kitchen table, wrapping the last strings of the spaghetti he'd cooked around her fork.

"How many brothers and sisters do you have?" she asked.

"Three brothers and four sisters."

"Wow. Eight children," Joey said and put one elbow on the table

as she stared at him. "What's it like growing up in a big family like that?'

"It's crazy at times, but fun. Somebody's always yelling or rushing in or out." He folded a piece of white bread and wiped the red sauce on his plate. "I loved it," he said. "I miss them."

"I'd like to be in a big family," Joey said. "Sometimes in a little family things get sort of tense."

The phone rang in the phone closet and Joey got up to answer it.

"Poppy! It's you," she said. "Are you here? Are you coming home?"

"I wish I could, honey, but I can't. Work, you know. Is your Mum there?"

"No, she's at work. She could call you later when she comes home."

"No, she can't call here. I'll try her tomorrow or soon. I've got her number at the office. Goodbye, honey. I love ya."

"I love you, too, Poppy," Joey whispered, but the line had gone dead.

"My father works so hard," Joey said, sitting down at the table again. "He just works all the time. It's terribly important what he's doing, of course: secret weapons and things. But he doesn't have time for anything else anymore, not playing the piano or playing with a dog or, well, you know, playing with his children. Of course, Mad and I have gotten so big now, he can't really play with us anyway."

"It's a problem a lot of people have right now," Tony said. "It's the war. After the war, things'll change."

"Maybe," Joey said and paused. "I think about Fay and Henry though. Henry comes home in time for supper pretty much every night, even though he is working in a war agency. But, of course, Poppy's more important. I mean, he's working on a secret project that's so secret we don't even know where he is." Joey sighed and looked at the window in the back door, where the evening light was seeping in around the edges of the blackout shade. "I wish you could come to Newbury, Tony. That's where we really were a family." She

looked down at the oilcloth suddenly, embarrassed to feel tears prickle.

"I'd like to someday," Tony said. "When peace comes." He leaned forward and put one forearm on the table near her elbow. "There are all kinds of families and families have all kinds of problems, Joey, but most of them survive, you know."

<p style="text-align:center">* * *</p>

Madeline seemed different when she came home in August. Her hair was shorter and she was wearing a braided hair band that she had made. She sat at the kitchen table in the blue dress she'd worn on the train, her duffel bag abandoned in the hall. "It was the best summer of my whole life," she said as her mother poured lemonade into four glasses. Joey pressed her dirty knees against the edge of the table. She and Fay had been helping Mona in her victory garden, unaware that Madeline was coming so soon. Joey watched her sister drink from her glass. She was more talkative than before, yet more distant somehow, more grown up.

"Want more sugar?" Joey asked. "We've got enough. We saved coupons." Madeline shook her head.

"You look so brown and healthy, dear," her mother said. "Beautiful really. It was a good idea, wasn't it? Going to camp."

"Oh, it was wonderful," Madeline said. "We got up every morning when Sheila—she's a full counselor—blew the bugle outside our tents. There were five tents. See? Each with six cots, and when the bugle sounded we'd jump up and dress and rush to the KDU. That's the Kitchen Dining Unit. And on Sundays we'd have pancakes with blueberries and maple syrup."

"Maple syrup's rationed," Joey broke in. "How do they do the ration books for all those people?"

"It's a whole different system at camp," Madeline told her. "We had square dances in the KDU, too," she went on and looked back at her mother, "and—"

"Did you invite boys to the dances?" Joey asked. "You said in a letter that there was a boys' camp across the lake."

Madeline gave Joey an irritated look and went on talking to her mother. "I didn't keep up with the war much," she continued. "Sometimes we sat in Sheila's tent at night and listened to the news. But not much. I mean the war seemed so far away."

"Good," her mother said. "That's good."

Madeline leaned back in her chair. "I feel I've been gone for months." She paused and looked around her. "Any news from Pop?"

"He's not allowed much communication, you know," her mother said and looked down at the sink. "I've had a few long distance calls, but he's very busy."

"How're all the boarders?" Madeline glanced toward the door.

"Fine," her mother said. "There've been some changes. We had a fifth for a week and Joey went and stayed with Fay."

"Tony made supper a lot of times and we talked. We...." Joey hesitated. How could she tell Madeline about those nights when she and Fay or just she alone had sat on the porch talking to Tony about God and war and other things?

"Joey, you've got to have a bath. You girls are filthy," her mother said. "You better get home and start yours, Fay. Do you want help getting that duffel bag up the stairs, Mad?" her mother asked, looking back at Madeline.

"No. I can carry it all right." Madeline stood a moment, staring around the kitchen and Joey followed her gaze from the battered refrigerator to the soapstone sink to the map on the wall, whose bottom corner had begun to curl upward, where the tape had peeled. Did Mad miss some special boy from that boys' camp across the lake, Joey wondered? She said she was glad to be home, but was she really?

* * *

When school began in September, Joey was startled by how different she felt as a sixth grader than she had as a fifth grader. The teachers, the crowding, the noises, and the smells were familiar now, almost comfortable. Fay was still her best friend, but there were other friends, too. She wore her hair in one long braid in back or let it

hang loose sometimes and pushed the sides behind her ears. She had penny loafers like all the other girls and two white dickies to wear under her sweaters.

She was a hall monitor and stood by the door to the stairs on the second floor to help new people find their way to their classrooms the first week. She shook her head sternly when people got out of line or shouted going down the stairs. Once she noticed a girl with braids coming upstairs. Her head was down and she was frowning, and for a moment Joey thought of herself a year ago, that lonely, worried person with her key hanging down over her sweater on a braided string; she felt she was barely related to that girl now.

<p style="text-align:center">* * *</p>

It was a warm Saturday morning in October. Joey paused on the second floor landing just as Tony opened the door to his room. He was wearing a dark green sweater and faded khaki pants.

"Wow," Joey said. "You look different. I've never seen you without your uniform. Do you have the day off?"

"Yup. The whole day." He smiled and the skin at the corners of his eyes crinkled. "It's beautiful out. Thought I'd rent a bike and go for a ride. Wanta come?"

"Me?" Joey said. "You'd like me to come?"

"Sure, if you'd like to."

They rented bikes in Georgetown and made their way down to the river. The maples were red and orange along the street and, as they emerged on the new Rock Creek Parkway, a flock of gleaming crows strutted on the the river bank. Joey followed Tony up onto Memorial Bridge. They paused halfway across and leaned their elbows on the concrete railing as they stared down into the moving water. "I've never seen the grave of the Unknown Soldier," Tony said. "Have you?" Joey shook her head and they bicycled on to the Arlington Cemetery.

They rode under the stone arch, past the open iron gates into the sudden quiet. Green lawns spread out around them and birds called. The road in front of them was steep and they pedaled slowly,

stopping to watch a rabbit bounce over the grass. They got off their bikes and pushed.

"It looks like it's a long way," Tony said. "Think you can make it?"

"Sure," Joey answered, but she pointed to a tree with spreading branches and deep shade underneath. "What's that?" she asked, trying to disguise her panting, as she stopped to rest.

"A willow oak, I think," Tony said. "It was Thomas Jefferson's favorite tree."

They reached the tomb of the Unknown Soldier, a huge white block of marble, and sat on the steps in front of the Memorial Amphitheatre to watch the changing of the guard. "It's so solemn," Joey whispered after the guard had marched past twice and handed his gun to the other guard. "And sad. That man inside, 'known only to God.'" Tony nodded and they got up and bicycled on.

Lines of white headstones spread below them on the green sloping lawn, and when Joey turned, she saw that more lines filled the hill above. She squinted, making the lines waver, then propped her bike against a post and crossed to peer at a gravestone nearby. "William Dickson, PFC MCCO 164 IF, 41 Division, World War l, Feb 12, 1889–June 12, 1939. "What do all those letters and numbers mean?"

Tony leaned over to peer at the stone with its rounded top. "He was a private in the infantry, but I don't know what those other letters mean. They give his division in World War One, I guess."

"He was fifty." Joey moved across the lawn. A clump of stiff, red carnations stood in a black can beside one gravestone and she stepped back, feeling that she had trespassed in a private space. Further on, she stooped down to read several more gravestones, doing the arithmetic slowly. "All these men were old," she said coming back to Tony. "I thought a lot of soldiers died young."

"Soldiers in battle often die young," Tony said. "But they get buried overseas. You have to be pretty important to get buried here. I read somewhere that they've built fourteen new cemeteries abroad."

"But how can the families visit them?" Joey glanced back at the can of carnations, which were turning dark.

"They can't until the war is over." Tony wheeled his bike around and pointed to a narrow creek below them, running through a stone culvert. "Pretty, isn't it? If you have to die, it'd be a nice place to be. Paderewski's here somewhere, I think."

"Who was he?" Joey asked.

"A famous pianist and a guy who did a lot for Poland. He died a couple of years ago, but he can't be buried in Poland now, because of the Nazis, so Roosevelt said he could stay here until Poland's free."

"Ah, that's like the President, isn't it?" Joey squinted at the white stones again, pulled her bike from the post and turned it so that she was beside Tony. "The whole place is sad," she said. "Pretty, but sad. I mean, I don't like thinking about death much, do you?"

"No," Tony said. "Neither do I. Let's coast down the hill and bike home."

* * *

November had come and the wind slapped Joey and Fay's cheeks and blew back their scarves as they walked home from school. "I'm not going to do that contest Miss Shelton wants us to enter," Fay said. "Are you?"

"I don't know." Joey shifted her books to the other arm. "I don't think so, but I might." Joey glanced down at a mound of wet leaves on the parking strip and thought guiltily that she often pretended to Fay and others that she was irritated with Miss Shelton's long homework assignments and her talk. But, in fact, she secretly admired their tall, awkward homeroom teacher with her intensity and her enthusiasms. Miss Shelton had brought a dozen copies of *Macbeth* from the library and had had the class read whole scenes out loud. Just last week she had picked different people to read Archibald MacLeish's new poem, "America Was Promises," and Joey had the most lines, because she knew she was one of Miss Shelton's favorites. That morning, Miss Shelton had explained that there was a city-wide essay contest on the Four Freedoms. Each contestant was to study the four Norman Rockwell posters on the board at the back of the room and write on one of the freedoms. Entering the

contest was not required, she said, but she hoped a few members of the class would be interested enough to try.

After she had parted from Fay and had made a peanut butter sandwich in the kitchen, Joey sat down at the table in her room and squinted. She could see in her mind the pictures of the Four Freedoms that President Roosevelt had talked about. She couldn't write about Freedom of Speech, because everybody would write about that. She couldn't write about Freedom of Worship either, because she didn't know much about religion, really. Her family never went to church, which was embarrassing sometimes, but then neither did Fay's family and she knew Tony had his doubts. She didn't know about Freedom from Want. She could only try to imagine what a thirsty soldier must feel like in the desert or a hungry girl lost in the bombed rubble of London.

Freedom from Fear. She thought of the picture of the parents in the fourth poster, standing beside a bed, looking down at their two sleeping children. The father was wearing suspenders, she remembered, puffing on a pipe, and the mother, who had a white apron tied around her waist, was bending over the bed, gazing down. What would it be like to have parents who stood over your bed together looking down at you like that? Poppy would never have had the time, of course, even if he hadn't had to go away to work on his secret weapons somewhere. Even if she and Mad had been little and cute, like the children in the poster, he wouldn't have had time; he had to help win the war.

Joey frowned, thinking suddenly of that winter night last year when she and Madeline had sat up in bed, listening to the sound of Mum's crying. Didn't Poppy love Mum anymore? Did he want a divorce? She sighed, remembering that old feeling of sick helplessness. Was that part of the reason why he never came home?

"I do not know the fear of war as others closer to it do," Joey began to write in her round printing. *"But war brings fear in many forms, and although I am hundreds of miles from London and Stalingrad...."* She crossed out *"hundreds"* and wrote *"thousands"* above it. *"...and*

all the other battlefields of this huge war, I know fear in my own way,
because war brings many kinds of fear, I think." She paused and reread
the words on the lined white paper. The sentence was long, but she
continued.

* * *

Mum announced that Joey's father would be home soon for a quick
visit, because he had some work to do in Washington. She said she
didn't know exactly when he would arrive, but when Joey came
home from Fay's house the next afternoon, she saw her father sit-
ting on the couch, his elbows on his knees, staring down at the rug
just as he used to do. "Poppy!" she said and started across the room.
"I didn't know you'd come already."

"Hi, honey." He stretched one arm toward her. "How are ya, Jo?"
She stood beside him, feeling his arm circle her waist as she stared
down at a balding place on his head.

"How long can you stay?" she asked.

"Not long, honey. Not long at all."

"Have you got a lot of work to do?" She looked at the cigarette
burning between his fingers.

"That's right, honey." He coughed and lifted the cigarette to his
mouth, inhaled, then coughed again. "A lot of work. I can't see much
of you this time, I'm afraid, but...." He was interrupted by another
cough and Joey felt him pull his arm from her waist to cover his
mouth with both hands. The coughing went on and he balanced the
cigarette on the rim of the ashtray and pounded his shirt front with
one fist. "That's better," he said as the coughing subsided. "How's
school, honey? Things going pretty well?" He looked back at her.
"You like being in the sixth grade? You're in the senior class in your
school now, aren't you?"

"Yes, Poppy," Joey said and paused. "I've got this neat homeroom
teacher. I mean, she gives us a lot of homework and everything and
not everybody likes her, but...." She rushed on, telling him about
Miss Shelton and "America Was Promises" and how she'd written
a piece for the Four Freedoms contest.

"That's good," her father said, but he was staring at the rug again. He was tired, she thought, and he was so far away from her life, her school and friends that it made Joey feel tired talking to him.

* * *

The secretary from the principal's office came into Miss Shelton's homeroom two days later and handed her a folded piece of paper. Joey looked up and saw Miss Shelton pull her breath in with a jerk as she read the message. "Class. Class." She tinkled the little bell on her desk. "Pay attention, class. I have some wonderful news. Josephine Lindsten has won the Four Freedoms Essay Contest. The award for the essay on Freedom from Fear. She'll receive it in assembly tomorrow morning."

Heat poured through Joey and she drew in her breath, then looked anxiously around at the class. Fay was squeezing her hands together in excitement, but the others might not be so pleased. She saw Polly lift her arms above her head in a cheering gesture. Dodo joined her and Joey sighed with relief.

* * *

Joey got out of bed that night when she heard her father come in and ran down the two flights of stairs. "Poppy," she said in a loud whisper. "Poppy, I won the essay contest. The Four Freedoms thing I told you about. The assembly's at nine tomorrow morning," she told him. "They're going to give me a prize. Can you come?"

She stood barefoot in her nightgown, looking up at him. "Can you, Poppy?" She glanced over at her mother who was standing in the doorway and saw her shake her head.

"Your father's only home for four days," her mother began and paused. "He's very busy, you know."

"I'm sorry, Jo, honey," he began. "I've got a meeting with some military guys at the War Department tomorrow morning at eight. But wait." He turned and hung his overcoat on the hook by the door. "Maybe I could push it up a little," he said. "Maybe. I'll see."

"It doesn't matter," Joey said. "I just thought since you're here and—"

"Listen, Jo," her father broke in. "I'll try. I have to leave here early in the morning to finish some stuff at the office and then, honest to God, I'll try. If I can put that meeting off until ten, I will. I really will." He clapped one hand on her head. "The thing is, I'm proud of you, honey. Really proud. That must have been a good essay, a good job. You've done well."

"I didn't think it would happen," Joey said and smiled up at him. "I'd forgotten all about it actually and then suddenly Miss Shelton.... She's the homeroom teacher I told you about. She got the news this morning in History and she told the whole class." Joey paused. Maybe Poppy would read the essay, but maybe not. He probably wouldn't have time.

"I'm really proud of you, honey." The clock in the dining room began its slow methodical chiming. "Midnight. Is that right?" He looked at Joey again. "You better get some sleep before your big day tomorrow."

He bent and kissed her on the forehead and her mother put an arm around her shoulder. For just a moment they were on either side of her, Mum and Poppy, and she felt warm and protected. Surely someday, when the war was all over and won, it would be all right; they would be a family again.

* * *

"I was so scared when I went down that aisle. I thought I'd throw up," Joey said. "I could taste the toast from breakfast."

"I was scared for you," Fay said. They were lying side by side on Fay's quilt-covered bed. "But it was so exciting. My Mom was smiling away and your Mum, too. Too bad your dad couldn't be there."

"He had a meeting," Joey said. "He's only here for a few days."

"I know, but...."

"He's working on something vital to the war effort," Joey started, defensive suddenly. Fay ought to understand that Poppy was an important scientist, who was doing something secret. She thought of Henry, Fay's father; he had settled at the dining room table last night to help them with a map they were making of the Pacific. She

could see him, leaning over, his hair slightly rumpled, erasing carefully, since Fay had put Hawaii too close to China. He had measured the right distance on the Mercator projection and helped them draw it in. Henry was working hard in the OPA, but Poppy was more brilliant and more important.

The front door banged shut downstairs and they heard Madeline's voice in the hallway below. "It's me. Where is everybody?"

"We're up here in my room," Fay called and pushed herself up on her elbows. "Mummy's in the kitchen."

Joey had meant to defend Poppy better somehow, but Madeline's voice held a certain exuberance and she raised her head expectantly.

"Guess what?" Madeline stood in the doorway looking in. "Pam and Ruthie and I are going to *They Got Me Covered* Saturday. It's all arranged. Pam's mother called Mum at the Center and Mum agreed." Madeline flung herself down into the upholstered chair opposite the bed and stretched out her legs, so that her feet in her penny loafers and white socks stuck straight out.

"You're lucky." Joey sunk her chin into her hands, making her elbows dig into the quilt. She thought of asking, "Can we go, too," but she said, "It's got everybody in it. Bob Hope, Dorothy Lamour, and Bing and—"

"Franchot Tone," Madeline added. "Even Veronica Lake." She laughed and pulled the front of her hair forward, so that it spilled down over her face.

Fay joined her laugh, but Joey stared, startled at how like the glamorous Veronica Lake her sister looked with her blonde hair drooping down. "There was a piece in *Life* about how hair like Veronica's can get caught in machinery in the war manufacturing plants," Joey began. "It can be dangerous. It showed a picture of Veronica with braids wrapped around her head." Joey looked at Madeline for a comment, then at Fay, but neither responded.

"That really blonde, blonde actress, Marion Martin is in the movie, too," Madeline went on, "and you know what Bob Hope said about her?"

"What?" Fay asked.

"'She's such a glow girl, her air raid warden doesn't let her come out nights without a turban.'" Madeline glanced from one to the other, then laughed as Fay joined in once more. Joey studied Madeline. She was feeling friendly now, but she would not want Joey and Fay to tag along to the movies with her and Pam and Ruthie. She and Fay would have to go by themselves, if they went at all.

"Hey," Madeline said, sitting up. "How'd it go with the prize and everything? Did you have to go up in front of everybody to get it?"

"It's just a certificate," Joey said modestly, but she felt herself flush as she slipped down from the bed, lifted the stiff white paper from the desk and passed it to her sister.

"This is great," Madeline said, reading the words slowly. She looked over at Joey. "I'm proud of you," she said. "I really am."

"She read the whole composition," Fay said. "All the fifth and sixth grades were there and the principal, Mr. Woodward, announced it and everything. Everybody clapped. Your Mum was there and mine, but not your dad. He didn't come."

Joey sat down on the bed again feeling warm as she watched Madeline read the sentences on the certificate. Madeline understood about Poppy not being there, of course, but more importantly Madeline, her almost grown-up sister, with her friends and her glamorous hair, was proud of her, at least for now.

* * *

Joey's mother announced that their father would probably not be home for Christmas. "But why not?" Joey began and stopped. She knew the answer: it was the war, of course, and Poppy's secret war work.

They had Christmas breakfast together around the fireplace in the living room and opened their presents. Joey got a book about Louisa May Alcott and Madeline got a white Angora scarf. Tony came downstairs in his uniform and Joey gave him a guidebook with pictures of Washington. Mum was bringing in a second pot of coffee when the colonel arrived with a bunch of red roses wrapped in

pink tissue paper for Mum and a big box of chocolates. Mum peeled the cellophane off the box of chocolates and they all peered in. "It's months, maybe a whole year since we've had any fancy candy," Joey said. "So we have to be really fair. The caramel's for Mum, because they're her favorite, and Tony gets—"

"Oh, Joey. Stop," Madeline said. "You don't have to do that."

Joey went to the fireplace and poked at the logs, then she stretched out on the rug. Maybe Madeline was right, she thought, and looked back at the group. With the presents arranged around them and the wrapping paper folded neatly, they looked like a poster of a wartime family: a mother, a sister and two servicemen boarders, a colonel and a Naval Intelligence officer. It was an odd Christmas compared to the old Cambridge ones, but it felt warm and cozy, and in a while she and Mum and Madeline would go down to the Center, where they would have Christmas dinner together in the officers' mess and then she and Madeline would help in the nursery.

Joey thought of last Christmas all at once and sucked in her breath, as she looked out at the stairs in the front hall. She glanced at her mother, who was stroking the fur-lined gloves Joey and Madeline had given her, while she talked to the colonel. So much had changed. Joey reached for a piece of ribbon on the rug and rolled it slowly over her fingers. What did it mean that Mum seemed happier with Poppy gone and that they were having a good Christmas without him?

1944

Chapter 12

SCHOOL began again in the gray cold of January, which slid slowly into the gray of February, then March began with a sudden smell of spring. U.S. Forces were fighting in the Marshall Islands, which were somewhere in the Pacific Ocean, but Joey was too busy to locate them on the map on the kitchen wall. She came home on a peculiarly warm afternoon and was surprised to see an unfamiliar Naval hat sitting on the hall table. Perhaps the lieutenant in Mum's old room had gone and another serviceman had taken his place. The hat was white with a stiff crown and a blue brim, decorated with the Navy seal. It was a WAVES cap, Joey realized suddenly, as she edged her books down beside it, and there was a black suitcase on the floor. She peeled off her jacket and hurried into the kitchen.

A woman with dark curly hair that seemed to spring up from her head was sitting at the kitchen table. Joey took in her white short-sleeved shirt, her bare forearms resting on the checked oilcloth, and her blue uniform skirt beneath the level of the table, just as the woman looked up at her and said, "Hello. I bet you live here, too."

"That's my sister, Josephine. Joey, actually," Madeline said. She was standing at the sink filling the teapot. As the woman continued

to look at Joey and then back at Madeline, her smile curled upward as though she liked them and liked being in this kitchen. "This is Ensign Rebecca Vaughn," Madeline said in a formal voice.

"Rebecca Vaughn," Joey repeated slowly and leaned against the sink. The name had a romantic sound, the name of a person who would have adventures in travel and love.

"I like Rebecca, but it's a mouthful," the young woman said, as if she sensed Joey's fascination with her name. "People call me Becky."

"Are you going to move in?" Joey asked.

"Yes," Becky told her. "I'm so pleased to find this room."

Joey glanced at Madeline. "Is the lieutenant leaving?"

"Yup. Left this afternoon for Fort Dix."

"I've read about the hot beds in Washington," Becky said. "One person leaves and another takes over. And now I'm going to sleep in a hot bed myself." She lifted one hand to her head, pressing down her curls. "It's thrilling."

"But you don't have to sleep on the lieutenant's sheets," Joey said. "We have clean ones."

"Honestly, Joey," Madeline broke in. "I've done that. Mum called and I changed the bed and vacuumed the room and put out clean towels, too."

"Oh," Joey said. Madeline was miles ahead. "Have you read the bathroom rules I wrote?" she asked. "They're pinned up on the wall. You're a WAVE aren't you?" she said, interrupting herself. "I saw your hat in the hall. Do you have to wear your uniform all the time or can you wear dresses when you go out? Can you have dates with Navy officers?"

"Sit down, Joey," Madeline said. "Do you want some tea?"

Joey sat down opposite the new boarder. "This is a wartime household," she announced. "Now, with you, we have four boarders—two Navy and two Army—and we salvage all our tin cans and our bacon fat and Madeline and I save for war bonds, too."

"Goodness," Becky said. "I feel I'm right in the center of things."

* * *

Tony plucked a piece of toast out of the toaster the next morning and passed it to Joey to spread with oleo. "Good morning," Becky said, appearing in the kitchen doorway. She was wearing her full uniform and she looked fresh and efficient, with her dark leather pocketbook hanging from her shoulder and her stiff white hat in one hand.

"Hi, Becky." Joey straightened and held up the smeared butter knife. "Ensign Rebecca Vaughn, I would like to present Chief Warrant Officer Anthony Argillo." Joey smiled from one to the other, pleased at her formality. "Tony lives in the room above the front hall," she explained to Becky. "And Becky's the one I was just telling you about," she said to Tony. "She moved into the lieutenant's room yesterday afternoon."

"I see," Tony said. "Are you working at the Navy Department?"

"Yes. The nine-to-five shift for the next few weeks anyway."

"Good; I'm working there, and that's my shift, too. Have some toast and coffee. We can go down together and then tonight we'll see if we can beat the rush and get a seat on a bus coming home."

Joey felt a glow spread over her neck and shoulders. They would have met soon anyway, but she had introduced them.

* * *

In the week following Becky's arrival, Joey rushed to finish her homework before supper each night, so that she could go down to the kitchen when Tony and Becky got home. She sat at the table in her room in the late afternoon, answering her History questions fast, conscious of Madeline stretched out on the bed beyond her, reading *The Rise of Silas Lapham*. Joey went out into the hall to listen for Tony's voice downstairs.

"They're not back yet," Madeline said. "They stopped at the corner deli yesterday to buy pasta and tomatoes for supper. Maybe that's what they're doing tonight."

"Maybe." Joey sat down and peered at her History questions. When she heard voices in the kitchen finally, she pushed back her notebook and started into the hall.

"You haven't finished your homework," Madeline said, getting up from the bed. "Mum said I was to make sure you finished all of it before you went downstairs."

Joey put her hands on her hips, gave Madeline a fierce look, then turned back to the desk with a sigh. *"Name the three pyramids of Gizeh."* She flipped the pages of her History book, found the answer and filled in the three names. *"Who was Ramses II?"* Joey wrote fast, copying the text. Tony had told her that Egypt was chaotic now, full of British troops, Americans, and spies. Why couldn't they learn about that instead of all this old, ancient stuff?

She ran down the two flights of stairs; she would finish the last two questions in study hall. The smell of cooking and the sound of talk was exciting. On the nights they didn't go to the Hartleys', she and Madeline often argued about whether to have chipped beef or Spam or whether to just eat cereal. But now Tony was stirring sauce at the stove, steam was rising from the big spaghetti pot beside him, Becky was chopping parsley at the counter, and everything felt different. The radio was playing music, not news, and it was a new war song.

"Praise the Lord and pass the ammunition," a loud, rich voice sang out and Becky swayed back and forth at the counter to the beat.

> *"Yes, the sky pilot said it.*
> *You've got to give him credit,*
> > *for a son-of-a-gun of a gunner*
> > *was he,*
> *Shouting, "Praise the Lord, we're on a*
> > *mighty mission...."*

Becky put down the paring knife and turned to Tony at the stove. She clicked her fingers and swayed as the singer went on. Tony reached for her hand and twirled her and they began dancing in the space between the stove and the kitchen table. Joey stood watching them, wrapped in a warm wonder. She didn't want the song to end.

Tony served up the spaghetti with his special sauce and they all sat down at the kitchen table. Becky said Tony should call the sauce, "the meatless marvel" and they began talking about food. Tony said his favorite food that you couldn't get during the war was rare steak, with the juice running out. Becky missed brownies and the icing on cakes and Madeline said rich ice cream. Joey was going to say ice cream, too, but since Madeline already had, she said butter and stood up to clear the table. Madeline filled the dishpan and added soap powder as Joey handed out dish towels.

"*Don't sit under the apple tree with anyone else but me,*" Becky began singing as she dried the tan bowl. "*Anyone else but me.*" Tony joined in and Joey sang with him, "*'til I come marching home.*" She lined up the dried glasses in the cabinet and hung the damp dish towels on the rack.

"Oh gee. Look," Madeline said as she stooped down to hang the dish pan on its hook under the sink. "We've gotta do all these. Tomorrow's collection day." She pulled a bag of empty tin cans from under the sink and lined them up on the counter. "We have to flatten them," she explained to Becky. "The tin goes into building bombers, supposedly."

Joey clenched her jaw. She hated it when Madeline said "supposedly" after a wartime rule. It wasn't "supposedly" at all; the metal was vital for bombers and tanks and winning the war. Madeline put a can on the floor and stamped down hard, mashing the cylinder flat.

"Watch this," Joey said and plucked a tall juice can from the bag. She lifted one foot to stamp, but the can rolled away.

"I'll get it." Tony retrieved it and stepped down firmly with his black, polished shoe, smashing it with a single step and went on to another can.

"When you finish those, there's this. A whole other bag," Madeline announced and pulled a second bag from under the sink. "Oh, shucks. Some of these aren't even washed."

"I'll do them." Becky unhooked the dishpan and began filling it in the dark sink. "Dump them in here." She shook in some

soap powder, washed several cans, and lined them on the counter.

"Hey, Ensign," Tony called. "You gotta dry them. They'll slip all over the floor if they're wet." Becky laughed and dried the cans and the others began mashing them fast, reaching over each other's shoulders to get the dried cans, bumping into each other and laughing. When the last can was done, Becky flicked some soapy water at Tony. He ducked, then whipped a damp dishtowel at her and Joey turned on the radio. Slow Glenn Miller music was playing. Tony hung up the towel, bowed to Becky, and they began to dance again.

Joey stared, watching their clasped hands, Becky's white blouse pressed against his shirt, her Navy skirt against his trousers. They ought to marry, Joey thought. Becky would like that, but she'd have to persuade Tony that he'd like it, too. Joey watched Becky tip her head back and smile at something he'd said. The lucky. She was old enough to be somebody Tony could really like. If Tony married Becky, she'd be glad, Joey thought, but she'd be jealous, too.

When the music was over, Joey dragged a battered wagon marked "Radio Flyer" into the kitchen from the garage and they piled all the cans inside. "Mad and I'll go down the alley with the wagon tomorrow and ask if anyone's got any more cans they want to add."

"Not me," Madeline said. "I'm not going down the alley begging for cans and rubber galoshes and old toothpaste tubes, war or no war."

"Fay's father found an old radiator in an alley when he was out being a warden one night," Joey said, ignoring Madeline. "And that's really good salvage metal. It might make a whole pursuit plane or a big part of one."

"Maybe," Madeline said.

"Okay now," Tony said. "You better put those cans in the garage."

Joey started to drag the wagon out, but turned back. "Have you seen our V-Home Certificate, Becky?"

"Oh, Joey," Madeline said. "She doesn't need to see that."

But Joey reached up behind the black-out curtain and took the

cardboard sign down from the window. "'We in this home are fight-ing,' Joey read. 'We know this war will be easy to lose and hard to win…. Therefore we solemnly pledge all our energies….'"

"Stop it, Joey," Madeline shouted. "Becky's mom probably has one in Philadelphia."

"She does," Becky said. "It's great. It shows that this household obeys all the war rules, conserving food and salvaging and all the other things, and buys war bonds, too." She added, "I've gotta go call my mother, but…." She smiled at the group. "…I loved this evening."

Joey lifted the handle of the Radio Flyer and pulled the cans out to the garage. When she came back into the kitchen, Tony was the only one left. It was Madeline's night to wash her hair and Becky had promised to put it up in pin curls after she made her call. "I've got to cut out 'Terry and the Pirates,'" Joey announced and opened the door to the basement, where a pile of newspapers was stacked on the top step. "It's been almost a month since I sent the last batch to Poppy. It's his favorite comic strip, you know. I don't know where I'm sending them, but I think maybe getting them will remind him of home."

"It will," Tony said. "You've been doing that a long time now." He stood a minute watching as Joey unfolded a pile of newspapers on the kitchen table, turned to the comic page, and began snipping. "I got some of that V-mail stationary today. I'm gonna write my brother in Italy," he said. "See ya, Joey."

All at once the lighted kitchen was quiet. Joey snipped out one strip, then opened another paper and cut out a second. She piled four strips together and sat looking at them. Would Poppy under-stand about Lace, the new character? Would he realize that Burma was gone? She had been an important character in the strip way back in the weeks before Poppy left, before Lace appeared and the boarders came. He had said six months maybe, but now it was more than a year since they had seen him, except for that one quick visit last fall, which didn't count really.

Joey stared at the soapstone sink and at the blue dish drainer on the drain board beside it. Things were exciting with Becky and Tony in the house and school was better now. She didn't worry about Poppy or Mum the way she used to. Mum was busy with her job and never drank sherry or cocktails. And Poppy? Joey didn't even think about him much anymore, she realized. She leaned back and looked up at a crack in the ceiling. That was the trouble; the war had turned from a dark, heavy thing into something that felt cozy, almost fun. But surely that was wrong, she thought, and frowned at the dish drainer, so wrong that something awful might happen.

Chapter 13

J OEY stopped at Becky's half-open door one spring afternoon. Becky had been changed to the swing shift, which worried Joey, since it seemed to her that she wouldn't have much time with Tony anymore. "Hi," Becky said. "Come in." She was sitting on the stool at the dressing table leaning over, a white swab of cotton in one hand. "Look at this."

"What are you doing?" Joey asked.

Becky gave a little laugh. "I'm trying these bottled stockings," she said and pointed to several long streaks of tan on her outstretched leg. "One of the girls in the office wore some last week and she said they were wonderful. You can keep them on for a couple of days—if you don't take a bath." She leaned further down and wiped the side of her leg with the cotton swab, leaving another long tan mark. Then she wiped again, filling in the area between.

Joey moved to the table and picked up the open bottle. " 'Stocking Fizz,' " she said, reading the label.

"That black pencil there comes with it," Becky said, "for making the seam up the back. But I don't think I'll bother with that."

"I bet it's less expensive than nylons," Joey said.

"Oh, nylons." Becky shook her head. "They're only for people

with black market connections. I wear rayons like your Mum, like most WAVES, but they get runs."

She straightened, wiped her hands and ran her fingers through her hair. "I'm thinking of getting a perm," she said. "Just the ends, you know, to keep the curl."

"I like your hair the way it is," Joey said. "It's bouncy and nice."

"You sound like Tony." She flushed. "You know what he said?" She clasped her hands together and her eyes took on a mischievous glint. "He said if I got a perm, I might look like a sea gull or even a scupper." She laughed.

"A sea gull?" Joey asked.

"They're easy women who follow sailors from port to port and a scupper is just a straight prostitute."

"Oh, sure," Joey said, pretending she knew.

"Well, that settles it. If you and Tony both like it the way it is, then no perm for me."

"You really like Tony, don't you?" Joey leaned against the bar at the end of the wooden bed frame.

"Mmm hmm." Becky's cheeks went pink as she ran her hands through her hair again. "We've only known each other six weeks, but I...I think I'm in love with him." She laughed and the pink suffused her cheeks and started up her forehead toward the line of her curls.

"That's wonderful," Joey said in a whisper. "Wonderful." I've been in love with him myself, she started to say, but stopped and said instead, "I'm glad. I've been hoping you would...." She hesitated. "Fall in love with him, I mean."

"He's so bright and funny, so generous, you know?"

"Do you think you might marry him?"

"Oh, I don't know, Joey. He likes me, too. I know that. But we want to wait until after the war and see how we feel then."

"I hope you're still in love. I think you'd be really happy together."

"We'll see. Marriage is serious business, you know," Becky said.

"You're deciding something for life, or almost." She looked down at the rug. "My parents haven't been happy together for years. I wish they'd separate or divorce or something, but somehow they can't."

Joey studied the pale tan border of the rug that Becky seemed to be staring at, too. "I know," she said. Poppy had been away so long and yet if he came back, would he and Mum be happy? Did they think they couldn't divorce, but could never be happy together either? Joey sighed. "I know."

<p style="text-align:center">* * *</p>

It was a late April evening and Joey felt as though she could fly down the hall. Things were working out just the way she wanted. *"When the lights go on again,"* she sang, as she came into the bedroom, *"all over the world."* Madeline was sitting on the double bed drying her hair with a yellow towel. *"And the boys are home again, all over the world."* Joey stopped and faced Madeline. "I saw something important this afternoon," she announced and raised her eyebrows as she looked at her sister. "The door to Becky's room was half-open when I came by and Tony was in there. He was kissing her." She raised her eyebrows higher, as she waited for Madeline's response.

"So?" Madeline said and tipped her head back, flinging her wet hair over her shoulders. "They've done more than kiss. I can tell you that."

Joey stared as Madeline began rubbing her hair with the towel. Tony spent time talking to Becky in the kitchen and she knew he spent time in Becky's room, too, late at night sometimes. Were they in bed together? Was that what Madeline meant? Joey looked out of the window at the street below. She wasn't going to admit to Madeline that she didn't really know what they would do in bed, besides kiss and snuggle down together and that couldn't be very serious. She watched the traffic start up, when the street light turned green. Anyway the important thing was that Becky and Tony were happy.

<p style="text-align:center">* * *</p>

The dusty windows in Joey's classroom were open on a warm

Tuesday in June, letting in the huffing roar of a bus below and the distant sound of a dog barking. It was study hall and Miss Kelly was not in the room. Joey sat with her back to her desk, gossiping with her friend in the row behind. The door opened suddenly and Miss Kelly came in. She was carrying a radio and seemed unconcerned with the groups of chattering students and the obvious fact that little studying was going on.

Joey watched her ease the radio onto her desk. Her rear end rose up as she stooped to hunt along the baseboard for an outlet. She plugged the cord in, straightened and clapped loudly. "Pay attention, everybody," she said. "Something very important has happened and I want you all to hear." Joey stared. Miss Kelly clasped her plump hands together in front of her breasts, which were straining the line of yellow buttons on her poppy-covered dress. There were pink splotches on her cheeks and the blondish wisps of hair at her temples looked damp. "I want everybody to hear this," she repeated as she turned the volume button.

What was happening, Joey wondered? Nobody brought radios into the classroom. *"Rinso white, Rinso white,"* came the familiar, cheerful voice. *"Happy little wash day song."* Joey gave her friend across the aisle a superior smile and watched Miss Kelly turn the tuning button. Were they going to listen to commercials all afternoon?

"...the landing of Allied Armies...the invasionary force of...." The broadcaster's voice was hoarse and hard to understand. Miss Kelly turned the tuning button again and a clearer voice said, *"Four thousand ships covered by eleven thousand planes hurled...."* Someone scraped a chair on the floor. *"The largest amphibious force in history,"* the voice continued.

Joey heard Mrs. Stratton's high heels in the corridor outside and glanced at the door as she came into the room. It must be her free period, since her sixth grade was in Science now. "Can you believe it?" she said to Miss Kelly. "Isn't it exciting?" She pushed her wire-rimmed glasses up on her nose and looked out at the room as she

and Miss Kelly stood with their backs to the blackboard. "Can you believe it, class?"

Joey stared at the radio, uncertain about what had happened. She heard the phrases, "Atlantic Wall" and "Hitler's fortress," as Miss Kelly and Mrs. Stratton talked. There was more static and Miss Kelly stepped in front of her desk. "Class, class," she said and clapped her hands again. "It's the invasion. The invasion at last. Don't you see? The Allied Armies have landed in Normandy, France." She turned and pointed quickly at the map of Europe thumbtacked to the side wall. "The great invasion of Europe is under way." Her voice shook and Joey, who had twisted to glance at the map, looked back at her. Did she have a brother fighting in Europe? Could pudgy Miss Kelly have a fiance, who was in France already?

"Right now, this very minute," Miss Kelly continued, "our soldiers are landing on the French beaches. This huge attack has been kept completely secret, so that it's taken the Nazis by surprise, even though they do have guns on the cliffs above. And it started this morning before any of us woke up. They're calling it D-Day."

* * *

Joey and Fay ran down the alley to Joey's house and burst into the kitchen through the half-open door. Joey stared, surprised to see Tony leaning against the sink, listening to the radio. "Isn't it amazing?" she said. "Will they free France? Will they take Paris?" She leaned back against the refrigerator panting.

"Will they capture Hitler?" Fay demanded and flopped down in a chair, panting, too.

"It's good," Tony said. "But it's very dangerous. Those beaches are manned with Nazi artillery and machine gun nests. It was no joke landing all those troops in the dark. I'm worried about the weather." He glanced at the radio, and hearing the organ prelude to a soap opera, he switched it off. "There was a storm Sunday and now another one's coming. Still, it's started." He gripped his hips with both hands, clutching the dark belt beneath his white shirt, and looked at Fay, then Joey. "Don't worry," he said quietly. "They're going to

make it." He picked up a newspaper lying beside the dish drainer. "Look what General Eisenhower said." He leaned over the paper and read out loud, "'The tide has turned. The free men of the world are marching together to victory.'"

"Victory," Fay said. "Wow. I want somebody to bop off Hitler tomorrow."

"Today would be better." Joey opened the bread box, then took a jar of peanut butter from the shelf above the stove. "Want one?" she asked and raised her eyebrows at Tony as she pulled white slices from the package of bread.

"Yeah, sure," he said. "Got any jam?"

Joey turned to the refrigerator, pulled out the margarine, and then a small glass jar half full of homemade jam, with a purple drip sticking to the side.

"It's the Nazi machine-gun fire from the bluffs that I'm worried about," Tony said. "I keep thinking of those guys on the beach."

Joey looked up at him, holding the knife with the peanut butter on it in one hand. Tony was thinking of his friends, his brother maybe or himself, landing on a beach at dawn, being hit by enemy fire from above. Tony, she wanted to say, don't you go into action, too. But she swallowed and looked down at the pieces of white bread she had lined up on the table. "You know what always makes me mad?" she said and dug the knife into the peanut butter jar. "You hear about a big victory or an invasion or something and you feel excited at first and then you think about all the people who are dead or wounded because of it, and it doesn't seem so wonderful at all."

"That's the way with war," Tony said.

"I know," Joey agreed. "I want peace."

"So do we all," Tony sighed. "But this seems to be the only way to get it."

Chapter 14

A FTER the excitement of D-Day, there were only two more weeks of school. Joey looked forward to summer with a sense of mixed relief and loss. She would be glad to break out of the routine of homework and classes and the daily walks and bus rides back and forth to school, but she knew she would miss it, too. The long hot days of summer began. Fay left to spend a month with cousins in Maine, and in just two days, Madeline was going to Vermont to be a junior counselor at the camp she had gone to the summer before. Mum had suggested that Joey might go to camp this year, too, but Joey resisted. She would rather stay home, she said. She could roll bandages at the church down the street and help with the neighborhood salvage campaign and she would have time to write in her journal and write stories maybe. And yet Joey sensed it wasn't any of those projects really, but a feeling of suspense and excitement in the house. She wanted to be near Becky and Tony; she wanted to see what was going to happen.

Nevertheless, the days were long after Madeline left. Joey walked down the block to St. John's church in the morning to roll bandages with neighbor women. She complained at first that everybody there was over seventy, but secretly she enjoyed the time: the smell

of coffee, the welcomes of the several women who always seemed to be there, the familiar tables spread with stacks of white gauze, the cool streams of air from the electric fan as it rotated slowly above the women's talk. Joey became fast and efficient, piling up the three-by-five squares quickly. Sometimes they put little bags together to be sent to hospitals, tucking in tubes of shaving cream on one side, chocolate bars in the center, pencils, memo pads, and packages of chewing gum.

Mrs. Cameron, a plump woman with a lacquered helmet of blue-gray hair, had dark, lipsticked lips that were always talking, often about her son on the Italian front, but equally often about her cat's brilliant intuitions. She announced that Joey was a wonder the way she worked, and after the first week, Joey took a peanut butter sandwich to the church and ate her lunch with Mrs. Cameron and her sad-faced friend, Mrs. Blackstone, whose nephew had been killed on the beach in Anzio. The three of them and a sprinkling of others stayed on and rolled bandages all afternoon.

One morning when Joey took her place at the long table, Mrs. Cameron asked, "Did you read what Mrs. R said in the paper last night, Josephine?"

"No." Joey looked up. "What?"

"Well, she's in the Pacific now, you know, visiting the young men in hospitals. Some of them got wounded when they went back to help rescue their buddies and Mrs. R told them how she admired what they had done. One soldier looked up at her and said, 'You would have done the same, you know.'"

"She would have, too," Joey declared and pressed one fist against the edge of the scarred table. "She would." She took a piece of gauze from the pile and began to fold it, going over the story silently, planning how she would write it in her war journal. Someday, somehow she would be like Mrs. R, not a First Lady maybe, but a courageous woman who would speak out about things that were important.

* * *

Joey stopped to buy a Good Humor on her way home from bandage

rolling one afternoon. She paid the Good Humor man and started down the street, thinking of how long ago last summer seemed, hunting up nickels and dimes with Fay and running down the sidewalk barefoot to the Good Humor truck. She licked her Good Humor slowly as she climbed the stairs to the upstairs hall.

"Joey. Joey. Is that you?" Becky jerked her door open; she stood on the threshold in her stocking feet looking pink and excited. Her white uniform shirt hung out over her dark skirt and her curly black hair was ruffled on top, as though she had been running her fingers through it. "Guess what?" she said and squeezed her hands together. "Tony and I are going to get married Friday! He's being sent to the Pacific Monday, so we just decided to go ahead and do it."

"Oh, how wonderful!" Joey put her arms around Becky, holding the Good Humor up high behind her back. "That's the day after tomorrow," she said and pulled back. "Wow. Have you told Mum?"

"Oh, yes. She's going to take the morning off, so we can plan. Tony's Catholic, you know, or he was, but he feels fine about St. John's."

"Where I do my bandage rolling?"

"Yes. It's close. We'll have the reception here. Just a few friends, the boarders and Mona and Henry and…. I wish my Mom could come, but the train trip would be too hard for her with her arthritis and there just isn't time. I'm going to wear my dress uniform." She turned and lifted a tailored, white skirt from the back of the chair and held it up. "I was just looking at it. It has a stain there. See?" She pointed to a brown spot several inches above the hem. "I've tried, but I can't get it out. Maybe I should go to the commissary tomorrow and buy a new one. But we haven't got much time." She turned the skirt, holding it by the waist, so that it swung out slightly. "It doesn't really show, do you think? There's so much to do in just two days." She draped the skirt over the chair and turned back to Joey. "I've got phone calls to make. I want to tell my sister and— Oh, it's so exciting." She paused and caught her bottom lip between her teeth a moment.

"Is he part of the invasion?" Joey asked. "Of Japan, I mean?"

Becky squeezed the fingers of one hand, holding them tight in the other. "I think so. He can't tell me that, of course, but I'm pretty sure. He'll be on a communications ship, I think." Her lip quivered and she glanced back at the skirt. "We've only known each other a few months. We ought to have more time and we would, if it was peace. But, you know, the war."

She pressed her fingers to her lips and her eyes glittered. "Remember my captain at work, Captain Hinton, the one that I keep complaining about? She's giving me a three-day weekend and Tony's going to make a reservation at a hotel downtown. And you know what? Captain Hinton gave me some sugar she's saved. She said to use it for the wedding cake. Can you believe it? That stern little woman with all her fussy rules. Suddenly she's giving me three days off and sugar, too."

Joey flung her Good Humor stick at the wastebasket, missed and threw her arms around Becky in another hug. "Oh, I'm so excited," she said. "This is my first wedding. I mean, the first I've ever been to and it's people I love. I mean, you know, I love both of you." She stepped back and sighed. Madeline and Fay would miss all this drama, she realized suddenly, since there would be no way either one of them could get home by Friday. Poppy would miss it, too, she thought, but then Poppy barely knew Tony and he had never even met Becky. She paused. Could that be true? Yes. Becky had come in March and Poppy hadn't been home since last November, long before Becky had come.

* * *

When Joey came down into the kitchen the next morning, she saw her mother sitting at the table, making a list. She glanced toward the sink, smelling steam, and saw Becky at the ironing board, pushing the iron back and forth over her white shirt. "Hi, everybody," Joey said. Tony was stooped over, one foot on the seat of a kitchen chair, polishing his black shoe vigorously.

"Now you've invited four friends from your office," Joey's mother

said to Becky, "plus Captain Hinton, and you said three of your Navy friends were coming, didn't you, Tony? Henry's going to try and get some champagne. There's no French, of course, but maybe that New York brand, Great Western, I think it's called. We'll serve iced tea, too, and ginger ale."

"By the way, Amanda?" Tony put his foot down and straightened. "Colonel Harry's agreed to be my best man."

"Wonderful," Joey's mother said. "He'll be a help."

"Right. He's already called about the license. I just wish I'd been able to give Dad a little notice. I mean, he and Mother and my sisters would love to be here." Tony sighed and sat down. "But train travel's impossible now and I know they don't have enough gas."

"Well, we'll have the church service and a little party now," Joey's mother said, "and then when you get back from the Pacific, Tony, you and Becky will have a reception in Philadelphia. You'll have both families and all your friends and we'll come, too, and help celebrate. But right now," she stood. "I've got to go see about the flowers. We want a bouquet and some nice white peonies and some roses, too, I think. Joey, see how much sugar Mona has. With that sugar Becky's captain contributed, I bet you'll have enough to frost the cake."

"Do you think you could get pink rosebuds for the bouquet?" Becky asked. "I'll be wearing my dress whites, you know."

"Oh, yes. Pink would be pretty. I'll go see." Joey's mother snatched up her pocketbook, which was hanging on the back of an empty chair, and looked at Tony. "Now you're going to get the license this morning, and don't forget you have an appointment with the minister this afternoon at two. He's a very sweet old gentleman, but shout. He's rather deaf." She pushed open the screen door and it banged shut after her.

"I'll get my cap and yours," Becky said to Tony. She folded the ironing board, put it in the kitchen closet, and started toward the stairs, holding her ironed shirt up with one hand. "Anything else we need for the license?"

"Money, but I've got enough. Wicky, wicky now," he added and winked at Joey. "Navy talk." He brushed some lint from his shoulder and patted his gold stripe.

"You're gravy," Joey said, reaching for another war expression. "Didya know that? I bet you didn't think on Monday that you'd be getting married this Friday, did you?" she added.

"No, but it's wonderful. Now I'll have so much to come home to. Hey." Tony reached into the pocket of his Navy trousers. "They just issued us new dog tags. Want my old one?"

"Oh, yes," she said and caught it in her cupped hands. "I'll keep this forever."

Joey held the dog tag in her hand as she watched Tony and Becky run down the sidewalk to catch an approaching bus. The bus roared off and Joey opened her sweaty hand to look at the brass dog tag. Tony's grandmother was sending Becky her ring, but Joey had the dog tag, which Tony had worn pressed against his chest.

* * *

The small congregation huddled in front of the altar in the large church, which seemed bare, with people in only the three front pews. But Joey's mother had brought two tall vases of white peonies and they gave the altar a festive look. The service had to begin promptly at two, since another Navy couple was scheduled for two-thirty.

Joey stood beside her mother in the first pew gripping the black hymnal, which felt sticky in her hands. Becky came down the aisle with Henry and stood beside Tony, both of them in their dress whites. The colonel stepped back and the white-haired Reverend looked from one to the other. *"Dearly beloved:"* he began. *"We have come together in the presence of God to witness and bless the joining together of this man and this woman in Holy Matrimony."*

Joey watched transfixed; she had never heard the whole marriage service, just bits and pieces in movies and soap operas. She heard her mother catch her breath when the minister asked Becky, *"Will you love him, comfort him, honor and keep him, in sickness and in health…."*

"I will," Becky said and Joey felt tears prickle in her eyes. Please God, take care of them, she prayed. And bring Tony back soon. Please. When she watched Tony look down at Becky a moment before he gathered her to him and kissed her slowly, tears filled her eyes and she wanted to put her arms around them both.

They made their way down Q Street in the hot summer afternoon, carrying the two vases of peonies. Joey felt a rush of pride as they entered the house, for the old living room looked spacious and welcoming. Colonel Harry had helped her move the two big chairs and the coffee table out into the garage last night to make more room and he had bought a special cleaner to rub out several large spots on the rug. The big vases of peonies and the smaller ones of roses and babies' breath exuded their different scents. Two of the windows in the bay were open and a breeze lifted the light curtains, blowing them in.

The cake, which Joey had made and frosted with Mona's help, sat waiting on the dining room table. It was decorated with pink rosebuds, and the two bottles of champagne, which Henry had procured, sat in buckets of ice at the other end beside the collection of champagne flutes Mum had brought down from the top of the china closet. Mona's lace tablecloth lay under it all, covering the stains on the table. It was all beautiful, Joey thought, and she knew that Becky and Tony, who were used to the usual shabby look of the old house, would appreciate its transformation.

Becky cut the cake with Tony's hand guiding hers and then they laughed and kissed again and hugged. It all went so fast. There was a taxi outside and suddenly the colonel was helping Becky in, handing her her bouquet. Tony bent and got in beside her, as they all waved from the steps and threw rice and rose petals, ignoring the smelly bus lumbering by and the several passengers who turned their heads to stare.

Mum went upstairs to bed after they had washed all the glasses and put the furniture back in place. The colonel left for his night shift and the lieutenant finished in the bathroom and closed his

door. Joey sank into the old gray chair and sat staring around the living room in the dimness. The house felt oddly empty with both Becky and Tony's rooms abandoned. What would it be like to marry, to have a husband to talk to and sleep with? Becky would get to know all the things in Tony's pockets: the change, the little Swiss knife he kept on his key ring in its red case, and his new dog tag. Would he take that off when they were in bed together? Joey squeezed her arms around her. If only...if only she were Becky.

* * *

Becky returned to the house Monday night. She had gone straight to work after saying goodbye to Tony at Union Station before dawn. "We had a beautiful time," she reported, as she sat with Joey and the colonel at the kitchen table. "Breakfast in bed both mornings. We didn't get up until almost noon and then we just wandered around. We went to the Mellon Art Gallery one afternoon and we had the most beautiful dinners right there at the hotel. The second night the *maitre d'* brought us a special French liqueur made from raspberries. It was delicious and he didn't even charge us for it. Imagine that."

"You must be tired," the colonel said gently.

"I think I am," Becky said and covered her face with her hands. "Sort of dazed," she added and stood slowly. "I'm going to go up and write him my first V-mail and then I'm going to bed."

"I'd be tired, too," Joey said as they heard Becky climb the stairs. "The wedding, then Tony leaving. So much to think about and remember."

"Yes," the colonel said. "I guess we all remember the day of our wedding the rest of our lives." He stood and began clearing the table.

The colonel would remember his wedding sadly, Joey thought, as she ran water into the the dishpan, since his wife was dead. How did Mum remember her wedding, she wondered? Joey had seen pictures of her mother in her long white dress, her veil blowing out. Was she excited? Scared? Did Poppy ever think of their wedding or did he try to forget it? Would she herself ever have a wedding, she

wondered, as she sprinkled soap powder on the dishwater. She would never marry Tony, although she would have done so, had she been older, had he asked.

Mum put the champagne flutes back on the top shelf and threw out the flowers when they dropped their petals. The old routine returned and Joey went off to bandage rolling every morning. Becky and Mum often left for work together, since they were both on the day shift again. The colonel was on the graveyard shift and the lieutenant in the back room was working the swing shift, so Joey saw them only in the late afternoon or early in the morning. An Army lieutenant moved into Tony's room, but he, too, was working nights and not around when Joey was home.

The hot days went on. There was a letter from Madeline in which she sounded busy and important. Joey took the calendar off the hook on her wall and sat on the bed to count the days until Madeline returned.

Chapter 15

JOEY was sitting at the table in Mona's kitchen, watching her chop apples for a pie, which was to be the crowning celebration of a welcome dinner for Fay, who was to return the next day. "Go get my glasses, will you, honey?" Mona said as she squinted at a cookbook beside her. "They're on the arm of the couch, I think. I can't read this recipe."

The glasses weren't on the couch arm, and when Joey reached down behind the pillows, she discovered a fat book hidden there. She read the title, *Forever Amber,* and stared at the picture of a young woman in a low, lacy gown that exposed her pink breasts almost to the nipples. This was the book that Madeline had borrowed secretly last month, Joey realized. She had heard her talking about it with Ruthie in her room. Now Mona was reading it. Joey held the thick book tightly, aware all at once that she needed it. She crossed the room and put it in her canvas bag with a knitting problem that Mona had solved. She would read all night, she planned, and sneak it back behind the couch pillows tomorrow morning. The glasses were on the coffee table and Joey returned to the kitchen feeling guilty and excited, as she handed them to Mona.

Joey read late, but by midnight she had barely begun the long novel, because certain passages made her shiver and she had to read

them again. The next afternoon, Joey showed the book to Fay. "Listen to this," she said. "This is her first man. See?" Joey began to read, *"'At last his arm reached out, went around her waist and drew her slowly toward him.... The restraint he had shown thus far now vanished swiftly, giving way to a passion that was savage, violent, ruthlessly selfish. Amber...returned his kisses eagerly...her desire mounted apace with his...'* I'm skipping a little," Joey said. "Here's where I wanted. *'But when he forced her back onto the earth she gave a quick movement of protest and a little cry.... Something mysterious, almost terrible, must lie beyond. Her hands pushed at his chest and she gave a frightened little sob.... Amber crying, half mad with passion and terror suddenly let herself relax.'"* Joey closed the book, holding the place with her finger and looked across at Fay. "What do you think? Isn't that something?"

Fay twisted one of her long braids. "I don't know," she began. "I don't think I'd ever want to do it. It seems so sort of embarrassing."

"I know, but not if you were Becky and Tony maybe." Joey looked over at the window, returning once again to her familiar image of them kissing at the end of the wedding. Had Becky kissed him eagerly in the hotel? Had she been half mad with passion? It *was* embarrassing in a way, but maybe if you loved the person, you could forget about the embarrassment, if you knew you'd be together all the rest of your lives.

"It's probably different if you marry," Joey said, "and want to have babies and a house and dogs. Maybe then it would seem sort of natural." Joey thought suddenly of her mother and Poppy. They had felt all that at least twice, when they'd started Madeline, then Joey. Would they feel it again? The thought made her squint and she looked across at Fay. "I've got to get the book back behind the couch pillows," she said. "Will you go talk to your mom in the kitchen? Please." She paused. "I know what you mean," she said. "It is embarrassing."

* * *

Joey's mother was still on the day shift. She and Joey and Becky of-

ten took their supper up to the porch on the hot summer nights and
sat on the glider talking about what had happened in their differ-
ent days or listening to the war news. General Bradley had taken
Cherbourg, which was good, but the bombing of London went on.
Two weeks after the wedding, a V-mail letter dropped through the
mail slot for Becky. She opened it in front of them in the kitchen and
read the first paragraph aloud, in which Tony described his day in
San Francisco. "The rest is...." Becky flushed and pressed the let-
ter against her blouse.

"Private, of course," Joey's mother said and smiled. "You go read
it alone. Joey and I will fix the salad. Come join us later, if you want."
Joey watched Becky fold the letter and start upstairs. What had Tony
written? *"Oh, my darling, Becky, how I long to be with you again. How
I long to smell your hair and touch your soft breasts...."* Would he write
that? Was he like Amber's lover? Had his restraint disappeared? Had
he been violent in his passion? Oh, what was it all about, she
thought, hugging herself. When would she ever know?

 * * *

Joey stopped in the doorway of her mother's room one late afternoon
and looked in at her mother, who was sitting on the bed in her slip.
She pulled a rayon stocking carefully up one leg and fastened it to
her garter belt, then pulled on the other. "Are you going somewhere
tonight, Mum?" Joey asked

"Colonel Harry and I are going to a concert at the Lincoln
Memorial," her mother said. "They're doing Beethoven's Fifth. They
call it the 'Victory Symphony' now."

"Why?" Joey asked.

"I think it's the Morse code for those notes in the beginning. Dit,
dit, dit, da dash. It's another bond drive."

"Oh," Joey said, but she was wondering how they had ever set-
tled on that name, "Colonel Harry." It sounded so childish.

Her mother stood and turned to the closet and Joey perched on
the end of the bed. Her mother looked strong and straight, Joey
thought, standing there in her slip with its lace border, her white
arms bare.

She plucked a blue dress with white polka dots from a hanger and pulled it over her head. The wide shoulder pads gave her a squared-off look, but the peplum was pretty, Joey decided, as she watched her mother fasten the large white buttons in front with their silver centers. Her mother sat down at the dressing table and stared at her reflection in the spotted mirror a moment, then picked up her powder puff. "We won't be gone long, dearie," she said, still studying her face. "You're having supper with Mona, you know. It's "I Love A Mystery" night, so I didn't think you'd mind."

"I don't mind," Joey said and watched her mother open her jewelry box and lift a string of artificial pearls from the clutter inside. She raised her arms to fasten the necklace at the back of her neck.

"Wait, Mum." Joey scrambled from the bed and bent over the open box. "These would be better," she said pulling out a string of pale blue beads.

"Hmm. Let's see." Her mother lifted off the pearls and put on the beads. She pulled at the necklace to center it, then stared at herself again. "I think you're right."

"These earrings," Joey directed, holding up some blue drop earrings. "They match, almost." She watched her mother clip one earring to her left lobe, consider her reflection, then clip the other earring on.

"Yes, that's definitely better, dearie," her mother said looking seriously at herself in the mirror.

"Do you like the colonel a lot, Mum?" Joey asked

"He's a good friend. I enjoy being with him and I love the Beethoven."

Joey lowered herself to the bed again and sat staring at her mother. The colonel was helpful and kind and they had known him all through the war almost. But the thought of him taking her mother's elbow as he helped her into a taxi or the thought of him smiling at her as he delivered some compliment about her looks tonight made Joey's shoulders hunch together in a shudder. "Mum," she started. "If Poppy never came back, would you marry the colonel?"

"Joey." Her mother twisted quickly on the dressing table stool

and looked at her. "Joey, for heaven's sake. Harry, Colonel Fenton, is just a friend. I wouldn't even go tonight if it wasn't for the Beethoven." She stared at Joey a moment, then stood. "Dearie," she said and put her arm around Joey's shoulders. "Your father's coming home. He really is. I know it seems awfully long. It does to me, too, but the war is going to end and he'll come home."

"I know," Joey said, thinking, but what will happen when he does?

* * *

When Madeline came home from camp in late August, Joey described the wedding, the cake she'd made, the crowd in the living room, the white flowers, Tony and Becky in their dress whites. But Madeline had news of her own; she had a real boyfriend, Scott Gray. He was handsome and smart and he loved swimming and canoeing and he thought Madeline was pretty and brainy, too. They were going to write to each other all year long until next summer when they would both be senior counselors. Listening, Joey had to admit that Madeline's news was important, but that didn't stop her from talking on and on about the cake and Becky's bouquet and the way Tony had looked when he leaned down to kiss her.

* * *

The telegram came on the twentieth of August. Joey opened the door and saw the thin Western Union boy standing on the top step in his tan uniform. He was holding a clipboard and when he asked for Mrs. Anthony Argillo, Becky darted from the kitchen, signed her name, snatched the yellow envelope from him and hurried up the stairs just as Mona came in through the back door.

A terrible, muffled noise began in Becky's room and Joey looked at Mona in horror, then watched as she hurried up the stairs. Joey clutched her arms around her and moved to the bay window. Please God, make it Missing in Action, she prayed. Please not dead. Please. Please.

"Joey," Mona said, coming back into the living room. "Put the kettle on for tea and call your mother, will you? She'll want to come

home, if she possibly can." She looked at Joey for a long moment and closed her eyes. "It's what we dreaded," she said. "The worst. I'm so sorry." She put her arms around Joey and squeezed her against her breasts. "Here," she said and handed her the telegram. "You can read it for yourself. Becky wants us to see." She glanced around her. "I hope your Mum can get here soon. I better go back up. Bring up the tea when it's ready. All right?"

Joey made the call, filled the kettle, then she opened the yellow envelope slowly.

THE SECRETARY OF WAR DESIRES TO EXPRESS HIS DEEP REGRET THAT YOUR HUSBAND, ANTHONY ARGILLO, WAS KILLED IN ACTION IN DEFENSE OF HIS COUNTRY IN THE PACIFIC THEATER ON JULY 30TH. LETTER FOLLOWS. THE ADJUTANT GENERAL.

July 30th? But that was almost a month ago. How could he have been dead that long without their knowing? She stared at the telegram, wondering who the adjutant general was and what he could possibly know or care about Anthony Argillo, who was Tony, not Anthony, and he was theirs.

Joey put the telegram back in its envelope and moved to the stove. She stared down at the kettle as she waited for it to boil. How could ordinary life go on? How could steam rise from a stained aluminum spout and cans sit under the sink, waiting to be washed and bent? How could people go riding by the front window in buses, when Tony, whom they all loved, was dead?

The teacup shook in its saucer as Joey carried it upstairs to Becky. Mona opened the bedroom door and Joey glimpsed Becky's outstretched legs on the bed, her stocking feet, and heard her muffled sobbing. When Joey started in, Mona shook her head, took the teacup from her, and closed the door. Joey sighed and went back down to the kitchen, where she stood looking through the window in the back door waiting for Mum. She glanced over at the stove and saw

Tony stirring his marvelous meatless spaghetti sauce, then she saw him running down the stairs in his uniform, then bicycling ahead of her in the cemetery.

When Mum arrived and went up to Becky's room, Joey opened the door and began to run. She ran down their alley, then crossed the street and ran down the next one and the next. She was not sure where she was exactly, but when she saw a rusted car with one door hanging open, she crawled in, panting and slumped down. Why Tony? Why him? Damn, damn. She realized she was sobbing and she mopped her nose with the back of her hand. The upholstery of the seat was torn and she could feel the wire spring beneath her as she leaned her forehead against the broken steering wheel. Something rolled between her feet and she sucked in her breath, thinking of rats, but it was only a beer bottle. She closed her eyes. Damn, damn. How could Tony be dead? She slumped down lower and continued to cry.

"Joey." Madeline was at the car window, peering in. "God, you came a long way." She was breathing heavily as she moved around the car and pulled herself up into the passenger seat. "It's lousy luck. Lousy." She put her hand on Joey's bare knee and they sat in silence a moment, then Madeline let out a sob and grabbed Joey in a hug. "It's awful, awful and so stupid," she said. Crushed against her sister's shoulder, Joey let out a moan and looked up at the dome light hanging from its socket above her. She could smell the 1411 Cologne clinging to her sister's sleeveless shirt. "It shouldn't have happened," Madeline said. "Not to Tony. Not to him. It makes me furious."

Joey pulled back, startled by Madeline's fierceness. "How's Becky?" she whispered.

"Awful."

"I should get back."

"No rush," Madeline said. "We'll go soon."

Joey swallowed and put one hand on the steering wheel. "He loved us all," she said. "He lived with us two whole years. He was practically our family."

"But he loved you most; you were his kid sister."

"I guess," Joey said and covered her eyes with one hand as sobs pressed up again. Madeline put her arm around her and Joey buried her face in Madeline's damp neck.

"I'd like to kill Hitler myself," Madeline said. "And bomb all those sneaky evil Japs."

Joey went on crying in her sister's arms. The black horror of Tony's death was all around them, the dreaded thing, but over it hovered something new and faint—Madeline, her proud, inaccessible sister, loved her and maybe always had.

* * *

A week passed, but the shock of the telegram continued to shroud the household. Becky went back to work, driving with Joey's mother each morning and coming home with her each night. Joey knew that Becky confided in her mother and felt grateful that Mum was available, but she felt vaguely betrayed. In front of Joey and Madeline, Becky acted quiet and brave and rarely spoke of Tony at all.

Joey stooped in the front hall one afternoon to gather the mail and glimpsed a white envelope addressed to her in her father's slanting handwriting. She piled some bills and advertisements on the hall table hurriedly and rushed upstairs to her room, shut the door and slit the envelope quickly. "Your mother wrote me about the death of your friend." She read the words in her father's neat hand. "The Naval officer, who boarded with you. I'm so sorry. I know he was a great friend of yours and I'm sure his death is a huge sorrow. War is a terrible business, Jo. When we finally finish this, I hope there will be no more wars in your lifetime." Joey read the letter slowly, then folded it and went to the window. She had been yearning for a letter of her own from him for two years now, instead of the bland postcards and letters addressed to them all. She had one finally, but it had taken Tony's death to gain it. She sighed and closed her eyes as a bus pulled away from the curb.

* * *

Joey lay in bed beside Madeline in the moist dark watching the

shadows change on the ceiling: a man's face with a heavy brow, a tailless duck. The night was hot and she had kicked the sheet to one side. Madeline turned on her back and sighed and Joey sighed, too. She felt grateful that Madeline was awake, because she wanted to talk and yet she felt anxious, because she didn't. "It happened so fast," she began. "I mean, they were married July second. They only had two nights together, married nights that is, and then July thirtieth he was...he was dead." The word came out in a half sob and Joey squinted in the dimness, angry at herself for beginning again.

"They met in the spring though."

"On March eighteenth," Joey said.

"Well, then they knew each other almost five months."

"It should have been five years or fifty. They should have had their whole lives together."

"Yeah, they should have," Madeline said.

Joey sighed and pushed her head up, pressing the pillow against the head board. "You know what I keep thinking? I just want to go down into the kitchen and find him there by the stove, boiling water for spaghetti, cutting tomatoes for his meatless sauce. Remember that? A lot of the time, most of it actually, I'm not even thinking about Becky. I'm thinking about me."

"That's okay," Madeline said quietly. Their bare legs were stretched out side by side, protruding from their summer nightgowns, and Madeline let one foot drop to the side, touching Joey's, so that it rested there like a comforting hand. "You loved him. We all did, but it's like I said, you were his kid sister."

"Ah." Joey raised one arm and pressed the back of her hand to her mouth. She didn't want to cry. "This stupid war just goes on and on, killing all the good people."

"We have to beat Hitler though."

"I know," Joey murmured and felt the warm pressure of her sister's foot.

Chapter 16

JOEY screeched as the cold water from the kitchen faucet rained down on her wet hair. Madeline, who was sitting at the table buffing her fingernails, looked over at her. "Do it again," she said. "You have to get all the soap out or it'll look greasy."

"I know. I've got it now, I think." Joey straightened and flung back her wet hair as the water drained out of the dark sink with a gurgle. She wrapped her head in a towel and bent over to rub it, then stopped rubbing and looked at Madeline. "I can't decide whether to wear my new Sloppy Joe sweater tomorrow or my pale blue one with a dickie. I just keep going back and forth."

School would begin the next morning and Joey would enter the seventh grade at McNeil Junior High, "a freshman," as they called it, while Madeline would be a ninth grader, "a senior," her last year of McNeil before senior high.

"Well, don't get the screaming meemies about it," Madeline said. "Why don't you wear your blue with the dickie the first day and the Sloppy Joe the next?" Joey felt Madeline's eyes studying her and she let the towel drop to her shoulders and rubbed the top of her head with one hand. "You know, what you really need is a haircut," Madeline said. "That braid you keep wearing looks childish."

"I've thought about cutting it," Joey began. "But Rosie's didn't have any time this week."

"Oh, Rosie's," Madeline said with disgust. "Rosie's Beauty Parlor. They specialize in blue rinses for old ladies, who come out looking purple. It's all right for Mona. She's practically gray anyway, but not you. Listen." She stood up suddenly. "I'll do it. I'll cut it right now. We've got some good scissors here." She opened the table drawer and pulled out a long pair of steel scissors. "I can do it. It's better to do it wet. I'll do a good job. I did Amy's in August and she liked it."

"Well, I don't know," Joey said. She bent forward to rub her hair again, hiding her face under the towel.

"Sit down," Madeline commanded. "I've got a comb." Joey sat, but she continued to rub the towel back and forth. "Stop," Madeline said, "Hold still. I need to see the length."

Joey let the towel drop to her shoulders. She squeezed a long, wet end, then looked up at her sister. "The thing is, I'm used to this length, Mad," she started. "I mean I like the long braid sort of and for dress-up, it looks okay when I do it in two braids and pin them up around my head."

"Okay for now maybe, but you need something better for junior high, you know, keener, more peachy keen." She picked up the scissors and bent down.

"Mad, I...." Joey jerked back.

"Don't. You'll make me cut it crooked. Just hold still."

Joey stared at the refrigerator and let her shoulders slump. She had been thinking about cutting her hair all summer and had never quite had the nerve. But she wanted to look good for junior high and Mad was right; she probably would do the job better than Rosie.

Joey sat listening to the snip of the scissors near her ears. Could Madeline really cut it so it looked good, or would it be shaggy and uneven? Joey gnawed at her lip as the snipping sound continued.

"That's it, I think," Madeline said finally and straightened. "No. Wait." She bent to snip once more, then twice on the left side. "There. I think that's it. I'll get the mirror."

Joey looked down at the long pieces of her brown hair lying on the floor, some partly curled at the end. She leaned over, meaning to gather one; they had been part of her and now she would just sweep them up and dump them in the trash.

"Here," Madeline said, holding out the short mirror she had unhooked from the back of the closet door. "Look at yourself. See? Isn't that good?"

Joey took the mirror and peered. "Oh," she said. "Oh, wow." She raised one hand and touched the soft edge hanging over her ear, uncertain how she felt.

"You look grown up. Tony would like you like that," Madeline added.

They heard footsteps on the stairs and Joey gave Madeline a quick glance as Becky came into the kitchen. Would she suspect that Madeline had just mentioned Tony?

"Joey. You've cut your hair," Becky said.

"Mad did it." Joey held up the mirror again and looked back at herself. "What'd you think?"

"It looks good." Becky moved around Joey, peering at her haircut, then stood smiling down. "It's nifty. You did a good job, Mad. Now you have a new look for your new school tomorrow," she said to Joey and let herself down into a chair at the kitchen table. "The first day of school is really important. I remember, though it seems a long time ago." She looked down at the oilcloth-covered table and then up at Joey and Madeline. "I've got something to tell you." She paused, looked down at her lap and up at them again. "I'm going to have a baby."

"What?" Joey stared and put the mirror on the table with a clatter. "You are? Really?"

"That's amazing," Madeline said. "When?"

"Early March, I think."

"Will you name him Tony?" Joey said. "I mean, if it's a boy."

"Yes, of course. Antonia, if it's a girl."

"Does Mum know?" Madeline asked. "Have you seen a doctor?"

"Yes. She went to the doctor with me Friday morning. I'm really happy about it. I mean, you see...." She stopped and gazed at the sink. "It won't make Tony come back, of course, but it will help, I think. It will help to have to make a good life for his child, our child. I mean, we both wanted to have children and...and.... Now I can't just sit around and be sad. I have a baby to get born and raise. "

"We'll help," Joey said. "Oh, Becky, you will have the baby here, won't you?" She felt her shoulders hunch together suddenly, apprehending another loss. "You won't go home to your mother?"

"I'm not sure. I haven't decided. I have to stop work at the Navy Department soon. No pregnant WAVES, but I'm going to volunteer at the Center for a few months. I want to stay here for the fall anyway." She stretched one arm across the table toward Joey and added gently, "We have some time together and after all we've been through, you and your Mum and me and Madeline, I think we'll always feel like family, don't you? I mean, even if I do go home."

"Oh, yes," Joey said. "Of course, of course." But if Becky left, would she really feel like family two years from now? Ten? Joey never wrote her friend Franny, back in Cambridge anymore. But she would write to Becky once a week, twice maybe, and when they went home to Cambridge, she would go to Philadelphia and visit. But Poppy would have to come home first and that might never happen, or not the way she hoped.

* * *

Madeline led the way down the sidewalk to the front entrance of McNeil Junior High and Joey and Fay followed, with Ruthie walking between. "You don't need to be scared, you know," Ruthie said, looking from Fay on one side to Joey on the other. "Starting junior high. I mean, it's easy. Besides you look neat, Joey, with that haircut Mad gave you." She laughed and raised her voice so that Madeline turned. "Joey's a real oomph girl now. Right, Mad? You ought to open a beauty parlor."

To her surprise, Joey liked the look of her new hair and its light soft feel. Becky had put it up in pin curls, using bobby pins from

Madeline's box, and when Joey combed it out in the morning, it had a fluffy look. She smiled at Ruthie and reached up to spread her short bangs on her forehead. She and Fay were both wearing their blue sweaters with white dickies, their pleated gray skirts, and their bobby socks, and they had both slid bright new pennies into the tops of their polished loafers.

The green metal lockers that lined the long corridors were taller than the ones at Radley and each had a combination lock. Ruthie told Joey to write the combination on a slip of paper and stuff it into her bra. "You'll know it by heart soon," she said. "But for the first week or two, you need to know the number's there in your bra in case you forget." Joey nodded, secretly pleased that she actually had a bra to put it in.

In McNeil, each class was in a different room with a different teacher and group of students. Everyone had a different schedule; Joey kept hers in the front of her notebook, where she could check it often. The building had three floors, but there were four staircases and the corridors were wider and brighter than the corridors at Radley and there were windows at either end. The smells seem to lie in layers: sweaty sneakers on top, body odors in the middle and cleaning detergent rising up through them from the bottom.

By the second day, Joey was sitting with her friends in the cafeteria, feeling no need for further support from Madeline and Ruthie. But as she imitated their elderly Algebra teacher to make her friends giggle, she had a strange feeling of apartness. She felt old, she thought, older than Ruthie, older even than Madeline. She had been at Becky and Tony's wedding, had seen them kiss and ride off in the taxi, had seen Becky when she came back after saying goodbye to Tony that early morning. She had read the telegram from the adjutant general and now she would be nearby as Becky's fatherless baby grew inside her. Joey felt even older than Mr. Wylie, their white-haired Algebra teacher.

She studied the list of after-school activities. Madeline had been in the debate club her freshman year, but this year she was on the

basketball team. Joey's eye fell on "Drama Club" and she wrote down the time of its first meeting. When she arrived, the classroom was crowded and a teacher dressed in black, who was in charge of the drama productions, announced that they were doing a modern play called *Our Town*. There were no acting parts for freshmen, she warned, but they were welcome to work on the set.

Joey kicked bunches of brown leaves as she walked home, muttering to Fay. "Come be in the Science Club with me," Fay said, but Joey didn't want to do that.

The following week Dodo told Joey that her English teacher, who was a man, was going to put on a play in November with just seventh graders. Was he going to take seventh graders from other classes, Joey asked? Dodo didn't know, but told Joey to ask. He was nice, she said. He might.

Joey identified Mr. Pierce, a thin man wearing thick glasses, and walked up to him when she saw him in the corridor. "Yes," he said. "Any seventh grader who's interested can try out." They were going to perform an unpublished play by a friend of his, *Dark Skies in the East*, he told her. It was a play about the French underground and it dealt with a French family in a Paris apartment who hid refugees in their attic and helped smuggle them into Switzerland. He listed the eight parts and said that tryouts were scheduled for the following Thursday afternoon at four. Joey borrowed a carbon copy of the script from Dodo and read the play.

* * *

Joey sat in the bathtub with her hair pinned up on her head talking to Madeline as the warm soapy water lapped around her. Madeline was standing in front of the mirror, pressing her hair on the side over her fingers to make it curl under. "I keep thinking about what Marie, the daughter, would feel like; what she would do," Joey said. "I think she'd be scared, knowing about those people in the attic, but excited and proud, too."

"You've got to have good grades to get a part, Joey, you know, even in a seventh grade production. You can't have a D in Algebra."

"I don't. I got a C-plus on the last quiz and I might get a B for midterm. A B-minus anyway."

"But I don't see why you're auditioning for the daughter," Madeline said. "Why don't you try out for the refugee mother or somebody more important?"

"There isn't a refugee mother," Joey corrected. "The family in the attic has lost their mother. She was shot as they escaped. That's part of the horror of it and besides…besides…." She paused and slid down deeper in the tub. "Marie may not be a major part, but she's a really good one."

"So you want to be her?" Madeline turned from the mirror and stared down at Joey.

"She's a wonderful daughter, Mad. She's smart and quick and she has a terrific sense of humor and when the moment comes that they think the Nazis know what they're doing and the father wants to stop, she insists that they get the current group out. She has a plan." Joey flung out a wet hand, holding the dripping washcloth, and said, "'Poppa, we cannot fail our friends, the LeMoisiers. I will go to the Cafe de la Lune tonight and talk with Herr Lieutenant Frorbacker while you and Uncle Jean get the LeMoisiers down to the cellar and off. It will be all right. I can keep Herr Lieutenant Frorbacker entertained. I'm sixteen now. I know what to do.'"

"That sounds kind of stupid to me," Madeline said. "Any Nazi officer would recognize a little French flirt."

"Not Marie. She's good at it," Joey explained. "And she knows the LeMoisiers' lives depend on her. The thing is, Mad…" Joey wrung out the washcloth and spread it on the porcelain rim of the tub. "…it's not just a play. It's actually happening. There are French people, Danes, Italians, and loads of others all over Europe risking their lives every day to help people escape the Nazis. Mr. Pierce said so. I mean, Mad, it's real." Joey frowned at the brass water faucet a moment, thinking, then she sank lower in the tub, so that the warm water enclosed her shoulders. "Oh, I just hope I can get the part. I want to be Marie so badly."

* * *

To Joey's delight, Mr. Pierce told her after the auditions that she had the part of Marie. Dodo was to be her mother, Mme. Moget, and tubby Nate Benson from her Science class would be Poppa. Rehearsals began the following week and Joey thought about Marie as she walked back and forth from school, how Marie felt about the changing refugee groups in the attic, how she felt about smuggling pots of soup upstairs at night, and how she felt about the bullying Nazi soldiers in the cafe, their smells, their shaved cheeks, and their hands. When Mr. Pierce asked for volunteers to help the set crew, Joey raised her hand and worked all day Saturday and Sunday afternoon, painting the set and hemming the old sheets they would use for curtains.

Meantime the new classes became more familiar, the groups of students and the teachers, the lockers and the smells. Madeline went to the movies two Saturdays in a row with a boy named Randy Wright. Was he nice, Joey asked? Did he want to kiss her? Madeline gave evasive answers, but she talked for hours on the phone with Ruthie.

Joey had her own secret; Charlie Howz was in 7B, the seventh grade class across the hall. He was playing Monsieur LeMoisier, father of the refugee family. He wore a rust-brown sweater and his blond hair stuck up in a cowlick behind. Whenever he and Joey were onstage together, Joey felt her face grow warm and she clutched her arms around her. In bed at night, she created happy scenes in which Charlie would linger in the wings beside her and whisper, "I love the way you do Marie, Joey. You're wonderful."

One Friday afternoon, she was going down the stairs and saw Charlie coming up. He was looking at his shoes and didn't see her, but for an instant his hand brushed hers on the metal banister. "Oh," he said and half smiled. "Hi." Joey played the moment over and over. She could see his head, his eyes looking down, the weave of his brown sweater, and then the moment of the touch and his voice, "Oh. Hi." He wouldn't have said that, would he, if he didn't like her a little, and a little could turn to more.

Chapter 17

DARK *Skies in the East* was a success. All five seventh grade classes crowded into the 7B homeroom on a Friday morning to see it. The curtains worked, the sets really looked like an attic and a cafe, and when Joey flung her arms out as she pled with her father, she heard her voice shake. The cast took bows and the applause went on and on. Joey wished the play could have been on the stage in the gym, like *Our Town*, but Mum and Becky, who watched from the back of the classroom with several other mothers, said it was wonderful. Mr. Pierce praised the cast and the set crew afterwards and said that the balding playwright, who had stood in the back, had told him he was pleased.

"I'm going to do another seventh grade production in the spring," Mr. Pierce told Joey and pushed his glasses up into his hair. "Shakespeare maybe or a Greek classic. Come try out. You oughta get a good part." Joey watched him help one of the boys push a tall screen out into the hall and thought how lucky they were to have him. He really cared about theater and this Seventh Grade Dramatists Club was all his idea.

With the play over, Joey had free afternoons and began baby-sitting for a family down the street. She took the two little girls on walks to the park, pushed them in the swings, and pointed out the

different patterns in the feathers on the backs of the pigeons that poked at their cracker crumbs. She began accumulating her own money for Christmas and worried over what she could buy for Becky's baby. A silver bowl would be too expensive, but a spoon maybe? Perhaps she should try to knit a blanket. But there were only three more weeks and she might not finish. Besides, it had to be a surprise and Becky was often around these days, wearing her loose-fitting tops. She had showed Joey a maternity skirt a friend had lent her with a kangaroo-like open place in front and a string tie for the belt. She was filling the open place solidly and often didn't go to the Center, but stayed home and read or chatted with one of the board-ers. She talked to Joey's mother about leg pains and weight gain and what the obstetrician had said and Joey listened, feeling excluded.

* * *

Poppy was coming home for a quick visit to do something at the War Department, Mum told them. He might come that weekend, or the following week sometime. He'd only be around for a couple of days, she said. Joey kept her face expressionless when she heard the news, but she began planning fast. Poppy would meet Becky finally and hear about the baby and more about Tony, of course. Maybe he'd stay longer; maybe he'd even stay on for Christmas. Why not? It was only ten days away.

When Joey came home from school on Thursday, he was in the living room, sitting on the couch in his old posture, elbows on his knees, his head bent, his eyes on the rug. "Poppy," she said and start-ed toward him.

"Hey, Jo. How are—" A cough broke through the question, raking and deep, not like his old familiar cough. A series of coughs followed and he covered his mouth with both hands. Joey watched, wondering if she should do something.

"Jack, I really mean it." Her mother came in from the dining room, holding a tray. "You've got to see Dr. Santini." Her voice was harsh. She glanced at Joey, barely acknowledging her, and put the tray on the low table in front of the couch. "Drink that bouillon,"

she said, pointing to the bowl on the tray. "It might help. I'll make an appointment for tomorrow morning. I'll tell him it's an emergency."

"Amanda, I just explained. I can't see Santini. I haven't got the time. I've got three meetings at the War Department tomorrow and I've gotta get back to the lab Wednesday. I haven't got time to see a doctor."

Joey stared at her father. His face looked gray and his eyes seemed to have sunk back into their sockets, giving him a strange, intense look. She glanced at her mother and saw Madeline behind her, hovering in the doorway. Had she and Mum been conferring about Poppy? Had Mum and Poppy argued, while she was walking home with Fay?

"All right, Jack." Joey's mother put one hand on her hip. The faded yellow apron she had tied around the waist of her dark red dress looked incongruous, especially with the black silk scarf at her neck. Her face was stern, as she stood watching Joey's father. He spread the napkin on one knee and picked up the spoon. "All right," Joey's mother repeated. "I'm not going to be your nursemaid. I have work to do, too. I'm on the swing shift this week. But if you want to punish your body this way, if you...." Her voice shook and she stopped.

"Pop," Madeline said and moved up beside her mother. "Go see the doctor. Okay? It'll only take half an hour. He's right downtown, right near your office."

Joey's father coughed again and dipped his spoon into the soup, then put it down. "Christ," he said and looked from Joey's mother to Madeline. "What is this? I come home after two years away and the first thing I get is orders to see some doctor." He lifted the bowl, tipped his head back and drank the bouillon down. Then he snapped a soda cracker into two pieces, bit down on one and stood. "I'm going to sleep for a while," he said. He coughed and started to the staircase. "Then I'll be off to the office. I've got a lot of work to do, goddamnit." The coughing came again in a series of raking noises, then subsided as he clasped the banister post. He looked back

at them and let his gaze rest on Joey. "I'm sorry," he said. "It's just an old cough. Smoking, you know. Nothing Dr. Santini can fix and I really haven't got the time. I've got a lot of work to do in the next two days. A helluva lot," he said and started up the stairs.

Joey followed Madeline and her mother into the kitchen. "I've got to get to work. I'll be home by eleven," her mother said. She hung the apron on its hook and put on the short maroon jacket that matched her dress. "Your father will sleep a while and then go to the office. He'll probably be home later than I am. Now why don't you two take your homework and go over to Mona's?"

Joey glanced at Madeline. Were they really going to leave their father alone in the house when he had been away so long? He didn't know any of the boarders. "Bring your Mongols," Madeline said in a sharp voice. "Those colored pencils of yours. I have to do a map of the Pacific." At least neither Becky nor the colonel were home, Joey thought. Thank goodness. They had not heard Poppy yelling at Mum and Madeline, and the other boarders hadn't either.

Two days later Poppy was gone. There had been no time to tell him about the baby and he never even met Becky, since he had come home so late both nights. Joey never asked whether he might be home for Christmas. That seemed childish and she never asked Madeline if he'd seen the doctor either. For some reason, she didn't dare.

* * *

Joey spied the perfect present for Becky's baby a week before Christmas. She was gazing in the window of a bookstore near school and saw a tall red and yellow cover with the title *Babar, the King.* She opened the door with its jingling bell and presented her earnings of the past month timidly, two dollars for eight hours of baby sitting. She walked home fast, swinging the book in its paper bag, certain that it would be the right start for the baby's library.

Joey showed the book to Madeline that night in their room. "You better give it to her soon," Madeline warned. "Becky's not going to be here for Christmas."

"What? But she said...."

"Her mother wants her to come home, wants her to see a doctor there in Philadelphia, and she's decided to go. It's only a couple weeks difference. She was going to go the first week of January anyway."

"I know, but Christmas without her...." Joey felt her mouth tremble.

"Yeah. It'll just be the three of us, I guess, plus Colonel Harry and any other boarders that are hanging around."

"No Poppy, of course," Joey said, meaning to sound matter-of-fact.

"No. Of course not."

Joey slid the book back into the bag and looked over at the window. "It's funny," she said. "It's not really Poppy I miss. He's so busy and far away. I miss...." She hesitated.

"You miss Tony. We all do and it isn't fair that we're not even going to have Becky."

Joey looked up, surprised at the anger in Madeline's voice. "But what about Poppy? Shouldn't we be missing him the most?"

"Gee, Joey. You're still stuck on that Norman Rockwell picture of the family, aren't you, the Mum and Dad and the two little kiddies. It isn't always that way, you know. Pop's been gone twenty months, not counting his two visits."

"He can't help it though. He's working hard on secret war things."

"I didn't say he could help it. But two years is a lot of time."

"I know," Joey said, but she was going through the old images of Tony. The pictures seemed dimmer suddenly and she couldn't tell whether he was wearing his uniform trousers or his civilian khakis. Were Becky's pictures of him growing dim, too? When Becky left, would she grow dim? What if they never got to see the baby? She let herself down on the bed with a thump.

"We can call long distance maybe," Madeline said. "That'd help."

"Yes, but.... 'Please don't call long distance this Christmas,'" Joey chanted in a singsong voice, imitating the radio warning. "*War calls always come first.*'"

* * *

Union Station was so crowded with servicemen and families the week before Christmas that it was hard to see the departures board through the crowd clustered at the entrance to Track 8.

A man in a dark uniform came through the tall iron gate, locked it behind him, and began flipping the white letters on the lines beside different train destinations with a long rod: "On time." "Late." Men pushed closer to see the board, craning their necks, squinting. Joey read "Late" on the line beside the train for Philadelphia and a Naval officer beside her muttered, "Ah, hell," and turned away.

"Oh, dear," Joey's mother said to Becky, whose bulging stomach was obvious under her dark blue coat. "It could be a while. Maybe we'd better go back into the main hall. We'll find you a seat somewhere."

"I could wait here, Mum, and watch the board," Madeline said, "and come get you when it says, 'On Time'."

"Coming through." Joey stared. A porter was pushing a soldier in a wheelchair through the crowd. "Out of the way. Out of the way." The soldier sat with one bandaged leg extended, a white bandage wrapped around his head, his vacant eyes staring. Joey looked away. Two sailors were sitting on their sea bags, slumped back against the gate; a third lay stretched out straight, his head on his bag, his eyes closed. How could he sleep there, Joey wondered. A loudspeaker voice was announcing something, but she could not make out the words. A colored soldier pushed through the crowd, his duffel bag bouncing on his shoulder, and stepped over the sleeping sailor.

The sailor woke. "Watch where ya going, ya goddamn spade," he yelled, but he did not get to his feet.

"We'll stick together," Joey's mother said. "Let's go back to the main hall." She picked up Becky's suitcase and turned. Madeline, Becky, and Joey followed. "Excuse us. Thank you," Joey's mother kept repeating, as she threaded her way through the crowds of uniformed men, past baggage carts and clumps of luggage. "Excuse us."

They wound on in a line with Joey last, trying to keep close enough so that her mother's polite pleas would cover her, too.

The main hall was almost as crowded as the train corridor. Every bench was filled. Men lay stretched out sleeping, some with tired wives or girlfriends sitting beside them. Others were crowded together on benches or sitting on duffel bags on the dirty marble floor with its black and white squares. A mother was holding a crying baby, while a soldier jiggled a little boy in a blue snowsuit up and down on his knee. Joey's mother stood a moment, glancing around her. Joey saw her eye the canteen in the far corner, but the line snaked way out into the hall. Joey longed to go to the Ladies' Room, but she didn't dare mention that; besides, it would be crowded, too.

Two soldiers in laced boots sat in elevated seats against one wall beside an Army lieutenant, as a shoeshine boy rubbed a cloth back and forth across the officer's shoes. A young man in a zoot suit passed them carrying a suitcase. His baggy black-and-white speckled suit, with its long jacket hanging down and the trousers dragging over his shoes, looked conspicuous among all the uniforms, Joey thought. Two MPs stood near one entrance, where the doors kept opening and flapping back again. One twirled a billy club, the other was peeling the wrapper off a piece of gum. Tony used to call MPs "bulldogs," she remembered.

The huge room seemed dim, lit only by the lights in the tall brass sconces. Joey looked up at the ceiling. "Why is the roof all dark, Mum?" she asked.

"Blackout, dearie. They had to paint all the panes black."

"Oh." Joey stared up at the huge dark arch. The station would have made a central glow in the night city, but who had gotten way up there with a bucket of black paint to cover all those panes? She gazed at the lonely-looking statues high above, then back at the canteen again. The baby had stopped crying, but the loudspeaker voice continued and the air in the hall was smoky and thick with the smells of bodies. The Ladies' Room would be smelly, too. She put down the leather bag she had been carrying for Becky, then

picked it up again, as a blond soldier stood up from a nearby bench.

"Here, ma'am," he said, nodding at Becky. "Take my seat. Please." Becky thanked him and moved over to sit down. "My wife's expectin', too. First time. First time for you?"

"Oh, yes," said Becky. "The very first."

"It'll be okay. I've just been with my wife in North Dakota. Now I'm shipping out. France maybe. Maybe Italy. Just hope I don't have to meet too many o' those damn Nazis. But I keep tellin' myself, there'll be a little bundle waitin' when I get home."

"When's your wife due?" Joey's mother asked. Joey continued to stare around her, as her mother and Becky chatted with the soldier. You couldn't really tell which men were coming from the battle fronts and which were going.

Joey rested Becky's bag on the floor between her legs and looked up again. A Christmas tree with garish red and yellow lights was propped way up in the space above the center door. How many people even saw it, she wondered, as they rushed through? Some would be on the way to war, like the soldier talking to Mum and Becky. Christmas in a troop ship or on a landing craft. What would that be like? She stared at the man, who lifted his hands to show Mum and Becky the size of the bassinet he and his wife had bought. He could be killed in a week and yet she had been complaining because Becky wouldn't be with them for Christmas. That was war, she thought and tipped her head back to look up at the statues again. War dwarfed all your little fussinesses and complainings. It made you feel guilty, but it didn't tell you what people at home should do, except flatten tin cans and be cheerful, and sometimes that seemed dumb.

Mum had left the group to check the departure board and she came hurrying back. "It's here. We've got to hurry. Take Becky's bag, Mad. Hurry."

They made it through the crowd, Mum saying, "Excuse me, excuse me," again and then Becky was on the train and they were outside the window waving. "Goodbye, goodbye. Call us right away about the baby. Please. Write soon. Goodbye."

* * *

Joey sat at the table she and Madeline used for a desk, writing in her war journal. *"This year our Christmas is going to be as lonely and dreary as Jo's was in Little Women. Poppy is not fighting in the Civil War, of course, but we haven't seen him for almost two years. Mum is a lot like Marmee, actually. Marmee was the center of things for Jo and Meg and Beth and Amy, just the way Mum is the center of things for Mad and me."*

Joey paused and reread what she had written. There was Mona, of course. She ought to mention her and Fay and Henry and maybe even Colonel Harry, who had been nice. She sighed. In a way it would be more interesting if they *were* completely forlorn. But Mona had lots of projects. When Christmas vacation began, Joey and Fay baked three dozen sugarless cookies and painted a bag of pine cones gold. They bought a real tree and Henry made a stand and they stood it up in the Hartleys' living room, although the tree was for both families, Mona explained.

On Christmas Eve afternoon, Joey and Fay helped decorate it, tying new strings onto the little carved angels and the red balls. Mona agreed with Joey that just green and white lights were best, but they broke down and put on two reds and one orange to please Henry and Fay. The decorating was supposed to be a family event, but Madeline went to a movie with Ruthie. She was sick of Mona, she said.

Joey and Madeline and their mother went over to the Hartleys' on Christmas morning and admired the lighted tree with the presents piled below. Mum gave Joey a little locket and Madeline got a new sweater and a silver clip for her hair. The colonel appeared with the lieutenant and just before Christmas dinner, the phone rang. It was Becky, calling to wish them Merry Christmas, despite the rules about only war calls, and when it was Joey's turn to talk, she had to admit that they were having a happy time.

Joey and Fay went to three movies during the week of vacation. Two were Bob Hope and one was Jeannette MacDonald in *Smilin'*

Through. Joey and Fay lay on Fay's bed, planning which movies to see next. But secretly, Joey was eager for school to start again. Vacation left too much time to worry. Once in school, she could think about her friends and her classes and ignore the huge empty spaces that Becky and Tony had left and the looming questions about Mum and Poppy, which seemed to have no answers.

1945

Chapter 18

WHEN school began again, it seemed almost cozy on winter mornings. Joey and Fay let the heavy front door crash shut behind them, closing out the cold, as they stood beside their lockers, peeling off their coats and scarves. They unbuckled their galoshes and kicked them off, then gathered their books for the morning and joined their friends, who were sitting on the stairs. The yellow ceiling lights were on and the radiators knocked. The smell of wet wool rose from damp coats and mittens and they leaned back against the tiled wall as they talked. Sometimes they compared answers to the History questions, but mostly they talked about who had seen the new Abbott and Costello movie or where Tammy had bought her blue Angora sweater and whether tangerine lipstick really looked good on Peggy with her red hair.

Toward the end of February Joey had to stay home with a cold. She sat in bed and read *London Pride*, the Kleenex box beside her. Mona brought the radio up and she and Joey listened to news broadcasts together. FDR, who had been elected to a fourth term, thank goodness, had a quiet inauguration at the White House, and the Allies reestablished the line broken by the Battle of the Bulge, which was good. There was a lot of of news about the Pacific, but it made her think of Tony and she turned off the radio.

<center>* * *</center>

Mona said she could feel spring coming, but the mornings still seemed cold and dark to Joey when she got back to school. She stopped to stare at a forsythia bush as she walked home with Madeline one afternoon. It looked embarrassed by its yellow flowers, she thought, as though it was not ready to bloom yet in the raw grayness of early March. When Joey and Madeline came into the front hall, Joey saw her mother's black suitcase sitting beside the table. "What's going on?" she said and paused, hearing Mona's voice in the kitchen.

"It's bound to be a good hospital," Mona was saying. "I mean, if the project sent him there."

"Yes, but I want to bring him home to rest and get really well." Their mother looked over at Joey and Madeline as they came into the kitchen. "Oh, girls, good. You're here."

Their mother was standing at the sink, wearing her navy blue suit with brass buttons on the cuffs. The short veil on her blue felt hat was pushed back and she took a last sip from the cup of coffee she was holding and put it down on the drainboard.

"What are you doing, Mum?" Madeline said. "Where are you going?"

"Your father's sick, dearies." Their mother paused. "He's in the hospital and I'm going out to help take care of him."

"How sick?" Joey snatched her mother's hand.

"He's got pneumonia. I'm afraid it's serious and I want to be with him."

"Where?" Madeline's voice was loud.

"You know I can't tell you that, dearie. You two will move in with Mona and Henry for a few days and I'll be back as soon as I can." She glanced up at the clock.

"But what about...." Joey heard the panic in her voice and realized that she didn't know what she wanted to ask.

"It's going to be all right. I'll call long distance soon. I'm going to try and bring your father back with me, so he can get well at

home." She glanced at the clock again. "I've called a taxi. It should be here soon."

"I'll go look out front," Mona said and left the kitchen.

"I know this is hard." Joey's mother put one arm around Joey's shoulders and Madeline moved closer so she could put the other arm around her. "But this is what I have to do. What I want to do," she added. "You'll be fine with Mona."

"What about the boarders?" Madeline asked, twisting to look back at her. "Do they know?"

"I talked to Colonel Harry and told him I'd be out of town for a few days and that you two would be staying with Mona. We have to be very careful about security—Poppy's work. Where he is and what he's doing, you know."

"You won't be gone more than three or four days, will you?" Madeline eyed her mother.

"Not if I can help it. But...." Her voice trembled. She had put on more powder than usual, Joey noticed, and her red lipstick was thick, perhaps because without them she would look worried and gray.

"It'll be okay, Mum." Madeline patted her mother's arm.

"Mr. Pierce said that the Seventh Grade Dramatists are going to do a Greek play at the end of the year in the gym, but he doesn't know which one yet." There wasn't much time to talk if a taxi was coming, Joey realized, and yet it might be good for Mum to think about something beside Poppy and his pneumonia. "He said we might have an evening performance, like the seniors."

"Wonderful, dear." Her mother reached through the neck of her blouse and tugged at her slip strap, then glanced down at her skirt. "Is it showing?" she asked Madeline, who shook her head.

Joey looked over at the door, aware that her mother wasn't really listening. "Mr. Pierce'll read us the play first and then...."

"It's here," Mona called from the living room. "It's right outside."

"All right, I'm coming." Joey's mother lifted both hands to press down her hat.

"Goodbye, dearies," she said and kissed them both, then pulled the veil down over her forehead. "Be good. I'll call you as soon as I can." She hurried into the hall.

"Tell Poppy to get well," Madeline said.

"Tell him we love him," Joey added and paused. The phrase sounded trite and yet it was true, wasn't it? The main trouble was they didn't know him very well anymore.

"I hope I can bring him home, dearie. We'll just have to see." Joey stared at her mother, hearing the ripple of fear in her voice. If he didn't come home, where would he go? When would they see her again and when they saw their father, what would he be like?

* * *

Joey and Madeline lay sprawled on the rug in the Hartleys' living room with Fay two days later, while the President talked about his trip to Yalta. There was no school, because of a teachers' meeting, and Henry had stayed home to listen to the speech. "*We share the responsibilities for peace with our Allies,*" the high stern voice was saying. Mona sat on the couch beside Henry listening, but Joey and Fay lay side by side reading the funnies on the rug. "*. . . joint decisions with Russia,*" the president continued. Joey raised her head. Madeline wasn't listening either; she was reading the women's page and Henry sat scowling at the rug as the president talked on.

"That was odd in the beginning," Mona said, when the speech ended. "The way he mentioned his braces, the ten pounds of steel, and the fact that he needed to sit for the speech. I've never heard him do that before."

"He never has," Henry said and raised his head, then lowered it again. "He's exhausted, poor guy. I just hope to God he doesn't get sick."

Joey studied Henry and frowned. The President can't get sick now, she thought. He has to finish the war.

"*This has been a live broadcast of the speech that President Roosevelt delivered to the joint houses of Congress this morning at the Capitol in. . . .*"

Henry turned the button to OFF. "I've gotta get to the office," he said.

Madeline pulled in her outstretched legs and stood. "I've got a paper to do for English." Joey looked up at her, confused. After Henry left, they could turn the radio on again and listen to "Amanda of Honeymoon Hill" and "Against the Storm" came right after. But something in the way Madeline started to the stairs made Joey stand and follow her up to Fay's room.

"Do you think the President's sick?" she said, aware that that was not what she wanted to ask.

"For heaven's sakes, Joey. How would I know?" Madeline turned her back and moved to the window.

Joey glanced at Fay's white bureau with the framed picture of her cousins in Maine and at Fay's bed with its striped quilt, where her dolls were leaning stiffly against the pillow. "How long do you think we'll have to stay here?" she asked. She felt a twist of pain, as she thought of the room she shared with Madeline in their own house, the picture of Queenie on her side of the desk, and the brass dog tag Tony had given her, hanging over it. It was silly to be homesick for a house that was right next door, especially when this house was brighter and more comfortable.

"I don't know," Madeline said without turning. "Mum didn't know herself. It all depends on how fast he recovers."

"What if he doesn't?" Joey said. "Pneumonia can be fatal." She drew in her breath, shocked at her words, remembering the telegram lying on the kitchen table. THE SECRETARY OF WAR DESIRES TO EXPRESS HIS DEEP REGRET. Who would telegraph if Poppy died? She wrapped her sweatered arms around her and felt her fingers pinch her skin through the wool.

Madeline looked back at her sister. "Mona told me they're using those new sulfa drugs that they use on the front." She crossed to the bed and sat down. "We can't worry about him all the time," she said and studied her sister, who was still clutching her arms. "Good things happen, too, you know."

They heard the phone ring downstairs and Mona's footsteps, then

her voice. They waited. Could it be Mum? Was she telling Mona good news or bad?

"Girls, girls," Mona shouted from the hall downstairs. "Becky's had the baby." Joey and Madeline rushed to the top of the stairs. "Her mother just called from Philadelphia."

"Is it a boy?" Joey asked, leaning over the banister.

"Yes, and she's named him Tony."

"Oh, wow," Joey said, imagining the newborn baby wrapped in a blanket and Becky lying back among the pillows, tired, but proud.

"Can we call her?" Madeline was hurrying down the stairs. "Her mother, I mean. How big is he? Did she say?"

Madeline was right, Joey thought, good things came jumbled together with bad ones. "Oh, wow," she said again and rushed down the stairs. "He's Tony Argillo, the second."

* * *

A week passed at the Hartleys, then two more, and by the time Joey and Madeline had word that their parents were returning, they had been living with the Hartleys three weeks. When they ventured back into their own house on the other side of the wall, it seemed chilly and oddly unfamiliar. "I turned the heat down. It's getting warmer now," the colonel told Madeline. "And with all of us boarders out all day or part of the night, it seemed unpatriotic to keep the heat on. I went ahead and moved myself upstairs, too. I discussed it with Mona. Now your parents can have the master bedroom, when they get here. More room for your dad to recuperate." Joey looked away, embarrassed that the colonel should refer to Poppy as their "dad," but then how could he know that they called him "Poppy"?

She was up in her room the next afternoon when she heard the sound of a car door opening and ran downstairs to the living room to peer out of the bay window. "Mad, they're here," she shouted. "The taxi's right outside."

"Are you sure?" Madeline hurried in from the kitchen and leaned over Joey to look out. Joey saw their mother get out of the cab, then watched as their father unfolded himself slowly. He gripped the top

of the open door and stared up at the house, while their mother stood beside the open trunk at the back of the taxi, watching the driver pull out two suitcases and a briefcase and put them on the sidewalk.

"Poppy, Poppy." Joey rushed down the steps to meet him, but paused as she saw her father stumble slightly on the sidewalk, then clutch the metal banister and start to climb the iron stairs. The collar of his gray coat was turned up and his old felt hat was pulled down, although the day was warm. Embarrassed at her childish shout, Joey stopped on the step above him. "Hi, Pop," she said. "Welcome home."

"Hi, Jo." He was in the hallway and the taxi driver was bringing in the suitcases. Mum turned to pay the driver, as Madeline and Joey stood smiling uncertainly at their father. He put his hat down on the table, ran one hand through his hair, then began to unbutton his coat with shaky fingers. Madeline took it from him and hung it on the hook behind the door. "Hi, Mad," he said and brushed the side of her face with an awkward kiss. He patted Joey's head, moved into the living room and glanced around it. "Good to be home." He sighed and sank down on the couch. Joey stood watching him. He was so thin, his cheekbones made ridges in his face and deep grooves rayed out around his eyes.

"How about making some tea, girls?" their mother said. "We've had a long train ride. Civilians were only allowed into the dining car for breakfast. Lunch was just for the servicemen."

"Oh, Mum. You must be starving." Joey got up and hurried into the kitchen with Madeline. Madeline filled the kettle and put cups and saucers on the wooden tray, while Joey dropped slices of bread into the toaster. "He looks so different," she whispered and poured some Karo syrup into a bowl, then mixed in cinnamon. "He's so thin." She went into the dining room to pull the good tea napkins out of the drawer of the highboy and came back into the kitchen as the toaster popped. "You know what I mean?" She took the slices out and spread them with the syrup mix.

"He's been really sick," Madeline told her. "Exhausted from working too hard. He's worn out."

"But he looks so changed, so old sort of."

"He almost died. Remember?"

"I know," Joey said. "It's kind of like combat fatigue."

The kettle began its hissing noise. Madeline moved it off the burner and reached up into the cupboard above for the box of tea, but Joey stared down at the tray. Tony had died and they would never see him again. What if Poppy had died, too?

Madeline put the plate of toast on the tray with the teapot and carried it into the living room. She put it down on the coffee table in front of her father and straightened. "You look good, Mad," he said. "Have you cut your hair?"

"A little. A couple of weeks ago." Madeline shook her head so that her hair swung out, brushing her shoulders, as she sat down on the floor beside Joey.

"What about you, Jo?" her father asked. "You like junior high?"

"Well, it's exciting in a way, but…." She paused. What could she pluck out of her busy life that might interest him? Her father was staring down at the rug. "We wrote you about Becky's baby," she said and glanced at the rug, wondering why she had begun with that. He had never met Becky, after all.

"The colonel's moved upstairs," Madeline announced, "so Joey and I fixed up your room, so you can sleep in it tonight, Mum," Madeline began. "It's nice and clean. Mona even washed the curtains.

"That's fine, girls," their mother said. "That was very efficient of you."

"Yeah, good," her father said. He lifted his cup, but put it down and let out a long raking cough. "Damn," he muttered and coughed again, then slapped his chest with his hand. He glanced at Joey's mother. "You think you can get me some more of that syrup stuff tomorrow? This damn cough is wearing me out."

Joey looked over at her mother, who was watching her father,

and then at Madeline, who was watching him, too. "Certainly," her mother said. "I'll get some this afternoon." There was a pause.

He was still sick and he had almost died, Joey reminded herself, as the pause continued. She thought of telling him that the Seventh Grade Dramatists were going to do a Greek play in the gym in May, but Mr. Pierce still hadn't told them what the play would be, so it would probably be better not to talk about that now. "Would you like some toast, Poppy?" Joey picked up the plate and held it out to him. Bits of gray bristle were poking through the skin on his chin and his eyes looked deep in his head with dark puffy places underneath.

"No thanks, Jo." Her father's cup rattled, as he put it down in the saucer. "I'm sorry, girls. Thanks for the tea and everything, but the fact is I'm beat. Twenty hours on that train. No sleepers, you know. The doctor wanted to keep me in the hospital another week, but I've got stuff I've got to do here right away." He leaned forward and clapped his hands together, making a hollow noise, as if he were about to start work. Then he stood and stepped around the low table and paused a moment looking down at them. His trousers hung over the tops of his wrinkled shoes, and his tweed jacket looked loose, as though it belonged to another man. "I'm going to bed for an hour or two. Then I'll get to work. I just need a little rest, a little sleep."

"Fine, dear." Their mother stood. "I'll come turn down the bed." She hurried up the stairs and Joey watched her father follow, gripping the banister, moving up the long staircase slowly. This must be the way families felt when men came home from the front.

She glanced at her sister, who had stacked the cups and was lifting the tray. One napkin lay forgotten across the arm of the couch, but Joey did not gather it. She went to the window instead. A bus stood at the sign across the street, resting at an odd angle. One rear tire was flat, Joey noticed, and the lights were on inside. But the bus was empty except for the driver who was slumped over the steering wheel, napping probably until help arrived.

* * *

Joey's mother closed the door to the kitchen when Joey and Madeline came in. "We'll let him sleep as long as he can," she whispered. "He's worn out."

"What does he mean about having a lot of work to do?" Madeline asked in a low voice. They had been whispering ever since their father went upstairs, although it was unlikely he could hear them in the kitchen. "I thought you said he wasn't going to work for a while. You said he was going to come home and recuperate."

"Well, he is," their mother said. "But he's got some things he wants to finish first."

"He looks like he needs a rest," Joey said.

"He does. You're right." Their mother sighed and let her eyes close slightly. "I can't really explain it, girls. There's something important he feels he has to do right now." She drew in her breath and stared at the refrigerator a moment. "We've got to help him," she said. "He's terribly tired, but...." She sighed and looked across the table at Joey and Madeline. "He'll be working here at home, telephoning some, typing in the dining room maybe. Try and stay out of his way when he's working. Don't make noise. I'm going to tell the boarders, too." She sighed again. "What your father's doing is important, but we've got our own jobs, too: the Center for me, school for you, the volleyball team, the drama club. You know what I mean. We'll just keep on."

Joey looked at her mother and saw the dark smudges under her eyes. She was tired, too, she thought; everybody was.

* * *

Joey was in the kitchen several evenings later drying the dishes, after Colonel Harry pulled them out of the soapy dishwater, rinsed them under the faucet, and put them on the drainboard. "We had auditions this afternoon," Joey told him. "And it was exciting and scary, too. I mean, when Mr. Pierce...he's the teacher in charge of seventh grade drama, you know...told us last week that we were going to do *Antigone,* I was amazed. It's a Greek tragedy, you know. And guess

what? We're going to do it in the gym, not in a classroom like our play last fall. But in the gym at night."

"Well, that *is* exciting," the colonel said.

"I *really* want to be Antigone. She's so courageous and wonderful. I tried to be like her in the audition and Mr. Pierce smiled at me afterward, as though he thought I'd done well. But there were at least a dozen other girls waiting." Joey heard her voice rise, as she emphasized "at least" and she hesitated. "Maybe six others. Four," she said, correcting herself. "If Mr. Pierce decides by Friday, we'll have six weeks almost to practice." Joey sighed and squeezed the dish towel. "Mr. Pierce told us the story and then I read it in the library yesterday. You know it, don't you?"

"I suppose I read it in high school," the colonel said. "But that was years ago. I don't remember it."

"Well," Joey began. She lifted the tan mixing bowl with its pale blue ring circling the top and began drying the inside. "It's about this Greek girl, Antigone. She's Oedipus' daughter and she really loves her family. Her two brothers fight over the throne in Thebes, and they're both killed. The older one is buried with honors, but Creon, the mean king, who's actually her uncle, won't let the younger brother be buried properly." Joey paused and looked at the colonel. "You know, I think I know what Antigone feels. I mean, sometimes I feel as if I had had an older brother, too, one that was killed fighting." She stopped.

"Yes," the colonel said and nodded at the dishwater. "He was a brother for us all. A younger brother for me. A son even. It's hard to get over."

He tipped the dishpan and Joey watched the soapy water rush out into the dark sink and eddy around the drain. The colonel bent to hang the dishpan on its hook under the sink. Joey was still thinking of Tony, but the colonel straightened and asked, "I don't understand why the uncle wouldn't let him be buried properly?"

"Well, he wanted to show his power," Joey said, "and...."

"So what did Antigone do?" The colonel untied the yellow apron,

revealing his tan uniform pants beneath and his belt buckle with its Army insignia.

"She goes out at night and finds the body and buries it, but she's risking her life, you see, because Creon said that anyone who tries to bury him will be killed."

"Does he find out?" The colonel turned to hang the apron on the hook at the back of the door and Joey hurried, knowing that he wanted to sit down in the living room with the newspaper.

"Yes," she said. "And he's furious. He has Antigone locked in a vault underground and she kills herself. It's terrible. It's so sad."

Joey put the bowl on the table and looked up. Her father was standing in the doorway, holding a pad of yellow foolscap. "Hi, Poppy," she said. She glanced back at the colonel, who looked large suddenly with his stomach sloping outward under his uniform shirt. "This is Colonel Harry Fenton, Poppy," Joey said. "You haven't met yet."

"Ah, yes." Her father nodded and moved over to shake hands. "I'm glad to meet you. I've been busy, you see, and...."

The colonel rubbed one hand hurriedly on the side of his pants and held it out. "I've heard a lot about you, Professor Lindsten. The girls said that you'd arrived. I've been working the graveyard shift this past week, so I kind of slip in and out, you know." He pulled his jacket with its epaulets from the back of a kitchen chair and held it dangling from one forefinger. "Good weather in Europe now. Let's just hope it holds. They say that carpet bombing's going well in Germany. Looks like we're getting those Jerries at last."

"Yes, yes." Joey watched her father turn to the stove. Maybe he didn't agree with the colonel about the bombing. He looked as though he hadn't shaved, Joey thought, as he stood there with his shirt sleeves rolled up.

"Want some stew?" she asked. "It's beans. We saved some for you. Mad called you, but she said the door was closed and you didn't want to be interrupted right then."

"Not now, Jo. Thanks." He coughed hard, making a raking sound in his throat. "Later maybe."

"Poppy, we're doing *Antigone* at school and I auditioned for her today and…"

"That's good, Jo." He looked at her a moment, then glanced around the kitchen. "Where's the phone book? Get it for me, will you?"

The colonel stared a moment, then picked up the paper from the seat of a kitchen chair. "Were you going to read this?" he asked.

"No. No thanks," Joey's father said. "Take it." He sat down at the table and pulled some typed lists from the back of the pad, as the colonel folded the newspaper under his arm and moved into the living room.

"Listen, Joey. I need to be on that phone for the next hour or two. You think anyone here was planning to use it? The colonel, that lieutenant upstairs? Anybody?"

"I don't think so, Poppy. Who're you calling?"

"Can't tell you that. Now let's see." He flipped a few thin pages in the phone book and began writing down numbers beside the names on his list. Joey tipped her head to read a name, but her father's handwriting was small and slanted. "Leo" Something. "Szil…?" Joey peered a moment longer, trying to make out the writing. Whatever he was doing looked detailed, even boring. She put the mixing bowl in its place on the cupboard shelf and left the kitchen. She had a lot of homework to do and she wanted to read *Antigone* again.

* * *

When Joey came into the front hall after school the next day, she could hear her parents' voices in the kitchen. Mum must have taken off more time to be home with Poppy.

"It's this whole damn thing, this complete reversal. That's what's so exhausting for me, so disorienting really," her father was saying as she came into the kitchen. "I mean, back in the beginning when we knew Heisenberg was working on it, when we knew about the

heavy water and the real possibility that Hitler would fund the thing...." Her father was sitting with his forearms resting on the kitchen table. A cigarette had burned low between his fingers. Her mother sat across from him in her good green suit, her legs crossed as if she had to get up soon and go off to the Center.

"Hi, Poppy," Joey said and moved to the sink.

"Hi, Jo." Her father looked at her briefly, then back at her mother. "I mean, Amanda, you do understand, don't you? It's not just me. If it were, you would have good reason to question what I'm doing. But I'm not alone. There's Szilard and at least a dozen others. I tell you, Amanda, this petition is crucial. Absolutely crucial."

Joey dumped some Jell-O mix into a glass and held it under the brass faucet. She turned the tap slowly, so that the water wouldn't come out in a noisy rush, but the sound made her father stop talking and look over at her again.

"How was school, honey?" he asked.

"Fine," she said. She drank the orangey mixture quickly, tipping the glass up, so that she glimpsed her father through the bottom, his head large and weirdly out of proportion. "Fine," she said again and put the glass in the sink. How little he knew of the world she lived in, she thought—school, homework, Fay, the Dramatists, and *Antigone*—and she knew nothing of his world at all.

* * *

Joey flew up the front steps two days later, hoping to find Madeline in the kitchen, her father or Colonel Harry even, but the kitchen was empty and had the sour smell of cooked beans that had been left in the refrigerator too long. She plunked her books on the kitchen table and rushed outside again, up the steps and into the Hartleys'.

"Fay. Mona. Guess what?" Joey panted as she clutched the banister post at the bottom of the stairs.

Mona emerged from the kitchen, wearing her striped red apron. "What, Joey? You look as if you were about to pop with news. What is it?"

"What's happened?" Fay called down from above.

"I got the part," Joey shouted. "I'm Antigone!"

"You are?" Fay rushed down the stairs and her mother stepped forward.

"Oh, Joey," Mona said, embracing her. "I'm so proud of you."

"I'm amazed," Joey said, stepping back. "I mean, I thought it might happen and yet there's been such a delay. Lizzy Turner was waiting in the hall after History. She tried out for Antigone, too, you know, and she said Mr. Pierce was going to put up a list, but he just came out into the hall and said we were sisters. At first I thought he meant Lizzy was Antigone and I was Ismene, but then Mr. Pierce said I was Antigone. I was amazed. I couldn't believe it."

"Did he post a list?" Fay asked. "Did I get the messenger? If I didn't, I'm going to be on the stage crew."

"I didn't see the list, but I guess he did. When he told me, I just said 'Wow' and rushed off. I was so excited."

"It'll be a lot of work on top of everything else," Mona said. "But you can do it, Joey. I know you can." Joey frowned, feeling a confused anger ripple through her. Mum should be here; she should be the one saying what Mona was saying. But it was the war, of course, and the Hartleys were really family. Joey drew in her breath, as Mona went on. "There's a lot happening right now. But you'll be wonderful. I know it. You'll be wonderful."

"I want to be," Joey said. She pulled off her jacket and held it by the collar as she looked at Mona. "The part feels so important to me. I don't know why, really. But I want to do it well."

Chapter 19

JOEY was listening to the radio upstairs as she did her geometry homework. Poppy had been home for a week and he liked to listen to the news in the late afternoon, but she wanted to listen to "Backstage Wife" first before she took the radio downstairs. After supper she and Fay were going to "run lines," as Mr. Pierce called it.

"...*a massive cerebral hemorrhage*," a radio announcer's voice was saying. "*The president's body will be taken back to the White House....*" What? Joey turned the volume button. "*...Delano Roosevelt, president of the United States of America, died this afternoon at 3:25 at his home in Warm Springs, Georgia.*" Joey sat staring at the fabric-covered arch on the front of the radio. Died? How could the president be dead? "*Funeral services will be held in the East Room of the White House. Interment will be at Hyde Park, probably on Sunday. Heads of state and members of congress are....*"

Joey jumped up and started downstairs. Poppy was reading on the living room couch or sleeping maybe. She stopped suddenly and grasped the banister. Maybe somebody else could tell him the news; he would be terribly upset.

Her father lay stretched out on the couch, one elbow over his

eyes. His feet in his maroon socks were propped up on the end of the couch and a newspaper lay open on his chest. Was he asleep? Should she wake him? His mouth and cheeks were slack, almost peaceful. Joey breathed in, feeling a momentary sense of power as she stared down at her father, filled with news that he did not know.

"Poppy, the president's dead." She watched him lift his arm, focus on her and frown. "He died this afternoon at Warm Springs. I just heard the news."

"Died? Oh, my God." Her father pulled himself up quickly and swung his feet to the rug. "Dead? Are you sure?" He pushed his fists down into the couch cushions on either side and scowled at Joey, as though she were to blame. She nodded, shocked at the change she had brought.

"Oh God," her father repeated. "Not now." He looked around the room, then back at her. "Everybody knew it was coming. I mean, the way he looked at Yalta. Those pictures. But...oh, my God. Not now." Her father bent his head into his hands, then looked up at her. "He was a great leader, Jo. We won't see his like again. Not in my lifetime." He let his head drop forward and covered his face with his hands.

"Want me to bring the radio down?" Joey didn't wait for his answer, but fled up the stairs, frightened. She jerked the cord from the socket behind the desk, snatched up the radio and rushed down the stairs. The dial lit up when she plugged in the cord. Would there be another broadcast, she wondered, and twisted the needle, but the news was on every station. Her father raised his head to listen, then bent it again, covering his face once more and Joey saw his shoulders shake. Was he crying? What should she do? Oh, if only Mum were here, if even Mona was. She glanced out at the hall, at the wallpapered surface separating the two houses. What should she do? She knelt by the radio and put one hand timidly on her father's knee, but he seemed not to notice.

He stood and began to pace the room. "I've gotta get on the

phone," he said and glanced around him. "This is terrible. Terrible timing for us, for the work, for...." He stopped and sank down on the couch again.

The front door opened suddenly. Joey looked up; it was Mum. "I knew you would have heard," she said, unbuttoning her jacket, as she came into the room. "I got a volunteer to take over." Joey sat back on her heels and watched her mother, who dropped her jacket on the chair, went to the couch and perched herself on the arm as she put one hand on Poppy's bent shoulders.

"The President's body will be taken back to Washington tonight," the radio announcer was saying.

"It's so sad," Joey's mother said. "If only he could have lived to see the end of the war."

"The first lady will accompany the casket," the announcer continued. Joey saw her father lift one arm and pat her mother's hand, as it lay on his collarbone. She stared; she couldn't remember when she had last seen them touch each other.

"It's going to be all right," her mother whispered and gripped his shoulders with both hands, bringing them down in a slow, massaging movement. "It's going to be all right," she repeated.

Mum was so calm and strong, Joey thought, watching her. How could Poppy have loved Sarah? Moments passed and it seemed to Joey that maybe Mum had soothed her father and everything really would be all right. She moved one knee backward, then the other, meaning to crawl away and leave them together, as the radio announcer talked on.

But her father hunched his shoulders suddenly, shrugging off her mother's hands. "I've gotta call Leo," he said and stood. "Goddamnit. This changes everything." He took a step in his stocking feet and stood glaring at the fireplace. "Leo got an appointment with the President for next month and now, now.... Oh god. This knocks the whole thing to pieces, the whole plan." He whirled around. "What the hell are we going to do now?" He demanded, glancing first at Joey's mother and then at Joey, as if one or the other might have an

answer. When they simply stared, he strode past them to the phone closet in the dining room and pulled the door shut.

"What's the matter with Poppy?" Joey asked and looked back at her mother. "Why is he so mad, Mum?"

"*At the Capitol,*" the radio announcer continued, "*aides of Mr. Truman disclosed that he had left for the White House only minutes before the news was broadcast to....*"

"Your father was going to meet with the President soon," her mother said. "This is a hard blow. Mr. Truman may not know enough to help." She leaned toward the radio and sighed. "That's enough for now. They're just repeating the same things." She turned the button to OFF and Joey watched the little yellow light go dark. In the sudden silence, she could hear the sound of her father's voice, talking urgently in the phone closet. President Roosevelt was dead and people all over the country were crying and wringing their hands, Joey thought, but her father was cross because an appointment would be canceled.

* * *

Joey was practicing in the living room two days later. "*'I will bury him: well for me to die in doing that.'*" She glared at the living room chair with the strings hanging down on its arm, surprised at its familiar look. For the past thirty minutes, it had been Ismene, her sullen sister. She paused and breathed in. She had been practicing so long that her voice was getting hoarse.

She walked into the dining room. A filing card box, speckled in black and white, sat on the table beside two pads of lined yellow paper, both of them covered with her father's slanted pencil writing. The smell from the ashtray full of cigarette butts made her cover her mouth and she turned away. Poppy was out somewhere this afternoon, meeting with someone else about something serious, which he couldn't talk to them about, of course. Joey sighed and went into the kitchen, where Ruthie sat at the table with Madeline. They were both painting their fingernails fire engine red.

"He's really cute," Madeline was saying. "And I think he sort of

likes me." She laughed and stretched her hand out to survey her nails.

Joey poured some ginger ale into a glass and sat down at the table, but Madeline went on talking as though she were not there. "The thing is, even if you have the party afterwards, he might not come."

They were talking about Harris Simmons, Joey thought, a blond guy Madeline had a crush on. "I brought him a Coca-Cola after the council meeting," she said, "and he said 'thanks,' but that doesn't mean—"

"He likes you all right," Ruthie broke in. "Honestly, Mad. I know he does. You just have to assert yourself. My Aunt Betty says the war has taught women that they have to speak up for themselves now and say what they want, and she works in a munitions factory. He'll come. Heck, if he asks you to the prom and you tell him you're going to my house after, he'll have to come."

"I wish they hadn't moved the prom date up the way they have," Mad said. "It's supposed to come the last week of school."

"I know. It's all because Mrs. Casey's the head chaperone. She wants to be free to go up to New York in case her husband's battalion comes home in June. I get so sick of this war sometimes." She sighed. "Listen, I told you my parents are going away that weekend, so Shirley'll be in charge and you know Shirl. She'll have some friends of her own over probably." Joey looked down into her glass. Mona had told Mum that Shirley, Ruthie's older sister, was fast. "Now the prom'll go to midnight," Ruthie continued. "Then we'll go to my house. Nobody'll know." She gave Joey a quick, threatening look. "Shirley won't tell. It'll be fun."

Joey took another swallow of ginger ale, then swirled the liquid in her glass. If Ruthie was having a party with only Shirley around, they were definitely going to do things they shouldn't. Joey took her glass to the sink. Mum wouldn't want her to go to Ruthie's, if she knew about it, but how would Mum know? Maybe Mona would get suspicious and tell her.

Joey went back into the living room, picked up the script from the couch, fixed her gaze on the chair, and started again. *"'I owe a longer allegiance to the dead than to the living,'"* she began, but Antigone's fierce anger seemed remote and the line felt limp.

Joey flung herself down in the chair that had been her sister, Ismene, and stared at the bookcase in the corner with its dusty glass doors. A fat gray book, *Art Through The Ages*, leaned against another one on the bottom shelf. Joey pulled it out and opened it to the section labeled "Greek Art." She flipped through the black-and-white photographs slowly and stopped at a page showing several ancient Greek coins. One was a young woman's face in profile. Her hair was pulled back and bound with a garland of lily-like flowers. Her nose was long, her mouth firm, and her eyes, even without pupils, had a determined look. She looked the way Antigone might, Joey thought, and reached up to her hair with both hands, pulled it back, and twisted it into a bun.

Joey felt all at once that she must have that picture of that young woman on that coin. She marched into the kitchen, took the scissors from the drawer and returned to the living room, ignoring Madeline's question about why she needed them. She snipped around the photograph quickly and removed it from the book. Turning it over, she saw the print on the back of the picture and drew in her breath; she had damaged a book they didn't even own. Joey looked up, half expecting to see Mrs. Trevor, the owner of the house, or Mum or Mona standing there, holding up a punishing forefinger.

Joey looked down at the serene, determined face again. She had done an awful thing, cutting that picture out of the book, but she wasn't going to confess it. That girl might well break a law to accomplish something important that she wanted to do. Joey closed the book and pushed it back into the bookcase. The page she had cut might not be noticed for years, and meantime she had the picture she needed, the girl who would inspire her to act like the true Antigone, brave and loyal to the last.

* * *

The lieutenant was leaving, so Joey and Madeline were free to move downstairs to the second floor again. It would be good for the family to be together on one floor, the colonel said, now that Professor Lindsten was home. Joey sighed, resenting his opinions. Madeline moved back into the room she and Joey had shared before the boarders came, but Joey did not move in with her. She wanted her own space, she said, and hesitated, considering Tony's narrow room above the front hall. She wondered if the room would be haunted by memories of him, but it seemed to her, as she stood at the window thinking, that Tony would have liked her to be there.

At first she was pleased with her privacy, her small desk with her books lined up at the back, her own closet and her single bed. But as she settled in, her closeness to her parents made her secretly uncomfortable. Upstairs on the third floor, she had been almost oblivious to their comings and goings in the night. But now their whispers seeped out into the hall and the sound of her father's coughing broke the quiet.

It was scary somehow to have so few people in the house; the colonel was the only remaining boarder and he would leave in June. When that happened, the household would be stripped back to just the naked family, Joey realized, alone with all their problems. Poppy often worked late into the night, and sometimes when she came home from school she could hear him snoring in his room. He had put the card table up in the bedroom for some of his papers and he continued to work on others, spreading them over the dining room table beside the speckled file box. He typed down there on his old Remington and often carried some typed pages or one of his yellow pads into the phone closet and talked and talked. Listening from the kitchen, Joey grew familiar with certain words and phrases: "radiation levels," "bomb test," "global destruction."

The closet reeked of cigarette smoke and the smell spread out through the house. He never had time to talk to them really. He was

always in the dining room typing or going off abruptly to meet somebody. Whenever Mum was home, she watched him with worried eyes and in the long ten days since he had returned, Joey had not been able to talk to her mother about *Antigone* at all. Madeline was furious about the phone. She told Joey that it was a family phone and she had calls to make, too. But she didn't say that to her father.

Joey woke one night shortly after her move downstairs and stared at the window, confused for a moment about what room she was in. Feeling chilly, she sat up and started to unfold the blanket at the bottom of her bed. She heard the noise of water in the gutter, but the sound was obscured suddenly by her father's low, urgent voice. "Everything depends on this petition, Amanda. Everything."

Petition? She'd heard that word before, but what was the petition about? Joey thought of the lists on the yellow pads, the open phone book, and the mess of papers on the dining room table.

"There's so much to do and time is so short now. So short."

"But Jack, you have to get well first."

"I'm well enough to work. I have to." Joey heard a muted pounding sound as her father crossed the room in his bare feet. Maybe he was standing at the window now, staring at the blackout shade. "I'll get back to full strength later, but right now there's no time to waste. I have to keep on."

There was a pause, then her father's voice came again, slightly muffled, as if he were pulling his pajama top over his head. "Sarah's apartment," she heard. "I told you...better place to work."

"But, Jack, you promised you'd give this a try. It's only been a week and a few days."

The floor creaked and Joey heard something that sounded like a belt buckle hitting the side of the chair. Was he getting dressed? There was a jingle—he was scooping his keys and some change from the top of the bureau. Joey imagined her father stepping into his pants. Where was he going? It was the middle of the night.

"I've got to get more done. I've got to have quiet." The phrases

were broken. Maybe he was bending over tying his shoes. "This job comes first. It has to."

"But Jack, even if she isn't there, it's her apartment."

"I tell you, Amanda, it's not what you're thinking. I need the space, the quiet. I've got so much to do."

"You put me in a very humiliating position, Jack." Her mother's voice rose. "What do I tell Mona? The children? They've figured out about Sarah, you know."

Joey clutched her arms around her in the shadowy dark.

"Oh God, Amanda. That's not the point anymore. I've told you I'm sorry. I truly am, but now I've got this huge job to do." There was a pause and his voice was softer. "Look, I'm sorry. I want to make amends and I'm going to, but this comes first. It has to. You know that. Before you or me or the girls or anything. If we can't stop this.... Don't you see, Amanda? Don't you understand?"

"Yes, I think I do, but why can't you work here?" her mother asked.

"It's the security, the.... There're people coming and going here all the time. I need a place where I don't have to pick up my work every time I leave the room, where I can talk freely on the phone. I can't stay here. I've got to work at this thing day and night."

"You could kill yourself, Jack." Joey's mother's voice was stern. "You almost died in that hospital."

"I know. I...." He added something Joey couldn't catch, then, "Amanda, if you really understood the full implications of this thing, you would do this, too."

"Perhaps, but...."

"I'll make Sarah's place into an office. I won't be interrupted there."

"And if she comes back, you'll work with her, I suppose." Her voice shook. "Jack, Jack. I nursed you all those weeks in that hospital and now you're making things impossible for me. Impossible." Joey could catch only part of what followed. Her father was

saying something about "the terrible responsibility," "the absolute necessity" for something.

"Don't I have any say in your life now?" her mother asked. "Any at all?"

"Of course, Amanda, but I can't work here. I've got to leave. I'm leaving now."

"Jack, you're sick." Her mother raised her voice, then added, "Don't go off like this in the middle of the night. Finish what you're doing here. Wait until the morning at least."

"I have to go now, Amanda. I can't sleep thinking about all I've got to do. If I have quiet, I'll get more done. See? I'll be home in a week, maybe two."

"Jack, wait. I told you the colonel is leaving soon and the girls can do their homework at Mona's. The house'll be quiet. Don't do this, Jack," her voice rose. "Please. Don't leave."

"Amanda, you know I'm working on something crucial to our lives, to the life of this planet, for God's sake. If this thing happens, it will change everything. Everything." There was a long pause. "Oh, Christ, we've been over all this." Joey heard the bedroom door open. "I promise you this." He seemed to be standing on the threshold. "When I get this thing going, when we get some momentum, I'll stop. I promise you I'll let others take over. But I've got to get the thing off the ground." There was a pause and he added, "I'll take a cab to Sarah's. I'll call you in the morning."

"Oh, Jack, damnit." Joey's mother's voice sounded tired.

"I'm going up to Princeton to see Einstein Saturday and then...then if we can get that interview with Truman and...." His voice softened and Joey couldn't make out the words.

The door to her parents' bedroom shut again. The floor creaked and she heard her father's footsteps on the uncarpeted stairs going down to the hall below. He was putting on his raincoat. She imagined him buttoning the round khaki-colored buttons, clapping his hat on his head. There was the rattle of the stained glass panes as he

opened the front door, then the sound of his feet on the iron stair-
case outside, then on the damp sidewalk, distinct at first, then fading.

She heard the bed in her parents' room creak as her mother
leaned back. She was reading probably, but maybe she was crying.
Joey stared at the creases in the blackout shade for what seemed a
long time, then she closed her eyes.

* * *

Madeline pushed back the kitchen door the next morning and put
her books on the counter before she sat down. "Where's Pop?" she
asked, looking over at her mother, who was pouring the coffee
grounds into the sink. "He said he'd drive me to school this morn-
ing. I have all my gym stuff, plus my notebook and these two history
books, which are really heavy."

Joey, who was already sitting at the table, looked down at the hay
bale of Shredded Wheat in her cereal bowl, but did not reach for
the pitcher to pour milk over it. She wished she had not heard her
parents in the night; it would be easier if she had slept through it
all like Madeline.

"I have to tell you something, girls." Joey's mother turned from
the sink to look at them. "Your father's gone to another place to
work. He felt he needed more privacy."

"Another place?" Madeline said. "What do you mean another
place?"

"He's going to work in a friend's apartment for a while." She
brought the coffee pot to the table and sat down. "It's a place he feels
will be quieter, where he won't be interrupted." She sighed and
poured herself some coffee, lifted the cup and sipped.

Joey studied the tan curving straws of her Shredded Wheat.
Apparently Mum had decided not to tell them that Poppy was in
Sarah's apartment.

"He'll be back," her mother said. "We'll see him. It's just...." She
put the coffee cup down in its saucer and covered her face with her
hands.

"Mum," Madeline said. Her voice had an adult sound suddenly, a mixture of fear and concern. "Mum."

Her mother lifted her head. "It's all right, dearie. I'll take you to school this morning on my way to work."

"We don't have to wait for Joey," Madeline said. "She's a slow eater. She can walk."

Irritation prickled over Joey and she squinted at her sister. "He's gone to Sarah's apartment," she announced in a low voice.

"What?" Madeline stared at her. "How do you know?"

Joey looked at her mother. "I heard everybody talking in the night." She saw Madeline give their mother a long questioning gaze.

"He *is* at Sarah's apartment," her mother said and sighed. "But Sarah isn't there. The apartment's empty and it's quiet. That's why he's gone there to work."

"But what if she comes back?" Madeline demanded and Joey looked down at the Shredded Wheat; her mother had asked the same question the night before. "What's he working on anyway that's so blasted important? I thought he'd resigned from that project when he got sick. What the heck is he working on there at that apartment?" She paused and put both hands on her hips. "I don't think it's *work*," she said.

"Stop it, Mad. Stop," her mother broke in. "Your father has an urgent project and it's secret. I can't even tell you what I know, which isn't much. We simply have to continue to believe in him."

"The secret is that he's leaving us to go live with her," Madeline shouted. "That's the secret."

"Stop it, Mad." Joey's mother glared at Madeline. "That is *not* the situation and I don't want you to talk that way again."

"Then why can't he work here?" Madeline said.

"Oh, for heaven's sakes, girls. Stop it. Will you? I've told you what I can." Her voice broke and she covered her eyes with her hands. There was silence for a moment, then their mother pushed back her chair and stood. "I told you he wants more quiet and frankly right

now I do, too." She clutched the sides of her sweater together and left the kitchen.

"You think you're so smart," Madeline said. "Eavesdropping all the time." She jerked the door to the refrigerator open and bent down. "Damn. There's no orange juice."

Joey poured milk over her bale of wheat and watched it drip off the ends. Things were even more of a mess in this family than in Antigone's.

Chapter 20

MR. Pierce had scheduled rehearsals every afternoon, which left only the evenings for homework. Joey had two Algebra tests and an English paper and in the rush of learning lines, going to classes, and getting her homework done, it was easier just to put Poppy's leaving out of her mind. She stared at a white piece of paper taped to the wall in the telephone closet: "In case of need, J. Lindsten can be reached at...." There was a phone number and an address underneath: "1825 New Hampshire Ave., N.W., Apartment 8," written in her father's neat, slanted hand.

"He's working," Joey told Madeline in the kitchen. "I heard him tell Mum."

"Fat chance," Madeline said. "He's gone to live with Sarah."

"It's just that he needs more quiet to work," Joey protested.

"Then why doesn't he call us? Why doesn't he come home for supper once in a while?" Joey didn't know why. She had to get Bs on her Algebra tests, Mr. Pierce said, and she must memorize her lines.

Tom Cooper, a tall boy with acne around his nostrils, was Creon, and Joey didn't like him. He knew his lines, but when he confronted her, after the guard had brought her in, he asked, "'*Dost thou*

disavow this deed?'" as if he were asking whether anyone had seen his gym shoes.

They stood opposite each other in Mr. Pierce's classroom late one Thursday afternoon, as Mr. Pierce sat watching them, his glasses pushed up into his sandy hair and his long legs in his khaki pants splayed out. The blackboard behind Joey and Tom was smudged with half-erased writing and the late afternoon light made a soft rectangle on the desk beside the window. Tom began and this time he flung his arm out and pointed. *"And didst thou dare to transgress the law?"* he demanded.

Joey covered her breasts with her arms. *"Yes, it was not Zeus's law,"* she said. She dropped her arms and squeezed her hands together. *"I knew a mortal could not override the unwritten and unfailing statutes of heaven."*

"Wait a minute, Joey." Mr. Pierce jumped up, pulled his glasses down into place and moved close beside her. "Don't do this." He clutched his sweatered arms around him, clasped his hands and cocked his head to one side. "Stand straight," he said, aligning his own body so that he was tall suddenly. "Don't squeeze your hands. Antigone isn't some kid trying to get something out of her uncle. She's a girl who knows she's probably going to die for what she believes." He sat down, then jumped up again. "Look." He took her head between his hands and held it straight. "Now this is where your head wants to be. See? You have to have the courage to make yourself vulnerable."

"Okay," Joey said, but the straight, open posture felt unnatural. Her arms rose up and she lowered them consciously.

"It's hard," Mr. Pierce said. "It's going to take time. This is a much bigger production than the play last fall. I mean, you know. The gym on a Saturday night." He stepped back and looked from Joey to Tom. "Now Tom, you're jiggling. You put your hands in your pockets again. Remember, you're not going to have pockets in your costume and even if you did, you wouldn't put your hands in them. You're a king." He sat down and pushed his glasses back up on his head.

"All right. Now try it again and keep still. There's power in stillness on stage. Remember that." They went through it again.

"You don't need to shout when you answer, Tom. Just bring the lines out clearly. They have enormous force in themselves. Let's go through it again. Look at each other this time. You're not talking to the audience, Joey, you're pleading with your uncle. Look at him, not me. He's the one you've got to persuade."

Joey lifted her eyes and looked straight at Tom in his plaid shirt and faded corduroy pants. His eyes were dark and secretive and she didn't want to look at the acne under his nose. They went through the scene again.

"You're getting there, kids," Mr. Pierce said finally. "Start with '*I knew a mortal*,' Joey.'"

Joey straightened. "*I knew a mortal could not override the unwritten and unfailing statutes of heaven*," she said. This time the lines came to her with a sudden force. Heat filled her and and her body felt light. "*So for me to meet this doom is trifling grief; but if I had suffered my mother's son to lie in death an unburied corpse, that would have grieved me.*" She brought "that" out with a shout and spread her hands as though the corpse lay on the scuffed wooden floor between them. "*For this I am not grieved.*"

"Good, good. Much better," Mr. Pierce said. "We have to keep at it now." He slapped Tom on the shoulder. "You've got a lot more to do, but you're going to be okay." He turned to pull his tweed jacket off the hook beside the door. "Let's call it a day. We'll run through that scene again tomorrow afternoon. All right?"

Joey turned back to the window. The warm, strangely inflated feeling that she had had as she said her lines the last two times lingered and she moved to the desk and put her hand down in the streak of light. She stared a moment at the blue veins on the back of her hand; right now she was more Antigone than Joey Lindsten.

* * *

It was Tuesday, May 8th, and school was closed because of V-E Day, but Mr. Pierce had gotten permission for anyone who wanted to

work on the *Antigone* set to come to his classroom that morning.

Joey was helping him rip clumps of old newspapers into long strips, which they piled on a desk. Joey leaned over to pick up another clump, spotted the morning *New York Times* and stopped to tear off the front page. "I want to save this for my war journal," she said and stared down at the headlines. *The War in Europe Is Ended. Germans Capitulate on All Fronts.* "I still can't believe it." She folded the paper and put it on the window sill beside her sweater.

"I know. It's really hard to believe," Mr. Pierce said. "Even after the fall of Berlin. Even after Hitler's suicide last week. It's been such a long time coming." He rolled up his shirt sleeves and picked up an enamel bucket. "I'm going to make the flour and water mix now," he said and started out into the hall to the janitor's closet. "The others ought to be here soon."

Joey followed him out into the hall. "When we first came down here to Washington," she said, "almost three years ago, I thought we'd beat Hitler in a month or two." She watched Mr. Pierce empty a bag of flour into the pail, run some water into it and begin to stir it with a wooden stick. "I was just ten, of course, but, actually a lot of people thought the war would end fast when the Americans got in."

"We all underestimated Hitler," Mr. Pierce said. His voice was sad and Joey wondered if he felt guilty about not fighting. She and Fay had decided that he must have been classified 4F because of his eyesight. Whatever the reason, they were lucky, she thought. Other schools had fussy old teachers who viewed drama productions as a huge nuisance, but Mr. Pierce loved directing them.

"You know what I just realized?" Joey said as he began to stir again. "All over Europe, people like the Le Moisiers in our play last fall will be free. This very morning, right now, they're free. They can step out of the attics they've lived in for so long or the cellars, and they can shout and hug each other and get cigarettes and chocolate from the soldiers and their lives will begin again."

"Not all, Joey," Mr. Pierce said. "A lot have been killed."

"Yes," Joey said and squeezed her arms around her. "I know. We had a boarder at our house last year and the year before, too. He was a Naval Intelligence officer, a chief warrant officer—He was killed in the Pacific last July," she said. "His ship was sunk. I...." Joey felt her voice shake. "We were friends. I still miss him. I mean, I'm just so mad that he, of all people, had to die."

"Listen, Joey." Mr. Pierce stopped stirring and gave her a stern look. "Use that anger. Hear? When you're up there pleading with Creon, remember your friend, that Naval officer. Hitler's acts and Hirohito's have angered us all and what Creon did angered Antigone." Joey opened her mouth to say something, but Mr. Pierce rolled one sleeve higher and resumed stirring.

There were voices on the stairs. Dick Hendrix pushed back the swinging door and started down the hall, followed by Bruce Nelson. Fay appeared with Margaret, a tall girl with frizzy hair in Fay's seventh grade section.

"Victory in Europe," Dick shouted and raised his arms high, his fists bunched tight. "Victory at last. Isn't it something, Mr. Pierce? Aren't you pleased?"

"I certainly am. Everybody is," Mr. Pierce said. "It's amazing. But come on now. We've got work to do." He picked up the bucket and they followed him into the classroom. He pointed to some wooden frames he had made, with chicken wire covers. "These are going to be the rocks," he announced. "The next step is to dip those strips of newspaper into this flour and water mix. See?"

Joey was suddenly aware of Charlie Howz, who had come into the room. She felt a burning spread from her neck to her cheeks and wished she had worn her blue shirt instead of her stained old white one. Suppose he said something to her? What would she say back?

Mr. Pierce poured the flour and water mix into a shallow pan on the floor. He picked up a strip of newspaper, dipped it into the pan and held it up a moment, letting the thick liquid ooze down, then he bent and patted it over the biggest rock. "It'll take a while to dry," he said, stepping back. "But if we can get them all spread today, we

can probably paint them Friday." He looked up at the group. "Let's get started. We want to have a finished set for the dress rehearsal. Okay?"

There were several rocks that still needed chicken wire, so Dick and Charlie took two hammers and a bag of nails from the collection of tools on the desk and knelt down to finish them. Joey breathed out, relieved by the space between the hammering and the job of dipping the newspaper strips. She took turns with Margaret and Fay soaking the strips in the flour paste quickly, then patting them down on the rocks.

"This is a big day for our family," Margaret announced. "We're going home just as soon as the war's over."

"We're going home, too, after the war," Fay said.

After the war, Joey thought, after all the fighting in the Pacific was over, after Tokyo had surrendered and Hirohito was dead. Would Poppy stop working on his project then and come home or would he divorce Mum and go away? She glanced over at Charlie Howz, but he had straightened. She watched him put some nails and the hammer back on the desk and turn to the door. "He's gone," Fay said, noticing Joey's stare. "I guess he's got something better to do." Joey stared, wondering what that could be, but she felt relief flood through her. She looked down at the flour mix again.

Joey raised her eyes when she heard Mr. Pierce laugh. He was talking to Bruce about the boxes with their chicken wire as he stood with one hand on his waist, his lightly furred arm protruding from the roll of his blue shirt-sleeve. If she were older, she would forget Charlie Howz completely; Mr. Pierce would be a wonderful boyfriend.

"The big thing is," he said, glancing back at the others. "We've got to make the set completely portable, so we can put it up in the gym Saturday morning before the big night. That's why we've gotta get it done soon." The nighttime performance was the climax, Joey thought. It would be in a real theater with a real audience at night.

They continued to work until Mr. Pierce announced, "Lunch break. Did everybody bring a sandwich?" He plunked a paper bag

down on his desk and pulled out a bottle of chocolate milk, a box of graham crackers, and a tower of Dixie cups. The group settled on the floor near the blackboard, unwrapped sandwiches, and stretched out their legs to compare their flour-splashed sneakers and their dungarees. Joey reached for a graham cracker and leaned back. It felt cozy sitting together beyond the drying rocks, talking as they ate. The clean smell of the wet newspapers was oddly pleasant, mixed with the spring smells of grass and wet earth seeping in through the half-open window.

They heard a horn honking. The sound continued and then another horn answered it. "They're still celebrating out there," Bruce said. "There were thousands of people in Times Square last night shouting and carrying on." He reached for another graham cracker, broke it in half, and added, "It makes me kind of mad. I mean, we've still gotta beat the Nips."

"Did you hear Truman on the radio this morning?" Dick asked. He wiped some sandwich crumbs from his mouth and squinted through his glasses. "My fellow Americans," he began, imitating the flat, Midwestern voice. Fay laughed and Margaret joined in, but Joey looked down. It was sad to mock poor Mr. Truman. It wasn't his fault that FDR had died; he was doing the best he could.

Another horn sounded, then a banging, which might be someone hitting a metal pan outside on the street. "It's dumb the way people are celebrating," Bruce said. "There's still a lot of hard fighting ahead." Joey remembered suddenly that Bruce's father was a lieutenant commander in the Navy somewhere in the Pacific and Fay had told her that his family had not heard from him since March. Should she say something, she wondered, but what?

"You're right, Bruce." Mr. Pierce crossed his legs in his paint-stained khakis. "The munitions factories didn't close today, you know, and most of the war workers are just keeping on with their jobs."

"My dad's the captain of a destroyer," Bruce said, looking at Joey.

"I know," Joey told him, remembering their worries about Tony.

"I hope he's all right. I bet he is," she mumbled. How terrible it would be to wonder whether your father was alive or wounded or dead; and yet in some ways it would be a relief to have an uncomplicated father off in action somewhere, a father who was doing something brave and obvious, not working on a secret project in a girlfriend's apartment, but a military father, who ran a ship and would come home to his family alive and heroic someday, maybe.

<p style="text-align:center">* * *</p>

There were only six days left until the performance. Joey knelt at the back of the set with Fay, stirring a can of black paint with a long wooden stick. Fay was stirring a can of gray and in a moment they would splatter the rocks.

"You were really good this afternoon, Joey," Fay said. "I watched from the back of the room. I was cleaning the brushes and you said your lines really well."

"Thanks," Joey said.

"At first I was kind of jealous of you, you know?" Fay said and lifted her stirring stick, so that several dark drops fell on the newspaper below. "But the messenger has a lot of lines and he's really important, too."

"Definitely," Joey said. "If you added them all up, you probably have more lines than I do."

Dick Hendrix and another boy were singing as they lined up the chairs.

> *Ven der Fuehrer says,*
> *"Ve iss der Master Race,"*
> *Ve Heil! Heil! Right in der Fuehrer's face.*

Dick made a loud raspberry noise and Joey groaned. "I hate that song," she said. "It's so stupid and it doesn't make any sense now anyway."

"You know what?" Fay said. "Mummy says we're going home to Cambridge soon."

"You are?" Joey stopped stirring and stared at her friend. "When?"

"Right after school maybe. Daddy has to get ready for summer school."

"June? But that's just a month away."

"I know, but the war's almost over now. I mean all the European stuff's finished," she said and put down her stick. "I want to go. I mean, we'll be back in our real house again. But I'll miss school, sort of. And I'll miss you." She looked over at Joey quickly and then back at her can of paint. "Still, you'll be coming home soon, too. Mummy said so. She says you have to be out of your house by July."

"I know," Joey said and stopped stirring. She stared down at the black, oily paint. "Everything's coming to an end. But I don't what's going to happen after the end."

"Hey. We can begin to spatter now," Fay said and straightened quickly, as though she didn't want to hear the sad things Joey might say next. "The rocks are dry." She dipped her brush into one of the buckets. "This'll be fun. See? You just clap the paint brush like this. Mr. Pierce showed me yesterday. I'll do the gray and you follow with the black." They spattered the big rock and Fay stopped to stare. "It really does look like granite. Doesn't it?"

Joey followed Fay, clapping her brush so that the black paint splattered over the newspaper surface that covered the chicken wire and down onto the newspapers below. They circled the rocks four times, spattering them thoroughly. "It's pretty much done," Fay said, stepping back. "Don't you think?" Joey agreed and they took the cans and brushes to the janitor's closet in the hall, where they leaned over the sink to wash their brushes, squeezing out dark rivulets of water.

"Fay." Joey turned to look at her friend. A piece of hair was hanging over Fay's forehead and there were dots of paint on her glasses. "Fay, did you ever know anybody whose parents got divorced?"

Fay glanced at her a moment, then stared down into the sink. "No. Did you?"

"No," Joey said and looked down the empty corridor.

* * *

It was a spring evening, three days before the performance. Madeline was talking on the phone to Ruthie and Joey was upstairs at her desk, writing a paper on Greek drama for English. She had picked the subject because she had thought it would be easy, but when she started she realized she only knew *Antigone* and nothing at all about the other playwrights or even about Sophocles' other plays.

Mum had left early, wearing her lavender blazer and her dangling gold earrings, because she was having dinner with the colonel before work. Madeline said they were just friends, but friends could fall in love and marry maybe. Joey sighed and closed her eyes.

The ring of the doorbell sounded below. Joey lifted her head and listened. Madeline probably hadn't heard, since she was in the phone closet with the door closed. Joey ran down the stairs and stooped to peer through the strip of colorless glass beneath the stained ones before she unlocked the door. The sight of her father waiting on the top step made her pull in her breath. "Poppy!" She jerked the door open, aware all at once that the evening outside was still light and full of wet spring smells. "Hi," she said and stared at him.

"Hey, Jo. How are ya?" He glanced around him as Joey stared. He was wearing his brown tweed jacket with the collar pulled up, khaki pants, and the old blue sneakers he used to wear at Newbury. "Anybody home?" he asked.

"Mad's on the phone and Mum's at work." Joey glanced down; she couldn't really tell him that Mum was having dinner with the colonel, could she?

"And you," he said and sunk one hand into his jacket pocket. "What are you up to?"

"Homework," Joey said. "I have to write a paper for English." She paused, aware once again of how remote her life must seem to him.

"On what?"

"Greek drama," she said and looked down.

"Ah. Hey, how's *Antigone* going? Your Mum told me you got the lead. That's terrific. Congratulations."

"Thanks." Joey stared at her father. So he and Mum had been talking. What else had Mum told him?

"Greek Drama. What a subject." He leaned back a moment and gazed up at the chandelier. "You'll talk about *Antigone*, of course. But what other plays?" He looked at her and smiled. "Let's see what you've done," he said and paused. "I mean, can I?"

"Well...." Joey hesitated. "Sure." She turned and led him up the stairs. The lamp was burning on her desk and she gathered up the pages she had written and looked at the first one nervously. "I don't like the beginning," she said and studied her father, who had sat down on the narrow bed.

"The first paragraph's always the hardest," he said. "Read it to me."

Joey settled on the floor holding the pages and took a breath. "'Although Greek drama can seem somewhat scary at first,'" she began, "'when you get familiar with a particular play, you may be surprised by the ways in which it makes you think about your own life, for it is the humanness of these plays that makes them so alive to us modern readers.'"

"That's good, Jo," her father said.

"Is 'humanness' a word?" she asked.

"You might use 'humanity' there. But that's a good start. Can I see the rest?"

"OK," Joey said, feeling hot. "But it's really rough. I just started last night." She handed him the sheaf of lined yellow pages and paused. Maybe she should run downstairs while he was reading and tell Madeline he was here; after all, they hadn't seen him in over three weeks. But she continued to sit on the rug, watching him.

"It's a good start," he said and handed back the pages. "How long's it supposed to be?"

"Ten pages maybe. I need about six more. I've got that bit about Euripides. But I ought to have something about Aeschylus, I guess."

Her father leaned forward and put both hands on his khaki knees. "A friend of mine in France told me he'd heard of

two performances of *Antigone* in Paris during the Occupation."

"Really?" Joey stared at her father. "That must have been danger-
ous. Why'd they do it, Poppy?"

"Well, you know when people are torn the way the French have
been between collaboration and resistance, I think they can appre-
ciate the ambiguities and tensions in Greek drama, especially *Anti-
gone*. Maybe it helped them understand their own situation."

"Oh," Joey said.

"*Antigone* is really about different kinds of loyalty, don't you
think?" her father went on. "I mean, there's loyalty to the state and
loyalty to the family. It's a sort of a weighing of the two, it seems to
me."

"Oh, no. It's not *weighing*, Poppy." Joey heard her voice come out
almost in a shout and she leaned forward. "Antigone does what she
does out of love for her brother and her family. I mean, Creon's her
uncle, but he's really the state. She's right, Poppy. There's no ques-
tion about that, even if you sympathize with Creon at the end.
Antigone knows that her family comes first. She doesn't *weigh*; she
puts her family above the state and she *knows* she's right. I feel that."
Joey pulled her knees close to her chest and wrapped her arms
around them.

"Ah," her father said. "I see."

"She does something so amazing." Joey glanced down. She hadn't
meant to sound emotional. "Maybe it is like the French," she said,
making her voice calm. "It's sort of like a conflict between what is
safe and what is right. I mean, to obey the Nazis would be safe, but
to resist is what is right, don't you think?"

"Yes. The French underground workers had enormous courage."

"I was in a play last fall about the French underground," Joey
said.

"Your mother told me. She said you were very good." He paused
and pulled a package of Lucky Strikes from his jacket pocket, shook
one out and lit it. "I was in *Antigone* years ago," he said.

"You were?" Joey stared. "What part did you play?"

"Creon." He looked down, as if embarrassed, then added, "It was challenging actually. I wanted to show…." He hesitated. "To show how divided Creon felt. I mean he loved his niece and he was proud of his son. But he decided for the state; it was a hard decision." Her father looked down, then up at her again.

"But it was wrong, Poppy. He should have seen that what Antigone wanted was right."

Her father blew out a long stream of smoke. "Right, wrong. We all think we know what's right until we get to the tough places." He looked up at the window, then back at Joey. "I think Creon felt split between his duty to his government and his loyalty to his family."

"But he made the wrong decision," Joey said. "He was a tyrant, a bad man. Antigone had the courage to do what was right." Joey's voice trembled and she clasped her knees harder. "She did. I mean, she didn't have to bury her brother, but she did, and that was right."

"Not everybody is so certain, Jo," her father said slowly. "Not every issue is so clear." He coughed and pulled a handkerchief from his pocket, then looked up at the window again. "The language is beautiful. Sheer poetry, some of it, don't you think?"

Joey pressed her lips together, disappointed that he had dropped the argument. He stretched his arms above him suddenly and looked back at the half-open window. "It's a beautiful evening. I worked all night last night and this afternoon I thought I'd take a break, so I went out for a walk. It's spring. I guess it's been spring for weeks, but I've barely noticed until now. The daffodils are almost over and there're tulips. There're some dogwood trees flowering right along Q Street. I walked and walked. I just kept going and came on over here. Hope that's okay."

"Sure, Poppy. Of course." Joey looked up at the window, too, feeling embarrassed. She thought of Antigone and asked suddenly, "Is Sarah in your apartment, too?" She felt the blood rush to her head, so that her ears sang and she wasn't sure for a minute if she could hear his answer.

"What?" Her father grimaced and glanced at her and then up at

the window again. "No, Jo. No." He let out a long sigh. "That was a long time ago." He sighed. "Right now I'm trying to do something hard. Something for the country and…. I can't talk about it, you know. It's difficult, but it's something I've got to do."

"Couldn't you come home?" Joey said. "For supper sometimes anyway?" She glanced up and saw that her father was staring at the window. "You could play the piano like old times and we could sing," Joey added. "It would be relaxing."

"Yeah, you're right," her father said, but Joey knew he was not thinking of the piano.

"Can you come to my play?" she asked and tensed as she looked up at him, knowing he would give her some excuse. "It's this Saturday night."

"I will if I can, Jo. I have to see how the work goes."

"Hi, Pop." Madeline stood in the doorway, looking in. "When did you come?"

"Hey. Hi, Mad. How are you?" Their father stood and moved to the doorway. "How're things with the student council? I hear you're secretary now. That's great. How's it going?" He waited, but Madeline didn't answer. "I went out for a walk," he explained. "I just dropped by."

"Mum isn't here," Madeline said and took a step back in the hall.

Their father shifted and put one hand in his jacket pocket. "I know," he said. "I was talking to Joey about her paper on Greek drama. Got much homework tonight, Mad?"

"Not much," Madeline said and glanced behind her. "Nothing really." She turned and ran down the stairs.

Joey heard her father sigh, then felt his gaze on her again. "Do you have to finish that paper tonight?"

"No. It's not due until Friday."

"Good. You have some time to think about it then." He started into the hall and down the stairs. He had not brought a coat, Joey realized, so he wouldn't stand in the hall a moment, buttoning it up and he didn't have a hat to clamp on his head or a briefcase to pick

up from the table. In seconds he would just open the door and be gone.

She looked up at him in the front hall. "Poppy," she started. "When will you come home? I mean, if you're coming home, if you decide to that is?"

"I am coming home, Jo, and it'll be soon." He put one hand on her shoulder. "I have to finish this job I'm doing." He scowled at a mark on the wall, then looked back at her. "It's hard," he said and pressed one hand down on the hall table. "Trying to get people to listen to you." He coughed and dropped his hand. "But other people are in this, too, scientists I know, and others. Now that the war in Europe is over, we'll make our case soon and my work, the part of it that I can do, will be over." He coughed and touched her shoulder again. "Ten days or two weeks maybe." He paused. "Three weeks, Jo," he said. "Then I'll come home. Three weeks," he repeated and turned. "I promise."

Joey stared at the front door after it had closed behind her father. He had made a promise; he had told her he was coming home.

Chapter 21

THE night performance in the gym had arrived; this was not a rehearsal, not a dress rehearsal, or even the Friday morning performance yesterday in Mr. Pierce's seventh grade room. This was the real performance on the stage in the gym. There might be a hundred people out there, Joey thought, as she peered through a tear in the worn curtain, which was pricked with holes, so that the light came through like tiny stars.

"My turn now," Lizzy Turner said and Joey stepped back to let Lizzy look out of the torn place. Voices rose beyond the curtain. "Where are you sitting?" "Save that seat for your father, Johnny." "Over there where I put my hat."

Lizzy, who was playing Ismene, looked almost unrecognizable in her mascaraed eyelashes and darkened brows. Her face was powdered white and her lips were a deep oily red. Lizzy turned, as if conscious of Joey's stare, and half smiled. Joey probably looked as unfamiliar to Lizzy as Lizzy did to her. Popular Lizzy, with her long blonde hair, was a friend now, her sister in the play, although Joey had never known her at all before *Antigone*. She wore a rose-colored gown with a gold border that her mother had sewn on, the same border she had sewn on Joey's white gown.

Both were draped, so that long folds fell from their left shoulders across their breasts. Joey had complained that that was a problem, because in her last confrontation with Creon, the fold slipped down her arm when she raised her hands to beg. But Mr. Pierce had told her not to worry about it. "It makes you look more determined, more desperate."

Dick Hendrix appeared from stage left in his green *kiton* and sandals. "Zounds," he said. "You two look like real glamour girls." He picked up a wooden spear and jabbed it teasingly at Tom.

"Cut it out," Tom said and raised his hands to anchor the wreath of artificial leaves on his head more securely. The audience's voices grew indistinct to Joey, then distinct again.

"Places," Mr. Pierce whispered loudly from backstage. "Quiet." Joey and Lizzy took their positions. Joey's teeth were chattering and she crossed her bare arms over her breasts and closed her eyes. "You OK?" Mr. Pierce put his hand on her back.

"Yes," Joey said, looking up. "Sure." But her teeth continued to rattle.

"It's professional to be a little scared before curtain," he said. "You'll be fine."

Mr. Pierce went out in front of the curtains and announced that the proceeds from the ticket sales would go to war bonds. Then, all at once, it was dawn. Joey was standing before the palace with her sister, Ismene, and she was angry.

"*What, hath Creon destined our brothers, the one to honored burial, the other to unburied shame?*" Joey felt the familiar heat spread through her and she went on. "*I will bury him: well for me to die in doing that....*"

Light seeped in from the corridor outside. Joey could make out the shape of her mother's head as she sat beside Mona in the third row with Henry on the other side. Joey lifted her arm to gesture and went on. She would show Mum and Mona and Henry; she would show them all that she, Joey, was Antigone.

The play went fast. They were coming to the end. "*Tomb, bridal*

chamber," she began, loving the words, "*eternal prison in the cavern-ed rock, whither I go to find mine own....*" She let her eyes move over the rows of audience and saw a figure at the back. A man had just come in. He raised his hand to his head, smoothing his thinning hair a moment. She knew that gesture. It was Poppy. He had come.

She was inside the tomb of rocks that she and Fay had speck-led, but now the rocks were craggy and damp. Joey crouched in the dim space behind, listening as Tom, her Uncle Creon, launched into his terrible confession of guilt and sorrow.

The old velvet curtains were pulled shut and the audience began to clap. Joey ran to Tom's side, sweaty now, her hands and knees dirty from the boards beyond the rocks, the loop of her draped gown fallen halfway down her shoulder. She clutched it back into place and the curtains flew open. The chorus bowed and parted and she and Creon moved into the center of the group with Lizzy and Fay and the others around them. They bowed and the audience clapped. Someone shouted, "Bravo!" and the audience began to stand, a few in back, then more, and suddenly the whole audience was on its feet, cheering. The cast made space for Dick and Bruce and the oth-ers on the set crew. Tom turned and beckoned to Mr. Pierce in the wings by the curtain and he and Joey parted as Mr. Pierce moved into the middle of the line, smiling and bowing, joining hands with Tom and Joey on either side, as the audience continued to clap.

The clapping went on and on and all at once Joey was alone on-stage, holding a bunch of rose-colored tulips that another seventh grader had handed her. She stepped back into the wings finally and Mr. Pierce clapped her shoulder. "You were splendid," he said "Just splendid."

Parents and friends crowded into the locker room. Mum hugged her tightly and there were hugs from Mona and Henry. "You were superb, dearie. Superb," Mona said. "I used up all my Kleenex crying."

Madeline ducked around the others and thrust a single rosebud on a long stem at her. "Oh, Mad. Lovely. Thanks." Joey bent to inhale

the delicate smell, then raised her eyes and peered out into the hall. "Where's Poppy?"

Madeline frowned and shook her head. "He didn't come."

"He didn't? But I thought I saw him. There was a man in back and he...." Joey stopped and stared at her sister. "Oh well. It doesn't matter," she said.

"Yes, it does," Madeline said. "He didn't come and it does matter." She turned from Joey, tunneled her way through the excited group and left the room.

The group thinned until only a few mothers and friends were waiting. Fay was helping Dick and Bruce strike the set and Joey meant to join them, but she sat down at the messy counter, strewn with make-up jars, mascara brushes, and safety pins, and bent forward to stare at the picture of the Greek goddess on the coin that she had propped up beside the mirror. It's all over, she thought, staring at the girl on the coin with her determined look. I can't be you anymore.

* * *

There were only two weeks left of school and everybody was talking about summer plans. Joey felt limp now that *Antigone* was over. There were no more rehearsals to rush to, no performances to work toward, and the warm, sweaty family of the cast and stage crew had dispersed. Fay's father had taken pictures of the play and some of the group painting the set. Joey had felt embarrassed by Henry's intrusiveness at the time, but the glossy pictures were surprisingly vivid, and when Fay suggested that they have a party Friday night for the cast and stage crew to show the pictures, Joey agreed. "You can invite Charlie Howz," Fay said.

"I don't know," Joey began. "I don't know if I want to." Charlie hadn't been that involved with the play and besides, Joey thought, it was much safer to fantasize about him than to actually be in his presence.

"There he is," Fay said the next day, when they came out into the hall at recess. "He's alone. Go ask him now."

Joey felt her jaws shake. "No, not now," she said, but she moved down the hall toward him. Charlie was turning a baseball in his hands, examining the stitching, but Joey was sure he'd heard her approach. "Umm," she began. Charlie looked up and she was startled at how close his eyes were to his nose; he had never looked that way in her fantasies. "Fay and I are having a party tomorrow night. Fay's father.... He's a photographer, an amateur one sort of, and uh, he took pictures of the play and all of us painting the set and stuff...and...." She stopped dazed, not sure what she had said.

He looked up at her and then back at the ball. There was a pause. Joey waited. Of course, he wouldn't come. "*You* want *me* to come to a party?" he asked and glanced up with what seemed at first to be a brief smile, then Joey saw a curl at one side of his mouth. "No thanks," he said and slammed the baseball into the mitt on his other hand.

"Oh," Joey said and backed away. It was all right that he wouldn't come. She'd never really thought he would. But that sneer felt like a well-aimed buzz bomb shattering a London church.

* * *

Joey sat on the edge of the tub, watching Madeline, who was taking bobby pins out of a row of pin curls on one side of her head. She was going on a double date that night with Jimmy Moser and Ruthie was going with Sam. Joey knew that Madeline didn't really like Jimmy, but he liked her and he was kind of cute, she said. "Where are you going?" Joey asked.

"*The Bells of St. Mary's.* It's got Bing Crosby and Ingrid Bergman."

"You lucky," Joey said, as she watched her sister drop another pair of bobby pins into the box on the side of the sink. "I love Ingrid Bergman."

"You can go with Fay. It's at the O Street Cinema all week."

"I know." Joey sighed. *The Bells of St. Mary's* wasn't the point for Madeline anyway; the point was, if or when Jimmy would cover her hand with his or put his arm up on the seat behind her and when he would squeeze her shoulders. Probably all three things would

happen. "You could have a boyfriend, if you wanted," Madeline said. "You know boys from that play."

Joey sighed again. The play was over. Charlie Howz had sneered at her, and only four people, all girls, had come to the awkward party at the Hartleys. She would never go on a date, she thought; it was all too complicated. "Has Jimmy invited you to the prom?" she asked.

"Yes, but...."

"But you're hoping Harris will ask you, before you have to give Jimmy a definite answer, aren't you?" Madeline's social games seemed suddenly tiresome to Joey, although she and Fay often speculated about them.

"If you know the whole situation, why do you ask?" Madeline said and pulled out another bobby pin, so that her hair hung down in four little cork screws on the side.

"After you go to the prom, you'll go to Ruthie's for a private party, won't you?"

"Maybe." Madeline turned from the mirror and narrowed her eyes as she looked at her sister. "If I do, that's something Mona doesn't need to know about. Hear? Or Mum either."

Joey stared down at the black and white diamond-shaped tiles on the bathroom floor. The two by the door were cracked and a tangle of hair was lying on one. "Well, anyway it's all just practice for the ultimate, I guess," she said, pleased by the word "ultimate." "Getting married."

"Oh, marriage." Madeline made a noise in her throat and put down the comb. "If I ever get married, and I might not, but if I do and things go wrong, I'm going to make my mind up clearly to divorce and just do it."

"What do you mean, divorce?" Joey sat forward on the rim of the tub.

"Oh, never mind. I just hate this stupid messing around, being so secret all the time, as if we were babies and couldn't figure out anything. Divorce isn't the end of the world. Lots of people do it. Look at Mrs. Simpson."

"Do you think they're going to get a divorce?" Joey asked in a low voice.

"Why not? Pop was home all of ten days after he got back from that mystery place he was working in for two years. He's obviously living with her. Why doesn't he just clear out and marry her? But oh no. He calls Mum late at night and they talk for an hour and he calls her at work and it's hell on Mum. He should just leave. It wouldn't make much difference to us. We've barely seen him in years anyway."

The phone rang in the closet downstairs, a faint sound. "It might be Ruthie." Madeline dropped more bobby pins into the box and hurried to the stairs. Joey ambled after her. The final test in Algebra was Wednesday, but Joey continued down the stairs. She would just read the funnies before she started studying. She'd missed "Joe Palooka" yesterday and "Superman." She pulled a pile of newspapers from the seat of one of the kitchen chairs and began opening them, looking for the comics section.

"Mum's not here," she heard Madeline say. Joey turned to look at her sister. She was standing in the phone closet with the door open, biting her lip as she held the receiver to one ear. "Yeah," she heard her say. "Yeah. Sure." There was a pause. "My blue dress with the red belt, I guess." Another pause. "Yeah, sure. Okay." She hung up the receiver, slammed the closet door shut and rushed up the stairs.

Joey followed her to the bathroom. "Who was it?" she asked.

"Pop." Madeline did not turn back to Joey. "He wanted some telephone number. Some physicist he thought was in Mum's book. Then he wanted to know if I was going out tonight." She picked up the comb and jerked it through the damp, blonde spirals of her hair.

"He asked me what I was going to wear and then he said to take care of myself. To be careful." She turned to Joey, her face flushed. "Honest to God," she said. Her anger hissed through her teeth and she stamped one foot on the tiled floor. "What business is it of his who I go out with? What I wear? He doesn't even know me anymore."

"Actually that night he stopped by,..." Joey started. She had not told Madeline about her father's promise, but she must tell her now. "...you know, when he helped me with my paper? He told me he was coming home soon. In three weeks, he said."

"Oh God, Joey. Do you honestly believe that?"

Madeline covered her mouth with the back of her hand and rushed out of the bathroom into the hall. She yanked the door to her room open and Joey heard a sob just before she slammed it shut.

Chapter 22

THE night of the prom had come, but Mum couldn't be there to see how Madeline looked; she was at work. She had had a terrible week. An enlisted man had hanged himself in a room at the Center. There had been police to deal with, the family and the newspapers. What had the poor soldier been worrying about, Joey wondered. Some terrifying scenes of war? An unfaithful girlfriend? Mum had phoned Madeline about shopping for her dress. She suggested that Mona go with her, but Ruthie went instead.

Madeline sat at Mona's dressing table, and Joey and Fay sat on the bed, watching. The bright red dress she and Ruthie had bought at Woodward and Lothrop the day before had a scoop neck that revealed the tops of Madeline's breasts pressed together almost like the picture on the cover of *Forever Amber*, a look Joey was sure Mum would not like. Besides, the red had a cheap sheen, Joey thought.

"You look lovely," Mona said and picked up a bottle of White Shoulders, removed the cap carefully, and sprayed Madeline's neck and wrists. The sweet smell enveloped them all and Joey wondered what Mona really thought.

Just last Saturday, Madeline had come home from a date almost three hours late, although she'd told Mona she would be home at

ten, and she hadn't even apologized. Mona had exploded. She had
told Madeline that she was acting irresponsibly and was headed for
trouble. She said Madeline had better be more careful or she
wouldn't be allowed to go out on a date for weeks. "You don't make
the rules here," Madeline had shouted in the kitchen. "You're not
my mother." Joey, who was listening upstairs in bed, had squeezed
her eyes shut.

She was sure that Mona had talked with Mum about Madeline,
for Mum had announced new rules the next morning. Mona had
been polite to Madeline all week, although it seemed to Joey that
she had never liked her much. Yet now she was spraying her with
perfume and was even lending Madeline her black velvet cape. But
Joey could feel the distrust beneath Mona's gestures. Right now, it
seemed to Joey, they were all afraid of Madeline.

The door bell rang and Joey ran downstairs. It was Harris in a
tuxedo with a black satin bow tie under his chin. He stretched his
neck as if his collar pinched and Joey saw a red line below his jaw,
where he must have cut himself shaving. Madeline descended slow-
ly in the red dress, its net overskirt billowing over the taffeta folds
beneath. Mona introduced herself, then Fay. Harris nodded awk-
wardly and said his father was waiting in the car outside. He held
the cape out for Madeline and she gathered it over her shoulders,
fastened the top button quickly and said a brief goodbye. Joey
watched her start down the iron steps with Harris behind. He fol-
lowed her around the corner where they got into his father's car, as
Joey and Fay watched from the bay window.

* * *

Joey turned over in Fay's wide bed and peered at the cot under the
window, where Madeline slept on the nights she and Joey spent with
the Hartleys. It was empty; the bedspread was still smooth, tucked
in neatly over the pillow. She looked at the clock. Twenty after three.
Could that be right? She glanced at Fay, who sighed in her sleep.
Joey felt for her slippers on the rug and tiptoed down the stairs.

The standing lamp beside the couch was on and Mona lay with

her legs outstretched, snoring gently, her head drooping to one side. Should Joey wake her? Madeline had said she'd be home by midnight, but she must be at Ruthie's still. Mona would be furious. But suppose Madeline wasn't at Ruthie's? Suppose she'd been in an accident or had been kidnapped. Should they call the police? If only Henry were here; he never got irritated with Madeline. But he had gone up to Cambridge. A book lay face down on Mona's lap. Joey peered at it. *Brave Men,* by Ernie Pyle.

She went upstairs and sat down on the bed. Mum would be home by five and if Madeline wasn't back by then, Mum would decide what to do. She pushed her feet under the covers and lay back. A car door slammed in the street below and she heard voices outside. Joey swung her legs out again and rushed to the window. She pulled up the black-out shade and looked down. A lighted car had drawn up beside the curb. The front door was hanging open and Madeline was getting out of the passenger seat, as others in the car waved and called out to her. Joey stared. Madeline started toward the Hartleys' front steps, but tripped and caught herself, clutching the post of the street light with one hand. She looked back at the car and lifted her other hand in a wide, sloppy wave as it pulled out into the street. They had been drinking, Joey realized; Madeline was drunk. Oh Lord, this was the trouble Mona had predicted.

Joey rushed down the stairs and opened the front door silently, determined not to wake Mona. "Mad," she said, hurrying down the damp stairs in her slippers. "Mad." Madeline rocked a moment on the sidewalk, small and exposed-looking in her red dress. Her naked arms were gray-white in the gleam of the street light above. Where was Mona's cape? Had she left it at Ruthie's? Had she lost it?

"I have to…have to…." Madeline caught Joey's arm and held it in a pinching grasp. "I…." She let out a guttural sound, bent her head forward suddenly and began to vomit. The thick orangey liquid fell in a lumpy pool on the sidewalk. Joey glanced up at the

lighted front window of the Hartleys' house. Would Mona wake and open the front door?

A bus slowed at the light and its shaking noise muffled the sounds. Madeline let go of Joey's arm and dropped to her knees in her red dress. Her head flopped forward and she pressed both hands against the damp concrete as she crouched there raking up more liquid, pausing, then vomiting again. Joey felt the old helpless feeling gush through her; Madeline was drunk like Mum had been. She watched her sister sit back on her heels, then stand shakily.

"It's okay now," Madeline breathed and grabbed at Joey's arm.

The damp feel of her fingers startled Joey and she remembered Mona. "This way," she said and pulled her sister toward their own steps. Mona must not see Madeline drunk. She must get her into her own bed in their own house, before Mona woke. She would think of some reason later why Madeline had gone to their house rather than Mona's. Anyway Mum would be home in a few hours.

"This way," she said, pulling her sister toward their own steps. Madeline seemed oblivious to the change of direction and Joey got her up the iron steps to the front door and looked back. The slimy mess on the sidewalk was plainly visible in the streetlight; maybe it would rain.

She pulled the extra house key out from under the doormat and opened the front door. They must hurry; she must get Madeline into bed before Mona woke and came over.

In the light of the hall, Joey was startled at her sister's looks. The front of her red dress was streaked with vomit and the net overskirt was torn. Her face looked thin and scared without lipstick and one of her matching barrettes was gone. Joey fixed her sister's hand firmly around the banister and began moving up the stairs behind her. Only six more steps, Joey counted, five, four. But Madeline stopped. She turned on the stairs and looked down past Joey.

"I don't care if Mona does see me," she announced and let go of the banister. "I'm sick of Mona." She stared defiantly at an invisible

audience below. "I'm sick of this whole damn family." She grabbed the banister and breathed out noisily. "This family's a mess. A real goddamn mess. Pop's having a stupid affair and he's never coming back, despite all our dumb pretending that he is, and Mum's working all the time so she won't think about it. And you." She stared at Joey all at once. "You're Miss Goody Two Shoes. Know that?"

"Come on, Mad," Joey whispered. "Come on."

She got Madeline into her room and closed the door. Madeline held onto the bedpost while Joey undid the row of covered buttons in back and pulled the smelly dress down over her feet. When Madeline kicked off her shoes and collapsed on the bed, Joey pulled the covers up over her shoulders.

She had been quick and smart, Joey told herself, as she closed the bedroom door behind her. She would sneak into the Hartleys', slide back in bed beside Fay, and when she heard Mona downstairs, she would go down with a story about why Madeline wanted to be in her own bed after the prom. By then Mum would be back and she would take over. She gripped the banister and started down the stairs, but stopped. Mona was standing in the front hall.

"That's quite a mess on the sidewalk," Mona said. "You put her to bed?"

"They had a war bond rally at the dance," Joey began. "That's why she was so late. They raised a lot of money, but Mad ate too much popcorn. She got sick and wanted to go to bed here and…." Joey could feel Mona's eyes. She let the sentence hang and sat down on the stair step suddenly, feeling her body shake. "Mad's right," she said. "Our family's in a big mess. We keep pretending it's all normal and because of the war, but it's not. It's not. It's awful." She put her head down on her knees as a sob pushed up. "Mum's always at the Center and Poppy never was here anyway. He didn't come to my play; he was too busy, of course." She was crying hard and mucous from her nose was running down over her upper lip. "I don't know what's going to happen and I'm sick of worrying about it all the

time." She put her head down on her knees again, then raised it to look at Mona. "Mad said I'm Miss Goody Two Shoes." Her voice choked, and as she mopped her nose with the back of her hand, she saw that Mona had mounted the stairs and was squeezing in next to her onto the step.

"Honey, honey," Mona said. She put one arm around Joey and pulled her close. "Mad's upset and she has some growing up to do. Marriages go through bad times. All marriages do. You have a brilliant father and he loves you and Mad very much. Whatever he does, he'll always love you." She squeezed Joey closer. "And your Mum. Well, your Mum is just one of the best people in the world. You know that." She put her other arm around Joey and hugged her. "It's a hard time," she said. "Very hard, but you'll get through it, and so will Mad."

"I don't know," Joey said. Her voice was choked and the sobs kept coming. "I hate the way everything is; the way it just goes on and on."

Mona pulled a crumpled Kleenex from her pocket and handed it to Joey. Joey blotted her lip, then blew her nose, as Mona watched. "What about some Ovaltine?" Mona said. "We'll have it all made when your Mum gets here."

Ovaltine? Joey shut her eyes. The proposal seemed grotesque. She opened them and looked down the stairs to the front door below. She could rush down, she thought, and out into the dark street. She could run along the damp sidewalks, through the dim alley, going on and on, past trash cans and stacked boxes and never come home.

"Come on, dearie." Mona said and stood. "Come on."

Joey pulled herself up shakily. It seemed to her that a door had opened into some wild weeping place within and she clung to the banister a moment, trying to decide whether she would cry some more or run away or just go on. She watched Mona's buttocks in her sagging wool dress moving down the stairs. Joey wiped her nose

with the Kleenex again, then on the sleeve of her bathrobe, and followed her down to the kitchen.

* * *

Joey was rinsing her cereal bowl in the sink the next morning when she heard her mother come down the stairs. "You're up, sweetheart," she said. "I thought you'd sleep a while." She pulled up the collar of her old blue bathrobe and wrapped her arms around her. "The house seems cold, doesn't it? Cold for May." She rinsed the coffee pot, put in fresh grounds, and placed it on the stove. "Joey," she began. She sat down and pulled the front flaps of her bathrobe together. "Joey, this is a hard time for us all, especially you. Madeline made some serious mistakes last night and you tried hard to help her and—"

"Listen, Mum. I can't talk now," Joey said. "I've got a meeting this morning." She glanced up at the clock, startled at herself. Mum had come down especially to talk with her and she was turning away. Why?

"A meeting?" her mother said. "On Sunday morning?"

"The drama club. I can join it next year in eighth grade, get a big part maybe. Mr. Pierce is going to be coach and he invited all of us over to his apartment to plan for next year."

"Oh," her mother said. "Well, that is important. When do you have to be there?"

"Eleven," Joey said. "I'm bringing doughnuts."

"You'd better get started then. Have you got enough money?"

"Yeah," Joey said and grabbed her jacket from the hook by the door.

"Bye, dearie." Her mother had come into the hall. "We'll talk later. All right?"

"Sure, Mum."

Joey felt the brightness of the May morning envelop her, as she shut the front door. Smells of damp earth and growing things rose up around her and she leapt down the steps, jumped over the pool

of vomit and ran down the block to the bus stop across the street. She would buy a dozen chocolate doughnuts at the Capitol Bakeshop, because Mr. Pierce loved chocolate. She glanced down at some daffodils poking up amidst the tangled ivy in a city garden. It was spring, almost summer; she could leave the mess in her house behind.

After the meeting, Mr. Pierce walked Joey to her bus stop. "If your family goes back to Cambridge this summer," he said, "there's a summer drama program in Boston I know about. You might consider applying." He talked of the teachers, the courses, the kinds of students and said, "I'd be glad to write a letter of recommendation." Joey's bus roared up. She thanked him and got on. "A letter of recommendation." Joey whispered the words to herself as she sat by the window in the bus. They sounded grown up and full of portent.

She opened the front door and went into the kitchen, where her mother and Madeline were sitting at the table talking. "I'm going to apply to a summer drama program in Boston," Joey started, but her mother shook her head and looked back at Madeline.

"Later, Joey," her mother said. "Not right now."

Joey took the stairs two at a time. Damn her, damn them both. Her news was important. She slammed the door to her room. Damn Madeline and her stupid prom. She'd tried to help her. Now she wished she hadn't.

She moved to her desk and hit it with her fist, then hit it again. Her science book fell off the top of the stacked books and the side of her hand hurt. "Damn," Joey muttered again and looked down. She kicked the baseboard and felt the blow through the toe of her shoe. She'd made a black mark on the dusty white wood. What about her? What about the drama program and Mr. Pierce? Didn't anybody ever think about her? She felt she was shouting the question, making spikes of noise in the air around her that were so piercing she didn't hear her bedroom door open.

"Mad's taking a bath," her mother said. "Tell me your news, honey. What's this about a drama program?"

Joey stared at her mother. Didn't she know how mad she was? Her mother sat down on the bed, crossed her legs and Joey began to talk. The drama program was in Boston, a kind of day camp for students seriously interested in dramatics. They took people thirteen to eighteen and after all she'd be thirteen in just three weeks.

If she could live with the Hartleys during the week, she said, then she could go to Newbury on weekends, if they went back that is. It wasn't as expensive as a sleep-away camp and there were a few scholarships. Joey leaned against the radiator cover and talked on. It sounded fine, her mother said. She would call Mr. Pierce tomorrow and find out more.

"Mad made a bad decision last night. She made several bad decisions," Mum said. "But she's learned a lot and she won't do that again. I'm glad you took care of her, Joey. She is, too."

"She is?" Joey felt the messy world of her life in this house seep up around her like dirty water: Mad and Harris, Mad and Mona, Poppy gone, the Pacific war, and her own boredom now that *Antigone* was over. She had broken down last night and blubbered right out there on the stairs and Mona would have told Mum about that, of course, and…. "Mr. Pierce said they might do *Oedipus*," she began, grasping at a floating stick, but the brown water kept rising. "Mad's too good for Harris," she said. "He's just sexy, that's all. He's not even smart; he's a sap really."

Her mother smiled slowly. "I know, dearie. But sometimes these things don't make rational sense. Sometimes you just have to live through them." She glanced up at the window and paused. "Something else, Joey. I'm going to be working the day shift now. We're going to close parts of the Center soon. I'll have to work some nights, but not as many. So I'll be at home more and that'll help, I think."

"Home like you used to be?" Joey asked.

Her mother leaned back a little and Joey saw her mouth droop in a look of sadness, then she sat forward and gave Joey her familiar smile. "I guess nothing is going to be like it used to be, really. But yes, I'll be at home more."

She turned her head toward the window. The room was quiet; somewhere nearby a crow called. "Your father and I have worked hard for the war and both of us have changed, I think." She folded her arms around her in her dark sweater. "I've changed. I know that." She waited.

"What's going to happen, Mum?"

"I'm not sure, dearie. But we'll work things out."

Chapter 23

J OEY sat at the desk in her room, gazing out of the window at the apartment building across the street as she whispered, "Richard the First, John, Henry the third, Edward the first, Edward the second.... " She paused. Memorizing a list of kings was stupid, but Mrs. Mooney's boring History class would be over soon and tomorrow was the last quiz. "A good teacher can make an enormous difference in the way you feel about a subject," Poppy once said.

Poppy. Joey looked up at the calendar on the wall. His visit seemed far off, that night when he had sat right there on her bed and talked to her about *Antigone*. He had made a promise, she remembered and lifted the calendar from its hook on the wall. He had come on Tuesday night, April twenty-fifth and he had said he would come home in three weeks. She had circled May seventeenth in red, she saw, but today was the twenty-third. He was almost a week past his promise and they had heard nothing from him. Had he meant his promise or had he told her a soothing lie because he thought she was still a child?

Joey opened her loose-leaf notebook, pulled out a sheet of lined paper and started writing. *"Dear Poppy, You have broken your promise to come home in three weeks, if it was a real promise, which I thought*

it was. *On April 25th, you said you would be home in three weeks. That would be May 17th, but it's May 23rd now and you're still not home and you haven't called. I am....*" Joey hesitated, trying to decide whether "disappointed" had one "s" or two, then settled on "sad" instead. *"Love from your daughter, Joey."* She reread the sentences slowly and wrote *"Josephine"* under *"Joey."* She would mail it to him, she thought, and went into Madeline's room to look in her drawer for an envelope.

There were no envelopes in the top compartment and none in the back. Joey straightened. Forget the envelope; she would take it to Sarah's apartment herself, she decided. She thought of the address taped to the wall in the telephone closet downstairs. She knew where New Hampshire Avenue was. She would take a D6 bus and change at Dupont Circle.

She went down the stairs quietly. She could hear Ruthie talking about Dave Saltzman, a boy in her Biology lab, who looked just like Van Johnson, she said. "He has that same cute smile." Joey knew she should tell Madeline she was going out, but Madeline would just tell her not to and she had to deliver this letter. She pulled on her jacket and glanced at the small blue pocketbook she never used, hanging by its strap on a hook behind the door. She could carry the letter in her hand or she could put in the pocketbook; that would look more grown up. She pushed the letter into the pocketbook, added her bus money, pulled the strap over her shoulder and started down the front steps. It wouldn't take long. She crossed to the bus stop. She would be back by supper and Madeline would never even know she'd left.

There was a long wait at Dupont Circle and Joey noticed with worry that the sky beyond the trees was growing gray. It might start to rain and she hadn't brought an umbrella, but she'd be home in an hour. A wind stirred the tree branches above her. She shivered and was glad to enter the bus at last with its smell of people and exhaust.

Joey gripped a hanging strap near the door and stared down at

a newspaper on the floor. CHURCHILL RESIGNS. What? How could Churchill resign now? He had to finish the war. Was he tired? Was he going home to Mrs. Churchill and their daughter? Joey looked out of the bus window. If Churchill could stop working and go home, why couldn't Poppy?

The bus turned up New Hampshire Avenue and Joey stooped to peer out the window, trying to see the numbers. She tensed when she glimpsed 1701 on a building; his apartment must be in the next block. She reached for the buzzer cord, but the bus veered into another street. T Street? Then they were on 16th. She pulled the buzzer hard and got off. A misty rain had started. Now she would have to hurry back down T Street to New Hampshire. She clutched her pocketbook against her side as she started down the street. When she crossed 16th, she heard a rumble of thunder. A newspaper flapped toward her in the wind and bits of branches scattered down.

Several men were clustered in the doorway of a shabby little market on the corner that had a lighted beer sign in the window. On the side of the building was a picture of Virginia Dare holding a glass of wine. Joey thought of crossing the street to avoid walking past the men, but there was traffic now and she was in a hurry. "You're gonna get wet, young lady," a rough voice called out. "Stop here a minute, why don't ya?" Joey shook her head and hurried on. "Where're you goin' anyway?" the man called.

Please, God, don't make trouble now, Joey prayed, and walked faster. She turned down New Hampshire. The numbers began with 1923. At least she was on the right side of the street. It was raining harder and she turned up her collar. 1903, 1901. If only she'd gotten off the bus sooner. She crossed the side street and went on.

There it was: 1825. A ragged hedge enclosed a weedy strip of lawn in front of the building and the concrete walkway up to the front steps was cracked. Joey pushed open the door and stared at the row of mailboxes on the left side of the dingy front hall. All at once a sense of the huge inappropriateness of her presence here

flooded through her. She had never met Sarah; Poppy had barely mentioned her, and yet she was in the hallway of the woman's apartment about to seek out her father. Should she? She could turn around now and take a bus back to Dupont Circle and then the D6 bus home. But Sarah might not be here. She hesitated. *"...I will bury him."* She heard her own determined voice reach out in the darkened gym. *"...well for me to die in doing that."*

Joey raised her hand and pressed the black button beside the narrow mailbox. She waited. Maybe he was out. Maybe she was out, too, and this show of courage would be for nothing.

"Who is it?" Joey looked around, not sure where the voice had come from. It was her father's voice, she realized, but what should she do? Her eyes lighted on a metal speaker beside the door.

"It's me, Poppy," she said, stretching so she could speak into it. "Joey."

"Joey?" His voice was startled. "What are you doing here?" She tried to think what to say, but did not answer. The loud noise of a buzzer followed. "Listen." Her father's voice was gentler. "The elevator's not working. Come up the stairs. It's just two flights."

The hallway of the third floor was dim, but she could see her father standing in the open doorway of the apartment at the end of the hall.

"Jo," he said as she approached. "Anything the matter? Is everybody all right?"

"Yes." Joey said. "Everybody's fine."

"You're wet," he said. "Come in."

Joey laid her pocketbook on the radiator cover in the hall and breathed in the thick, closed smell of old coffee and cigarette smoke as she peeled off her jacket. She picked up her pocketbook again, uncertain whether to clutch it against her side or pull the strap over her shoulder. "Your hair's wet," her father said. "I'll get you a towel."

Joey looked into the living room. There was a battered table by the wall where a black phone sat amidst several sliding stacks of paper and typed lists of names, like those her father had been

working on at home. She saw the speckled card file box that used to sit on the dining room table, and the Remington typewriter with its carriage pushed to one side. There was a green couch with a spring hanging down and on the low table in front of it was a plate with a half-finished sandwich and a coffee cup. Was she here?

Her father returned with a towel. Joey put her pocketbook down again, rubbed her hair briefly, picked up the pocketbook and fumbled a moment, undoing the snap. "I brought you this." She held the sheet of notebook paper out to her father, then pulled the strap of her pocketbook up on her shoulder and started to squeeze her hands together, as she watched him grasp it. She dropped them suddenly. Stillness has power, Mr. Pierce had said.

Her father motioned her to the couch and unfolded the letter. She sat down and he perched on the other end near the half-eaten sandwich. Joey looked around her as he began to read. A seersucker jacket hung over the back of a straight chair and her father's old brown briefcase sat on the floor, its leather strap hanging down. Joey glanced at the door leading to what must be the bedroom. Was Sarah in there?

Her father looked up from the letter. "Well, I guess you're right," he said. "I am late."

Joey felt the blood rush into her face. "It's not a matter of late," she began, her face burning. "It's a matter of understanding. Are you ever coming home, Poppy? Mad doesn't think so, but I do, and I need to know if you're not." Her voice shook, but she clenched her jaws, determined not to cry. "I know you're busy with your secret work, but…." Her voice trembled. "We've had V-E Day. Everybody says the war's going to end soon and Mum and Mad and I have to be out of the house in a few weeks and…." She took a breath. "I mean, I think you've got to think about us now, Poppy: Mad and me and…and Mum especially. I mean…." Joey twisted a thread hanging from the couch cushion. Oh Lord, what had she said?

Her father put her letter on the coffee table and sighed. "Jo,

honey. Jo." He stood and moved to the table, looked down at the papers, then back at her. He was wearing his old blue sweater; one hand was in the pocket of his khaki pants and he looked thin, with dark fleshy places under his eyes.

"I don't mean to cause a scene," Joey began, relieved to feel past the point of tears. "But I thought I ought to come."

Her father glanced at the bedroom. "I'm glad you did, Jo. Very glad. Do you want some coffee? Do you drink that now?"

"Yes," she said and felt a queer sense of power as she studied her father. He was definitely more nervous than she. "Coffee would be fine," she told him, although she had only drunk it twice before.

"Good." He stacked the empty cup on the plate, pushing the sandwich over, and took it into the kitchen alcove. Joey sat a moment looking around her. The plaster was flaked in the corner and the heavy molding made the room seem dark. The couch pillow beside her was stained with something brown, coffee maybe, and there was an old braided rug on the floor. There were no plants on the window sill, no pictures on the walls even.

Joey stood, embarrassed suddenly to have her father wait on her, and moved to the kitchen doorway. The space was small and windowless. Several unwashed plates were stacked in the sink and the faucet was dripping.

"Hope you don't mind it warmed up." Her father had turned the gas on under an aluminum coffee pot on the stove. "I just made it an hour ago."

"No," Joey said, "that's fine." She sucked in her breath. "Where's Sarah?" she asked trying to make her voice casual, but she heard it shake.

"She went to Chicago in February," her father said. "She's working there now."

"You mean, you've been living here alone?"

"Pretty much. Another physicist was here for a couple of weeks in the beginning. Then he left."

"Oh," Joey said and glanced at a spread of typed pages on the

counter. There was a bunch of yellow pencils near the sink. "Oh," she said again. Madeline was wrong; Sarah wasn't here.

Her father poured the coffee into two white cups. The rim of one was chipped, but he held the good one out to her. "Do you want milk?" he asked. "I only have the powdered stuff. No sugar either, I'm afraid."

"Powdered's okay," she said and watched him take a package from the cabinet beside him. Perhaps he didn't have a bowl, she thought. "I'll pour it in," she said and tipped the package over her cup. She took a spoon out of the sink and stirred it quickly.

They carried their coffee into the living room and sat down in the same places on the couch. "What are you doing here alone, Poppy?" Joey asked and picked up her cup with both hands to disguise her shaking. "I mean, I know you're working, but this isn't a physics lab. What kind of work are you doing here anyway?"

"Ever heard of an atom, Jo?"

Joey shook her head. She took a sip from her coffee, which tasted bland, lacking the flavor of chicory that Mum always added to the rationed coffee. But how would Poppy know about chicory, living here alone?

Her father stirred his coffee with a spoon and put it down, making a bubble of wetness on the table. "There is a super weapon based on something called the atom," he began. "And I was one of the people who helped to create it. I worked hard, Jo, very hard, and then...." He straightened and sighed. "Then all at once I realized that it must never be used. Never. The Nazi threat is over now, so there's no reason to use it, you see?"

"But what about the Japs?"

"They don't have this thing." He let out another sigh. "We could demonstrate it to them maybe, scare them. But we *must not use it*, Jo."

"The Japs killed Tony," Joey said. "They sunk his ship in the Pacific." She paused, surprised at herself. She had thought that she had folded the sorrow of Tony and put it away. "You never even knew him," she said and felt anger thumping inside.

"That was a loss for me," Joey's father said. "I would have liked him, I think, and his death was terrible. And there have been so many others. Thousands," he said and covered his face with his hands. "But even so, we can't use this weapon." He looked at her again and shook a cigarette from a crumpled package of Luckies he had pulled from his pants pocket. "I've been trying for weeks to get people to agree that it must not be used. Trying to get Truman's attention, Churchill's, the scientists I know. But it's hard. The whole thing changed, you see, when the military took over." He coughed.

There was a pounding sound above them and they both looked up; someone in the apartment overhead was crossing the floor in bare feet. "I'm not alone in this effort, Jo," her father continued. "I'm one of many and I've done about as much as I can. There are others now who've gotten involved, who have more experience and better contacts and I hope to God they'll succeed." He put down the unlighted cigarette and massaged his eye sockets with the heels of his hands. "There are a lot of good people working on it," he said. "Physicists I know. The leader's a Hungarian. A brilliant man."

"I see." Joey looked down at her coffee feeling oddly betrayed; the whole point of her mission was getting obscured by his talk of this weapon thing. "But, Poppy...." She looked at him.

"I know. You didn't come to hear about this," he said and took another gulp of his coffee. "You came here to get some answers to some big questions." Her father put down the cup. "Isn't that right?"

"Yes." Joey straightened, feeling her determination rise. "Are you going to come home or are you...." She hesitated then plunged on, aware that the wave of bravery she was riding could crash soon. "Are you going to get a divorce?

"I don't want a divorce, Joey," her father said and ran his hands through his thinning hair. "I want to come home. I want us to be a family again. I want to go back to teaching. Harvard wants me to start in the fall." He paused, then looked around the room. "Your Mum and I have talked a little. Right now I'm not sure how it's all going to work out, but I want to come home."

"When?" Joey was startled by the harshness of her tone.

"Soon. Very soon." He sighed. "I've been sick, Jo. The pneumonia left me weak and I've been working very hard." He stared at the table legs a moment, then turned to look at her. "But that's an excuse. I've been a bad father and I know it. Very bad." He looked back at the table legs as if searching for some message, then he dropped his head again.

"Maybe you have been a bad father," Joey said. "But you're the only father I have." She saw him raise his head and look at her and she went on. "You're the only father Mad has, too." She felt a flood of warmth spread through her. "The thing is, Poppy, you don't know very much about us right now. You didn't come to my play and that was all right, maybe. I didn't really think you would. But now we've got to pack up and leave the house and you're not around to help. The important thing, though, is Mad. She's had a bad time and you don't even know about it."

"What do you mean?" He sat forward, frowning, his eyes on her. "What kind of bad time?"

"She went to a friend's house after the prom and had too much to drink. She got sick on the sidewalk and the guy she was with is a dope."

"Whose house did she go to? What time did she get in?"

"Ruthie's," Joey said in a low voice, aware all at once that she was tattletaling on Madeline. "It was after three."

"Damn," her father said and stood. "Goddamn. I should've been home." He moved to the desk and pressed one fist against the top of the speckled file box. "Christ," he said. "It's like everything's exploding."

Joey watched him a moment. A car was trying to start in the street below. Cars were old now at the end of the war. The engine coughed again, then stopped. "The prom's not the point, Poppy," Joey said and leaned forward, anxious to leave her betrayal of Madeline behind. "Mad's over that."

"What's the guy's name?" Her father scowled. "Mad's boyfriend."

"Harris Simmons." Joey bit her lower lip and looked down.

"Is she seeing him now?"

"Poppy, I…I don't know," she said.

"Ah, Jo. I don't mean to put you on the spot." Her father moved back to the couch and sat down. "That wasn't fair of me." He picked up the cigarette, then reached in his pocket for matches, but seemed to find none. "I haven't paid enough attention to you girls. To your Mum either. But, you see, this thing I've been working on…. It's something that could blow up whole cities, thousands of people." He stood again and moved back to the table. "It could destroy us all," he said and took a kitchen match from the blue and white box weighing down some papers and lit the cigarette. "It's been so urgent, Jo; it's taken over my life." He blew out some smoke, then sat down on the couch again.

"The fact is we've made some progress," her father continued, "gotten some signatures and commitments, but it's hard to persuade people now while we're still at war."

"Yes," Joey said and leaned forward, feeling that something crucial had been left behind. "Did you love Sarah?" she asked suddenly and felt the sharp edges of her bottom teeth against her upper lip.

Her father scowled, then looked at her again. "I thought so for a time, but that was long ago. I kept procrastinating, muddling. I made a mess of things." He let out a low whistle. "I couldn't decide what to do."

Silence surrounded them for a while. Joey thought of Antigone. She had known exactly what to do. Her father sighed and covered his face with his hands again. "I wish I could have done more to stop this thing, Jo. This super weapon. If only I had been able to force an agreement or…. But the military…." He sighed and covered his face with his hands. "I feel I've failed, despite all my work, and I know I failed you and Mad and your Mum."

Joey waited for him to lift his head and look at her, but he continued to sit with his head down. That word, "failed," had a terrible weight for him, she thought, as she watched him push the folds of

skin on his forehead up toward his hairline. A nicotine stain wrapped his forefinger in a wide yellow band and she heard his breath come out with a rattling noise. She waited, not sure what to do.

"Remember Newbury, Poppy," she said, trying to make her voice soothing. "Remember how we used to walk down the driveway to watch the sun set over the meadow? Queenie would rush off into the tall grass and you said her tail was like a flag. Remember?"

There was a long pause. Her father raised his head finally and looked at her. "You're a good girl, Jo. Know that?" Joey shook her head, feeling a mixture of warmth and embarrassment.

Her father pushed out his arm and glanced at his watch. "Hey. It's almost five," he said in his normal voice. "Does your Mum know where you are?"

Joey shook her head. "She's not home. Neither is Mona."

"What about Mad then?"

"She thinks I'm upstairs studying for a History test. She was in the kitchen talking to Ruthie when I left."

"We better phone her. Then we'll go home. I'll come with you."

"You will?" Joey watched her father stump out his cigarette and pull his sweater down. Maybe he had told Mum that he was coming soon, but it was she who was making him do it, she thought, and felt a surge of strength as she looked up at him. "All right," she said. She pushed her hair back behind her ears and settled the strap of her pocketbook on her shoulder. "Let's go."

* * *

Joey and her father ran through the misty rain toward an approaching bus and found seats side by side toward the back. It might have been a good time to talk, but Joey felt drained and sat staring at the bus window in silence, watching rivulets of water run diagonally across the glass, relieved when her father began reading a discarded newspaper.

Madeline seemed embarrassed to see her father standing in the front hall, despite his phone call. "I'm home," he said and put both hands in his pockets. "I hope you don't mind."

"We're only having macaroni and cheese," she said. Joey made a salad, although there was just one tomato and the lettuce was limp. She added some parsley that Mona had grown in the narrow backyard and that provided a moment or two of conversation. Then there was sporadic talk of school and the summer ahead. Joey cleared the table and Madeline filled the dishpan.

Her father watched them, then yawned. "I think I'll go stretch out on the couch for a minute. A little sack time. Okay? " He glanced around the kitchen, then went into the living room.

Madeline shook some soapy drops from her hands and closed the kitchen door behind him. "What did you do this afternoon anyway?" she whispered, turning to Joey. "Did you go to his apartment?"

"Yes. I took him a letter," Joey whispered back.

"What did you tell him? What did you say?"

"I told him we wanted him to come home. I said he'd promised that he would and he was late." She twisted the striped dish towel.

"Honestly, Joey. You're such a child. You think you can fix everything, don't you? You probably didn't even know whose apartment you went to or why Pop was there." She let out a sigh and rolled her eyes toward the ceiling.

"It's Sarah's apartment," Joey began in a rapid whisper. "She went to Chicago in February. I don't think she's coming back. He's been working there alone on this weapon thing he's trying to stop."

"Oh, Joey." Madeline glared at her sister. "Honestly." She said the word out loud, letting the angry, denigrating sound break through their lowered tones. They looked at the closed door and waited, but the living room remained quiet.

"He might have loved her once," Joey said. "But he...."

"Did you think *you* could talk him out of loving her more than Mum? Did you?" Madeline gathered a fistful of forks and spoons and plunged them into the dishpan with a clattering noise. "Don't you realize they have to make their own decisions?"

"Yes, but he told me he wanted to come home and...." Joey hesitated. Maybe Madeline was right. Maybe he had come home just

to make sure she got back safely and stayed to supper to be polite. "I think he means to spend the night," she offered.

"On the living room couch," Madeline said. "He asked me to bring down a quilt."

"Why down there?"

"Don't you understand anything, Joey?" Madeline's voice went up in an arc of irritation. "He barely knows Mum anymore; he hasn't been home in months. It's over two years now, not counting the ten days after he came back from the hospital."

Joey twisted the dishtowel again. "But he's here now. In the house."

"And how long do you think that's going to last? How do you think it'll make Mum feel?" She paused and put a clump of wet silver on the drainboard.

"He told me he wanted us to be a family again," Joey said, feeling tears prickle in her eyes. Had Poppy really said that? Maybe Madeline understood more than she did. Maybe he would leave in the morning or even tonight. "He's worried about the secret weapon," she said. "He told me he was trying to stop it."

"Oh, that." Madeline pushed the macaroni pan under the faucet and turned the water on hard. "I'm sick of that thing." She grasped a Brillo pad from the back of the sink and started to scrub, then stopped and shook the water from her hands. "Your play," she said and looked at Joey. "*Antigone*. You think you can be a heroine like that girl. But you can't. This isn't a Greek tragedy, you know. This is our family."

Madeline left the kitchen, leaving the macaroni pan soaking. Joey stood by the sink a moment, unsure whether to follow her or go into the living room and talk to her father. She started scrubbing the pan. One thing she wasn't going to do was to go on memorizing those kings. She heard the key in the back door as she was loosening some sticky pieces of macaroni. Her mother came into the kitchen, the shoulders of her black raincoat damp. "Hi," Joey said, aware that she must tell Mum at once that Poppy was home. But she squeezed the

Brillo pad in one hand, hesitating, not sure whether Mum would be pleased or cross.

"Anything left for supper?" her mother asked.

There was a clatter of footsteps on the stairs and Madeline came into the kitchen, letting the door swing shut behind her. "Mum," she said in a loud whisper. "He's here. Joey brought him. He had supper with us and he's in the living room now. On the couch."

"He's here?" Their mother stared. "When did he come?"

"Joey went to his apartment and talked him into it."

"She what?" Their mother turned to stare at Joey.

"I...." Joey watched her mother pull off her damp raincoat and drop it over the back of a chair. She strode into the living room and Joey and Madeline followed.

"Jack." Their father raised his head, then swung his stocking feet to the floor. "Jack, what do you mean coming in here like this without giving me any warning?"

"I want to come back. I...." Joey felt her father look at her, then Madeline. "Joey came to the apartment this afternoon. We talked and I thought the girls needed me. I've done about all I can do on the petition. I want to come back."

"And you thought it would be that easy? Just walk up the stairs and come into the house whenever you felt ready?" Their mother put both hands on her hips and shook her head. "Jack."

"I told you last week I thought I'd be coming home soon."

"Yes and you said that the week before, too. Jack, you've been gone over two years."

"And now I want to come home." He stood and coughed, then coughed again.

"But this isn't your home anymore, Jack. You abandoned us. Remember?"

Joey, who was standing in the doorway of the dining room, felt her teeth rattle and clamped her jaws together. Mum shouldn't say "abandon," should she? It wasn't really that.

"Oh, God, Amanda. I went off to work on a crucial war project

and then I had second thoughts, like a lot of others. I've been work-
ing hard to ensure that it will never be used. You know all that."

"Other things happened, too. Remember?" Their mother's voice
was stern.

Their father glanced back at Madeline and Joey, put one hand in
his pocket, then bent and picked up a crumpled package of Luck-
ies from the coffee table.

"I left my job and nursed you for a month in that hospital and
brought you home only to have you abandon me again."

"You knew why. We talked and talked." He coughed.

"I'm not talking reasons. I'm talking feelings—mine, Madeline's,
Joey's, too." She paused and pulled her breath in audibly. "The
arrogance of you just coming in here, thinking.... I mean really,
Jack."

"I'll go," their father said. "I'll go right now."

Joey watched her mother sink down in the heavy, gray chair with
its dark fringe and sigh. "I'm not certain what I want in the long run,
Jack," she said. "I've told you that. I know you've been working des-
perately hard. But having you intrude like this without a word to
me, it's...it's humiliating."

"I understand. I'm going," their father said. "I'll call you tomor-
row at your office."

"Yes," their mother said in a low voice. "Do that. I'm sorry."

Joey watched him take his jacket from the hook in the hall, push
his arm into the sleeve and look back. For a moment she thought
he might touch her shoulder or pat her head, like old times, but he
only stared, then opened the door, making the glass panes rattle, and
she heard his feet on the iron steps outside.

Joey looked back into the living room. Her mother was sitting
with one elbow on the chair arm, covering her face with her hand.
Why did you say all that, Mum, she thought. I brought him home.
But her mother continued to sit with her hand over her face, her
shoulders slumped.

* * *

Joey sat at the kitchen table with Madeline a week later, an open package of Oreos between them. "I hate packing," she said and glanced toward the dining room, where her mother was in the telephone closet, talking to her father.

"I'm not doing any more. I feel sick," Madeline said and reached for another cookie. "That rich dinner with Colonel Harry last night. All that cream sauce and then that wine. Ick."

"Well, it made a closure," Joey said, trying out a term that Mr. Pierce had used. "And it must have cost him a pile of moolah."

"Probably," Madeline said, "but he wanted to do it and it's good he didn't leave yesterday. He was better at packing the Hartleys' car than Henry was."

"Henry's not very practical," Joey said and sighed as she looked up at the cupboard doors hanging open like brown wings above the stove. Three cardboard boxes sat on the floor—two closed, one with the flaps still open—and on the kitchen table beyond them was a messy stack of newspapers. Joey tipped back in her chair and looked up at the ceiling. "It's funny. I used to not like Colonel Harry much, but I'll miss him now. He's been part of our lives for so long."

"You were always jealous of him. You thought you could persuade Mum not to like him and fix that up too."

Joey rocked forward so that the front legs of her chair came down with a thump. She put both elbows on the table and looked hard at Madeline. "I told you I was sorry, Mad," she said and glanced back at the telephone closet. "About going to Pop's apartment and everything. But you have to admit that I made him think of us—think harder, I mean. And now they have to decide one way or another."

"Maybe," Madeline said. She tossed her head as if the phone conversation beyond them did not concern her at all. "They could go on like this for months or years, you know, talking, talking, stuck in their indecision."

"Yeah, maybe," Joey agreed. "But maybe not."

They heard their mother close the door to the phone closet. "That was your father," she said and sat down at the table. "He wants to

come back. You heard what he said last week. He feels he's done as much as he can on his project. He says he wants to go to Newbury soon, now that your school's over. He wants to start cleaning it up and repairing things. The place has been empty a long time." She folded her arms around her and let her breath out slowly.

"The thing is I'm not quite ready, girls," she said. "I've still got work to do at the Center and we have to be out of this house by the end of the month, you know. I'm going to live in Vivienne's apartment on Capitol Hill for a few weeks. It's big and close to the Center, you know, and we can all fit in there until you leave for camp, Mad, and you." She looked at Joey. "Leave for Boston."

"Is Poppy going to be alone at Newbury?" Joey pulled one of the dark, round cookies apart and licked the white sugar filling inside.

"He's been alone a lot," their mother said. She leaned back and stared at the map on the wall. "He's been very sick, you know, but he's remarkably strong. He's recuperating now and I think he's going to get back to his old self in time. Dr. Santini thinks so, too, though, of course, he wants him to give up smoking." She paused. "Look girls." Their mother put both forearms on the table. "I want to be as clear as I can. I think your father and I will be together again later. But right now I.... I just don't want to be around him for a while. Too much has happened, too much pain and...." She breathed out again and looked from one to the other. Madeline had left the table and was leaning against the sink. Joey reached for another Oreo. "Can you understand what I'm saying?" their mother asked.

"I'm coming with you, Mum," Madeline said. "I'll have two weeks at Vivienne's before I go to Vermont."

"Well, we'll see how long it takes to get packed up here. We'll ship most of the things, but your father can take some in the car."

"He'll have a lot of work to do at Newbury," Joey said. "The lawn'll be full of weeds and wild cherries sprouting. I bet the front porch is a mess."

"Ed says the roof needs to be repaired right away," their mother said and sighed.

"Poppy likes fixing things though," Joey said. "It'll be good for him to be in the country again."

"Yes," her mother agreed. "Once we get some of the big jobs done at the Center, I'll go join him, I think."

"The war's almost over and...." Joey let the sentence trail. "But Poppy's worried that somebody might use that super weapon he helped make."

"I know," her mother said.

"Mona told me that she and Henry might go out to Newbury and help," Joey said. "So I could go out with them on weekends when I'm not at drama camp and help Poppy until you come."

Joey felt her mother's long stare. "Yes, that might work out, Joey." She paused. "Do you want to drive up with him?"

"Maybe," Joey said. "But I don't know what we'd talk about all that time."

* * *

It was a hot morning and Joey and Madeline were sitting on the iron steps in front of the house, waiting. The door to the hall was open behind them and inside several large tan boxes were stacked under the table, each one tagged and tied with thick string.

"Did you give Mum your key?" Madeline asked.

"It's on the hall table."

"You've got money. Where's your suitcase? Did you put in your PJs? You might have to spend the night at a tourist home, you know."

"I know. They're right in there."

They looked up as a car slowed by the curb, but it wasn't their father. "Listen, Joey," Madeline started. "It isn't that I don't love him and stuff, you know. I feel sorry for him in a way, but angry, too. It's like Mum said. Right now I just don't want to be around him."

Joey stared at a dusty window in the apartment house across the street. "I know," she said slowly. "I know." She stretched out her legs and looked at her sister. "I keep thinking about Antigone, Mad. She was so sure of what she was doing, burying her brother and everything. I used to think that was really brave, but now...now. I don't

know. I mean, we're mad at Poppy and yet we all love him. Even Mum says that. We don't want him with us, you and Mum don't, and yet in a way we do. You know?"

"Yeah," Mad said. "It'll take time probably. And that thing he helped make, that super weapon or whatever it is, Mum says they've never tried it out, so it might not work anyway."

"What I think is," Joey continued. "Antigone was wrong, sort of. I mean things are mostly gray, not black and white the way she saw them."

"Here's the picnic, dearie." Joey's mother put a paper bag on the hall table and stooped over Joey, leaning one hand on her shoulder. "I put in a Coca-Cola for you and a Moxie for your father. He likes those, you know. Mad made the sandwiches and I put in some grapes. It's going to be hot in the car. Oh, wait." She straightened. "I brought home a nice pair of sunglasses last week. I found them in the officers' lounge. Nobody's claimed them. Your father could use them on the drive, I bet; his eyes always get tired in the sun. I'll go get them. Call me when he gets here, dearie." She hurried up the stairs.

"He likes Spam sandwiches," Madeline said. "I don't know why. Wait. I think I'll make another one, just in case." She stood and went into the kitchen.

Alone for a moment, Joey watched a bus slow for the light, then pass it, clearing her view of the apartment house across the street and the sign with its black letters, "Q Street." In minutes or half an hour maybe, she would leave this street and this house with all its memories. She looked down at the rusty joints of the iron steps and thought of Queenie hopping up those steps long ago, her license tags jingling, and those summer nights when she and Fay had raced down them barefoot to buy Good Humors and the afternoon of the wedding almost a year ago, Becky and Tony in their dress whites and she and Mum carrying the blue vases of peonies back from the church. Then there was the Western Union boy with the telegram. She had come up those steps mumbling her lines in

Antigone and Poppy had gone down them when he left in the night and now she was leaving it all. She looked up at a streak of white cloud in the sky above the apartment house, its delicate edges spreading, growing into something larger or dissolving softly into the blueness beyond.